Arts of the South Seas

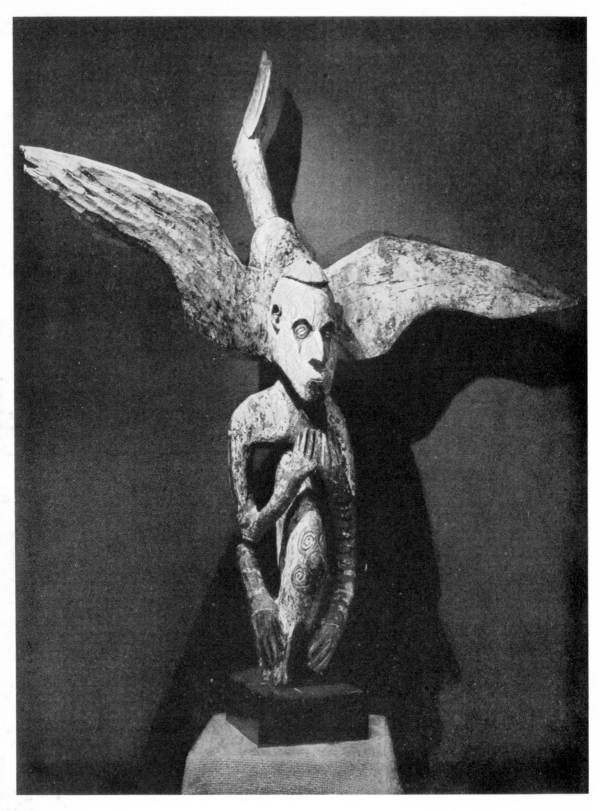

Human figure surmounted by a bird, from the Sepik River, New Guinea. 48″ high. Collection Washington University, St. Louis. (4949-1)

ARTS
OF THE
SOUTH SEAS

BY RALPH LINTON AND PAUL S. WINGERT IN

COLLABORATION WITH RENE D'HARNONCOURT

COLOR ILLUSTRATIONS BY MIGUEL COVARRUBIAS

THE MUSEUM OF MODERN ART

Reprint Edition 1972 *Published for The Museum of Modern Art by Arno Press.*

Copyright 1946 The Museum of Modern Art, New York. Printed in U. S. A.

Library of Congress Catalog Card Number 76-169308
ISBN 0-405-01567-4

CONTENTS

ACKNOWLEDGMENTS

The exhibition upon which this book is based has been organized by Rene d'Harnoncourt in collaboration with Professor Ralph Linton and Paul S. Wingert of the faculty of Columbia University. A grant from The Rockefeller Foundation made possible the additional experimental and research work necessary to demonstrate through a new display method the complex relationships between the various Pacific cultures. Charles P. Mountford, Honorary Assistant in Ethnology of the South Australian Museum in Adelaide, acted as consultant on aboriginal Australian art and assisted the directors with his expert counsel in the preparation of both the exhibition and the publication. Miguel Covarrubias gave permission to reproduce in this book four of his gouache paintings of Oceanic sculptures and took an active part in assembling the objects and in their installation. On behalf of the President and the Trustees of the Museum of Modern Art, the directors of the exhibition wish to express their gratitude to The Rockefeller Foundation, Mr. Mountford and Mr. Covarrubias, and to thank the following persons and institutions for their generous cooperation:

For the loan of works of art: American Museum of Natural History, New York; Brooklyn Museum, New York; Buffalo Museum of Science; Chicago Natural History Museum; Milwaukee Public Museum, Wisconsin; Newark Museum, New Jersey; New York Historical Society; Peabody Museum, Harvard University, Cambridge; Peabody Museum of Natural History, Yale University, New Haven; Peabody Museum of Salem, Massachusetts; Philadelphia Commercial Museum; Museum of Art, Rhode Island School of Design, Providence; Royal Ontario Museum, Toronto; South Australian Museum, Adelaide; United States National Museum, Washington, D.C.; University of Pennsylvania Museum, Philadelphia; Washington University, St. Louis. Also Mr. and Mrs. Gordon Bolitho; Lt. John Burke, U.S.N.R.; Max Ernst; John Ferno; Capt. Sheldon A. Jacobson, U.S.N.R.; Mrs. Harold Florsheim; L. Pierre Ledoux; Prof. Ralph Linton; Miss M. Matthews; Charles P. Mountford; Dillon Ripley; Dr. V. G. Simkhovitch; John and Margaret Vandercook; John Wise.

For information and assistance: Dr. Joseph O. Brew; Miss Geraldine Bruckner; Donald Collier; Miss Katherine Coffey; Dr. Carlos E. Cummings; Dr. Daniel S. Davidson; Walter H. Diehl; Dr. Ernest S. Dodge; Dr. Robert Fennell; Mrs. William S. Godfrey; Col. Clifford C. Gregg; Dr. Herbert M. Hale; Chauncey J. Hamlin; Dr. Lawrence W. Jenkins; Dr. H. W. Janson; Dr. Herbert Krieger; Dr. Paul S. Martin; Dr. T. E. McIlwraith; Dr. W. C. McKern; Dr. Margaret Mead; Fred Orchard; Dr. Cornelius Osgood; Wallace Reese; Mrs. Isabel H. Roberts; Dr. Donald Scott; Dr. Frank Setzler; Dr. Harry L. Shapiro; Dr. Herbert J. Spinden; Dr. Charles R. Toothaker; Paul Warren; Gordon B. Washburn; Miss Bella Weitzner; Dr. Alexander Wetmore; Mrs. Karl E. Wilhelm; Miss Beatrice Winser; Mrs. Natalie H. Zimmern.

Arts of the South Seas

For three centuries the distant islands of the South Seas have held a strange fascination for the Western World. The tales of early explorers and adventurers, often edited by romantic stay-at-homes, made us think of a perilous paradise inhabited by picturesque children of nature. But recent reports from the men stationed in the Pacific theatre of war struck a grimmer note. These men learned to know the islands the hard way—fighting and sweating it out in the suffocating heat of the damp jungles and in the desolation of god-forsaken specks of coral lost in a vast ocean.

Seen against these contrasting backgrounds, the arts of the South Seas become a vital document that gives reality and substance to the dreams of the romantics and fills the stories of mud and rock with dramatic human content. Here is a record of the extraordinary achievements of scattered groups of primitive men who conquered the isolation of a vast island world and created in it a series of rich cultures.

The terms *South Seas* and *Oceania* are used in this book to designate the large section of the South Pacific Ocean that includes Australia, Melanesia, Micronesia and Polynesia. There is good reason for dealing with this region as a unit since each of its component cultural areas has marked affinities with one or more of the others, so that together they constitute a network of related cultures even though no single important feature is common to all.

The arts of Indonesia are not included here in spite of the fact that among them are found survivals of the old cultures that linked the Pacific islands with the Asiatic mainland. For instance, the sculptures produced on the Island of Letti and those of the Dyaks of Borneo be-

long to these early art forms and are therefore very closely related to some Oceanic work. Most Indonesian art, however, has been so strongly influenced by the late sophisticated Asiatic court styles that its inclusion as a whole among the arts of the South Seas would be inconsistent.

In spite of its variety and beauty, Oceanic art is still relatively unknown. Anthropologists have of course dealt with many of its regional and local manifestations but have treated them chiefly as a source of useful evidence in their studies of other aspects of native life. Only a few artists and art lovers, most of them associated with advanced movements, have recognized its full esthetic value.

The appreciation of foreign art forms by such a group is always connected with the group's own preoccupations. It is significant, therefore, that Oceanic art was among the last of the primitive arts to be "discovered." The Cubists, in their search for the basic geometric forms underlying the complex shapes of nature, turned to African Negro art. The reviving interest of modern sculptors in direct carving and their emphasis on actual volume without recourse to "painting" with light and shade, led to a new appreciation of the ancient sculptures of Mexico and Asia Minor. More recently, the interest in the dream world and the subconscious that first developed during the later phases of Expressionism, made us aware of the Magic art from Oceania. The affinity of this Magic art with certain contemporary movements is not limited to concept and style but can be observed also in the choice of materials and in technique.

Each of these "discoveries" of foreign art styles called for a new method of approach. The

solution of formal problems admired in African Negro art can be appreciated in terms of pure esthetics. Yet an understanding of the relationship between content and form in Melanesian sculpture calls for some knowledge of the cultural background of the native artist. The growing realization in our art world that a work of art can best be appreciated in the context of its own civilization, together with the increasing interest in art shown by many scientists, holds a great promise. The collaboration among these groups should contribute greatly to our knowledge and understanding of the creative potentialities of mankind.

In trying to gain an understanding of Oceanic cultures and the development of their many contrasting components, a survey of the factors that produced them is necessary. The native populations of the entire region are composed of descendants of successive waves of migrants from the Asiatic mainland who belonged to many different racial types and represented various phases of cultural progress. It is generally believed that the ancestors of the aborigines of Australia were very early settlers who remained relatively undisturbed by later migrations. The Papuans of central and western New Guinea may also have come at a very early date but were followed by the ancestors of the Micronesians and Polynesians. The Melanesians originated probably from an early intermixture of Papuans with the later migrants.

In certain sections racially well defined groups have lived next to each other for generations without losing their cultural identity, while in others they have merged to form new homogeneous groups. In the case of successive migrations of people of the same ancestry, the newcomers were either completely absorbed by the early settlers or formed an aristocracy within a racially uniform people.

The great variety of inherited aptitudes and cultural characteristics the immigrants brought with them was further diversified by the climatic conditions and natural resources of the islands on which they settled. In central Australia they found vast deserts and steppes; in the mountains of New Zealand cool pine forests; on the coast of New Guinea dense tropical jungle, and in Micronesia small wind-swept coral atolls with just enough soil to support a few palm trees and patches of scrub. Once the influx of Asiatic migrants ceased, innumerable regional cultures grew out of the adjustment of many distinct groups of people to a great diversity of physical surroundings. These cultures developed undisturbed by influences from outside Oceania, but the constant traffic from island to island made for a wide distribution of regional ideas and art forms.

The division of Oceania into four major regions comprising twenty cultural areas is a convenient device to organize the exceedingly complex material into more or less homogeneous units, and has been adopted as such in this book. A similar organization of the material can be found in many anthropological publications, except that Fiji, usually considered as part of Melanesia, is here included among the island groups of Polynesia. This was done because the art of the Fijians is very closely related to Polynesian work although their languages, cultural characteristics and physical appearance are predominantly Melanesian.

As has been said, there is little uniformity in the scope and content of the various cultural areas. Some of them, like the Huon Gulf, cover only a small section of an island while others, like Central Polynesia, include several archipelagoes. The arts of Easter Island, New Zealand, the Marquesas and the Admiralties show few stylistic variations while those of the Solomons and the Sepik River area of New Guinea can be subdivided into many distinct local

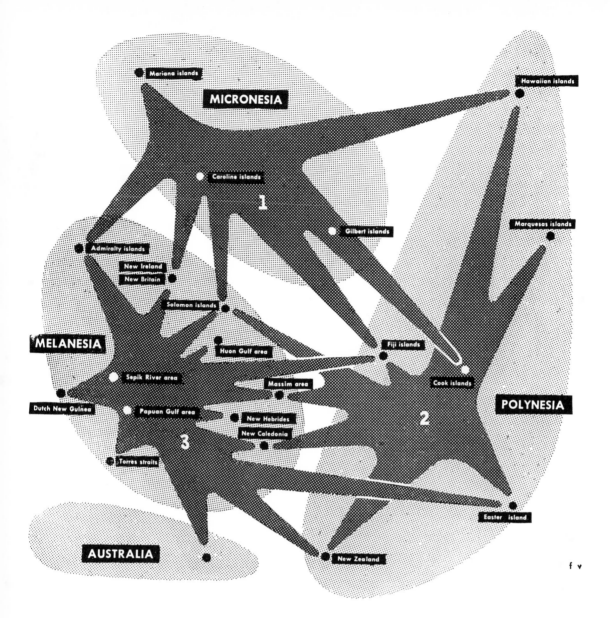

DISTRIBUTION OF BASIC TRENDS IN OCEANIC ART

1. Natural forms simplified; ornamentation grows out of function and technique.

2. Natural forms geometrized; intricate surface patterns.

3. Natural forms exaggerated and distorted with rhythmic organic curved surfaces.

This chart is based on the character of the objects themselves and does not attempt to show the historic process of distribution of these trends. That each one of them can be most clearly discerned in one major region and appears in less distinct form in the others does not necessarily indicate a radiation of the trend from a center to marginal areas. In some cases it may indicate simply the survival of a widespread tendency in central areas less exposed to other influences.

Arts of the South Seas 9

styles. In the case of both Australia and Micronesia the entire region was treated as a unit because the available material, in spite of its often considerable esthetic merit, is too limited in its variety to make subdivision practicable.

A careful examination of a representative collection of the arts of the South Seas reveals the existence of a number of basic trends that often extend through many cultural areas and sometimes even cross regional borders. The extreme economy of means, for example, that produces such elegant simplicity in the sculpture and useful objects from Micronesia can also be clearly recognized in some of the Fijian and Central Polynesian work and may even be traced to the islands of northern Melanesia. This trend may well have originated in the scarcity of raw materials on the Micronesian coral atolls which made wasteful elaboration impractical. Its appearance in island groups such as Fiji and Samoa, where natural resources are abundant, suggests that it eventually turned into a style accepted mainly for its esthetic appeal. This is further borne out by the application of its formal characteristics to ceremonial figures that served no utilitarian purpose.

Very pronounced in the arts of Central Polynesia is a preoccupation with geometric order which may well reflect the intricate, systematic structure of social and religious concepts. Many objects are decorated with angular patterns that often cover their entire surface. In some cases, as in the adzes from the Hervey Islands, these patterns are so deeply incised that the adzes can no longer be used as tools and serve only ritual purposes. Such geometric designs have evidently a ritual significance of their own and occasionally become so elaborate that they change the basic shape of an object until it becomes an abstract form. The emphasis on geometric order is less evident but still noticeable in the arts of New Zealand and other marginal regions of Polynesia, where it survives in decorative surface patterns superimposed on organic forms. In Melanesia still another dominant tendency appears. The art of the Sepik River area and the Papuan Gulf of New Guinea, as well as that of some of the other nearby islands, has a strong almost violent emotional quality. This is most apparent in the carved images of ancestor and nature spirits produced in this region. Organic interplay of curved surfaces lends these sculptures life and motion. Distortions and exaggerations and the use of strongly contrasting colors give them an aggressive dramatic intensity. Many of the figures are the work of men initiated into the secrets of ceremonial life and are purposely made to awe the uninitiated members of the tribe. Even if the means employed by the artist to impress his audience are often spectacular, one cannot speak of intentional deception, for the artist believes his work to be filled with the power of the spirits and considers himself their agent and instrument. A combination of showmanship and deep conviction makes this art an ideal vehicle for its magic content.

To what extent this trend has spread outside Melanesia is difficult to ascertain. It is evident, however, that the dramatic intensity of the Easter Island carvings is similar to that of Melanesian sculpture and that the basic forms of Maori carvings resemble in dynamic quality the work from certain sections of New Guinea.

Far too little research has been done up to now to make possible a systematic analysis of Oceanic art based on considerations of content and form, but even a preliminary survey provides many stimulating points of departure. There is no doubt that the great variety of styles and the outstanding quality of individual works of art from the South Seas would make such a study a major contribution to our knowledge of the primitive arts of the world.

INTRODUCTION

The ancestors of the Polynesians unquestionably came from Indonesia, that is, the mass of islands lying immediately to the south of eastern Asia, but the details of their migration are still unknown. Apparently they reached Polynesia by two routes. It was a short step from Indonesia to Melanesia and the penetration of this region was the first move in their eastward spread. However, most of the Melanesian islands were inhospitable and the migrants pressed on until they reached Central Polynesia. Presumably this first migration was a slow process and many Polynesian colonies must have been established in the Melanesian islands, but by the time Europeans arrived these stragglers had been absorbed into the older black population of the region. Their disappearance may have been hastened by malaria. The modern Polynesians are highly susceptible to this disease while the Melanesian blacks are little affected by it. Even today the line between black and brown peoples in Oceania follows the malaria line, brown populations being found only where the disease is absent. The lost colonists left behind them various elements of culture: their domestic plants and animals, and the modern Melanesian languages, which are more closely related to Polynesian tongues than to those of the black aborigines.

While some of the Polynesian ancestors were pushing their way through Melanesia, others were exploring and settling the far flung Micronesian islands. Apparently the Micronesian penetration began somewhat later than the Melanesian one, after the ancestors of the present Malays had appeared in Indonesia, for the Polynesians who came by this route show a considerable admixture of Malay blood. In Micronesia the migrants found neither hostile aborigines nor deadly diseases, but the coral islands which form this part of Oceania were so poor in natural resources that they had to abandon many of their original arts and crafts. Even most of their domestic plants and animals were lost. At the same time they were able to preserve or develop patterns of political organization greatly superior to those of the migrants who had taken the Melanesian route.

The Micronesian migrants seem to have been the first settlers to reach Hawaii, but in Central Polynesia and the Marquesas Islands they found their relatives of the Melanesian migration already well established with a technological equipment much better than their own. The Marquesans were able to beat off the newcomers, but in Central Polynesia they established themselves as an aristocracy. The situation there was much like that in England after the Norman conquest. Like the Saxons and Normans, the two waves of Polynesian migrants had a common remote ancestry and a great deal of similar culture. After the first shock of invasion, the two groups fused to produce a hybrid culture richer than either of its predecessors. It was this culture which was carried to New Zealand and Hawaii by the great migrations of the thirteenth and fourteenth centuries A.D.

Polynesia was the last part of the earth to be occupied by man and even its first settlers were far from "primitive." Only a people who were already well along the road of civilization could have made the long voyages required to reach its outer islands. Even the first Polynesian migrants probably did not leave Indonesia much before 1000 B.C. By this time the great civiliza-

tions of India and China were already flourishing on the mainland and beginning to make themselves felt in the islands. Traces of their influence appear in the art, social institutions and philosophy of the historic Polynesians, but the outer islands of the Pacific were too poor to support an elaborate technology. The Polynesian culture, like that of the Greeks, combined simplicity of daily living with richness and subtlety in social forms and things of the mind.

Throughout the whole of Polynesian history there was more or less voyaging back and forth between the various island groups, but there were also long periods of isolation. These made possible all sorts of local developments. Nevertheless, there were certain main themes of Polynesian culture which were expressed over and over again in different ways much as, in music, the same basic theme may be interpreted in different styles. The most significant of these themes had to do with certain concepts which permeated Polynesian life and with certain basic patterns of religious belief and social organization.

The most important concepts were those of *mana* and *tapu*, the latter the source of our own word taboo. *Mana* was power, usually of a sort which we would call supernatural. Its presence in objects was shown by superior efficiency, as when a net made consistently good catches. In individuals it went with high birth, learning or skill in craftsmanship. Gods had *mana* in superlative degree and this gave them more than human powers. Similar concepts exist among many uncivilized peoples, but the Polynesians had developed the additional concept that *mana* was contagious. It could flow from one person or thing to another simply by contact. They also believed that the *mana* of an individual or object could be destroyed in various ways, usually by contact with something considered unclean.

The concept of *tapu* was an outgrowth of these ideas. The Polynesians used the word to describe something which was psychically dangerous. *Tapu* objects or acts were to be avoided because (a) they brought the individual into contact with *mana* higher than his own or (b) they were injurious to his own *mana*. In either case the results would be disastrous for him. Contact with too much *mana* was very much like picking up a live wire and the consequences were equally fatal. Since the presence of *mana* could not be detected by ordinary observation, places and things which were *tapu* were usually marked in some way.

Chiefs and priests had the power to make various acts *tapu* and such *tapus* were the main agency in maintaining law and order. They might be permanent rulings, like our own laws, or temporary measures which could be revoked when the need for them had passed. Persons who broke the *tapu* were thus brought into contact with the *mana* of the chief or god and death followed automatically. The whole concept was mechanistic and impersonal, involving no idea of sin or of deliberate punishment.

These same ideas of *mana* and *tapu* permeated Polynesian religion. The power of gods and ancestral spirits differed from that of men in degree but not in kind. A living chief might have more *mana* than a minor ancestral spirit, especially one of another clan, or the deified patron of some craft and thus be able to ignore the *tapus* connected with his worship. Sacred objects were *tapu* because they were impregnated with the god's *mana* and everything connected with worship was dangerous to those who did not understand the rules. The emotional content of religion thus became lost in a maze of precautions and prescribed procedures. The gods were not so much worshipped as manipulated. The Polynesians used a single term for priest and skilled craftsman and the

priest was primarily a technician who knew how to deal with divinities as a technician of another sort knew how to build canoes. There was a seeming exception to this in the case of the inspirational priests, who became possessed by the deity and spoke in his name. However, such priests merely loaned their bodies to the god temporarily so that the ritual priests could approach him more directly. They themselves had no influence with the deity.

All the more important Polynesian crafts were carried on by specialists and a man's *mana* was expected to find expression in one or another activity, as house building, carving or war. All the Polynesian gods were similarly limited in their interests if not in their powers. Each great cosmic deity had to do with a certain part of the world, such as earth, sea or sky. Other gods were the patrons of special activities, the patron of war taking first rank in several localities. However, such deities, if worshipped at all, were the objects of formal, state religions. The significant Polynesian deities were the ancestral spirits, worshipped by their own descendants, and the guardians of crafts, who were usually the spirits of famous craftsmen. The real ties uniting man with the supernatural were the ties of kinship and of common occupation, the same ties which united man with man.

The fundamental unit of Polynesian society was a group very much like a Scottish Highland clan. All members of such a group traced descent from a common ancestor, occupied a common territory and normally intermarried. The highest social position in the group was enjoyed by the individual who could trace descent from the group ancestor through a line of first-born children, whether boys or girls. The other members of the group were graded in social importance according to their distance from this line as established by their ancestor's birth order.

However, since the group was comparatively small and its members had intermarried for generations, every individual had the choice of several descent lines. When two individuals invoked relationship in dealing with each other, they diplomatically selected the kin ties which would correspond with their actual positions in the group as determined by wealth, prowess in war or other sources of acquired prestige. The system was rigid in theory but flexible and realistic in use.

The individual who was of highest descent in the group was regarded as the living symbol of the ancestral line and the embodiment of the group's *mana*. He or she was treated as a sacred object, on a par with the image of a deity. Contact with such a person or even with anything which he had used was *tapu*. In some regions these sacred persons were the actual rulers and, since their decrees were backed by tremendous *mana*, their powers were almost unlimited. In others their sanctity immobilized them, much as it immobilized the Emperors of Japan in the Middle Ages. They spent all their time observing the rules connected with their sanctity, leaving the business of ruling to persons of lower descent. Within the clan the powers of a chief were always tempered by his subjects' claims as relatives, but when one clan had been able to conquer others, the power of its chief over these subjects was unchecked. In general, chiefs were deified after death and became the main guardians of their clans.

Genealogies were kept with great care and the deeds of famous ancestors were remembered from generation to generation. However, the Polynesians were unique among historically minded peoples in that they never looked back to a Golden Age. The clan was likened to an upward reaching, outward stretching tree, always alive and growing. The eldest child in each generation was believed to have more

mana than its parents and in several localities a chief lost his office as soon as his first son was born. He continued to rule until the boy became old enough to take over, but ruled as regent and could not break a *tapu* which the son imposed. This forward-looking attitude made the Polynesians one of the least conservative of native peoples. They lived in anticipation that new things would be better than the old and were always eager for novelties.

This attitude did much to hasten the downfall of the native culture. The Polynesians admired the superior technology of the white men and lost interest in their own arts, which they regarded as old-fashioned. They welcomed the Christian missionaries and abandoned their official religions practically without a struggle. Unfortunately, the change in religion also destroyed the *tapu* power of the chiefs and with it the whole basis of social control. Alcohol and imported diseases ravaged the islands and it seemed for a time that this gifted people was on the road to extinction. Fortunately the tide has now turned and the native population is on the increase in most parts of Polynesia. The modern natives have shown themselves intelligent and capable of developing a new culture suited to modern conditions and they will one day be able to take their place in the family of nations.

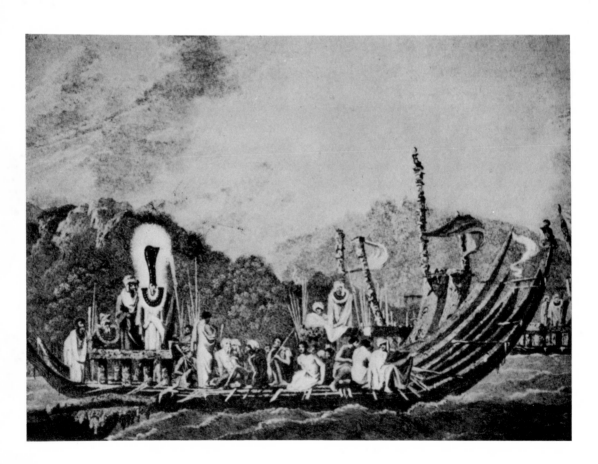

Engraving showing the Tahitian fleet about 1770, from Cook's Voyages.

Polynesia: Introduction

The 180th meridian, which is the geographic boundary between Melanesia and Polynesia, passes directly through the Fiji Islands and the group is, in many respects, a link between these two great Oceanic areas. Its western islands are large and mountainous, like those of Melanesia, with rich soil, excellent timber and abundant stone for implement making. Their climate is hot and humid, again as in Melanesia, but malaria is absent. The eastern islands of the group are much smaller and are, for the most part, atolls like those of Micronesia and Polynesia.

The first settlement of Fiji seems to have been made from Melanesia. There is no technique by which it can be dated, but the fact that at least one Fijian tribe spoke a Papuan language suggests that it was fairly early. In Melanesia the Papuan languages are, with few exceptions, spoken by the people from the interior who are descendants of the aboriginal population; the Melanesian languages proper by coast peoples who are later arrivals. In any case, a population which was essentially Melanesian in physical type, language and culture was firmly established in the group when the Polynesians arrived. Thereafter they were continuously exposed to Polynesian influences.

As a result of these contacts there was a strong infusion of Polynesian blood into the eastern islands and much less infusion in the large western ones. Polynesian concepts of rank and political organization spread throughout the whole group in varying degrees and many Polynesian items of art and technology were taken up by the Fijians. Since the latter were more skillful craftsmen than their Polynesian neighbors, many of the borrowed techniques were

developed to a higher level here than in the region of their origin. The final result of this mixture was a series of cultures which were more Polynesian than Melanesian in character, although many Melanesian features survived, especially in social organization and religion.

Fijian physical type varies with the degree of Polynesian admixture. However, most of the modern Fijians are tall and powerfully built with very dark skins, flat noses and stiff, kinky hair of coarse texture. This hair made a profound impression on the first European visitors and is commemorated in our gollywog dolls and in our comic strip pictures of cannibals. At the time of the discovery, Fijian women wore their hair cut short but the men allowed theirs to grow into a great mop, sometimes as much as four feet across which was then clipped, much as one would clip a hedge, into ridges, cones and other forms. To complete the picture the hair was often dyed blue, green or red and two or more colors might be used on the same head. Men whose hair was not of the proper

FIJI ISLANDS

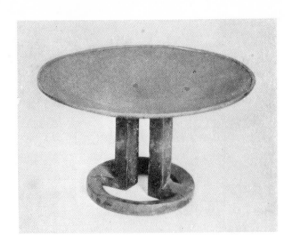

Priest's oil dish from the Fiji Islands. 11″ diam. Collection Peabody Museum of Salem, Salem, Mass. (E10.441)

length or texture wore elaborate wigs and the barbers and wig makers were a special class of highly respected craftsmen. Each chief had his barber who spent hours preparing his hair for festive occasions. It is said that when the King of M'bau visited the Queen of Tahiti in the early eighteen hundreds he spent the last day of the voyage in the hands of his hairdresser and then sat up all night so as not to disarrange his coiffure.

Fijian material culture included certain Melanesian survivals. Pottery was used for cooking and for water vessels. The latter were often modeled in decorative forms and glazed with pitch. The bow was used in hunting and war and some exceedingly elaborate club forms and many barbed spears must have been developed from Melanesian prototypes. However, clothing was made from bark-cloth, manufactured and decorated by Polynesian techniques, and wooden utensils, houses and canoes were of Polynesian rather than Melanesian form. The Fijian sailing canoes, in particular, were built on enlarged and improved Polynesian lines. Some of them were large enough to carry crews of two hundred men and had ninety-foot masts

with one-hundred-and-twenty-foot yards. In spite of their skill as ship builders, the Fijians were timid sailors and rarely attempted anything but short inter-island voyages.

Social organization was also of mixed Polynesian-Melanesian type. Each tribe was divided into several clans, the members of each clan tracing descent from a common ancestor in the male line. All the clans in a village were divided into two groups and persons belonging to the same group were strictly forbidden to intermarry. Choice was further restricted by a rule that one must marry the child of a mother's brother or father's sister who, under this system, would belong to a different clan and group from one's own. This close inbreeding seems to have had no injurious effects even when carried on for many generations. Polygyny was much commoner here than in Polynesia and chiefs might have as many as twenty wives at a time. In general, the position of women was low. They did most of the heavy field work and took no part in the ceremonial life of the group. Unmarried men were believed to suffer severe penalties after death and when a married man died it was customary to strangle his wife and bury her with him so that he could present concrete evidence of his married status. When a wife died it was enough for the husband to cut off his whiskers and bury them with her.

Each tribe had a hereditary chief who was regarded as semi-divine and accorded high respect. The other members of the tribe were divided into nobles and commoners who were full members with the right to hold land and transmit it through inheritance. Below these came the "strangers," outsiders who had been spared when captive or who had come as fugitives begging the protection of the chief. These had no civil rights and lived as tenants on the chief's land, paying goods and services directly to him.

Trade was unknown in ancient Fiji but a brisk exchange of surplus goods was carried on through an institution known as *kere kere*. Each man had a number of friends from whom he could beg anything he needed while they could beg from him in turn as need arose. There was no standard medium of exchange, wealth being rated in manufactured objects and especially in sperm whale teeth. These teeth were the most valuable objects known to the Fijians and had to be included in ceremonial exchanges. A whale tooth also had to be sent to a chief with any important request and if he accepted it he was in duty bound to grant the favor.

The western Fijians retained certain religious practices of Melanesian type. The early missionaries report a mysterious figure dressed in banana leaves and with its face covered by bark-cloth which wandered about the trails at certain times making a curious sound and clubbing or spearing anyone whom it met. They also report the existence in one island of a men's secret society with elaborate and terrifying initiation rites. However, these were isolated survivals. In general, Fijian religion lacked such mysterious and terrifying elements. Their nearest approach to a supreme being was a serpent deity who had been involved in creation, but he had long since coiled himself in a cave and the only indication of his presence was an occasional earthquake caused by his stirring in his sleep. He had no temples and received no sacrifices. Worship centered in the clan deities who were, almost without exception, deified human beings. Each clan deity had its temple, a high roofed house set on a high stone platform, the height being a symbol of the god's importance. The temple contained a small image of the god and was watched over by a priest. Priests wore a special costume and their duties consisted in taking care of the temple and image, seeing

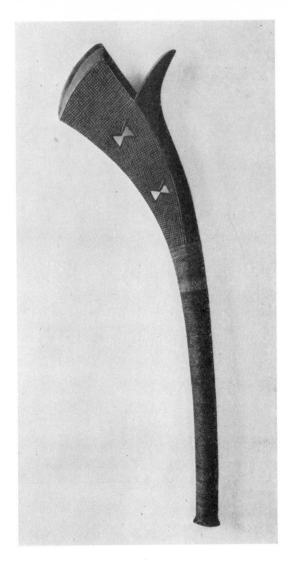

War club from the Fiji Islands. 48″ long. Collection University of Pennsylvania Museum, Philadelphia. (P 3186-b)

that sacrifices were made in proper form and, on special occasions, allowing the god to possess them and speak through their mouths. Since the priest received a share of all sacrifices and, in some cases, the profit from temple lands as well, the post was a lucrative one and was usually hereditary in some family of high rank.

The Fijians are, perhaps, best known to Europeans for their warlike habits and for the practice of cannibalism. Fijian tribes were at

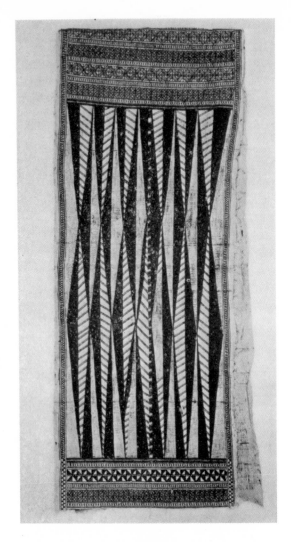

Tapa cloth from the Fiji Islands. 34 x 170″. Collection United States National Museum, Washington, D. C. (34744-B)

war most of the time, but they were not a particularly courageous people and the casualty lists were small. To paraphrase a well known verse: They went forth to battle but they usually ran away. A measure of their ferocity can be found in their weapons; huge clubs of fantastic form and elaborate decoration and many barbed spears of unwieldy length which seem to have been designed quite as much to reassure their bearers as to injure the enemy. The importance of cannibalism in the native culture

was considerably overrated by early writers. After a battle, the victorious party would eat the bodies of their slain enemies. Captives might also be killed and eaten while blood was hot and there was an unpleasant Fijian rule that all castaways went into the pot, but even enemy tribes were not hunted for meat. Cannibalism seems to have been inspired partly by motives of revenge, partly by the wide-spread idea that it was an effective means of acquiring an enemy's desirable qualities. Human flesh was taboo to women and even men used forks in eating it so that they would not have to touch it directly with their hands.

Fijian art shows an almost complete lack of Melanesian affinities. The cult figures which represented the clan gods or served to decorate their temples were carved in the same convention as those of Micronesia and Western Polynesia and have the same static, impersonal quality. Utensils for ceremonial use show fine design and finish, but are rarely decorated. The most interesting of these utensils are the shallow dishes used to hold the oil with which priests and chiefs anointed themselves. Even in these the forms are essentially functional. Rank was closely associated with height in the native mind and the dish with a raised base, shown on page 16, was made in this form so that the hands of the man holding the dish would be below those of the priest using it. Vessels for ordinary use were, in general, cruder in form and finish than other Polynesian utensils. Men found their main esthetic expression in the shaping and carving of clubs, which here show a variety of form and excellence of design and workmanship unparalled in any other part of Oceania. Women found theirs in the decoration of barkcloth. Styles of decoration varied with the tribe but, with the exception of a few small plant and animal figures shown in silhouette, the designs were all angular and geometric.

18

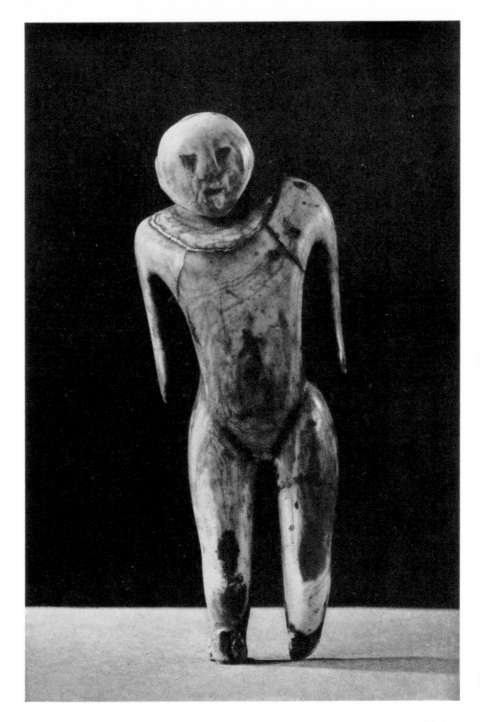

Ivory figure from the Fiji Islands. 8″ high. Collection University of Pennsylvania Museum, Philadelphia. (18194)

This figure is probably an ancestral image. Its form and material indicate that it dates from the early period of contact with Europeans. Although the artistic convention is purely native, the material is walrus ivory. Objects made from these Arctic tusks are not uncommon in Fijian collections.

Polynesia: Fiji **19**

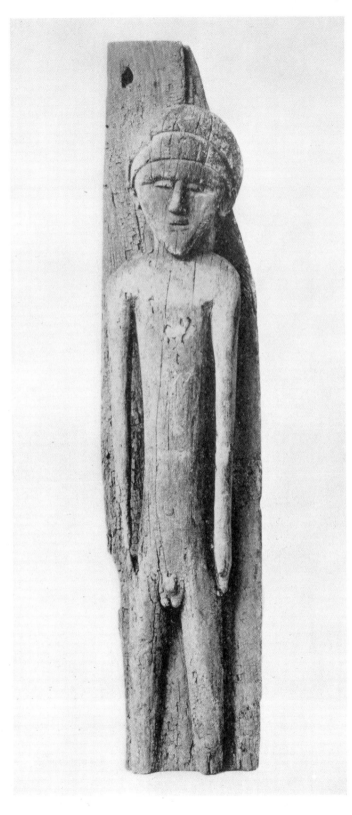

Male figure from the Fiji Islands. 45½" high. Collection United States National Museum, Washington, D. C. (3275)

Human figures carved in high relief are extremely rare in Fijian art. This one was collected by the Wilkes Exploring Expedition over a century ago and no information as to its use is available. It may have formed part of the door post of a temple.

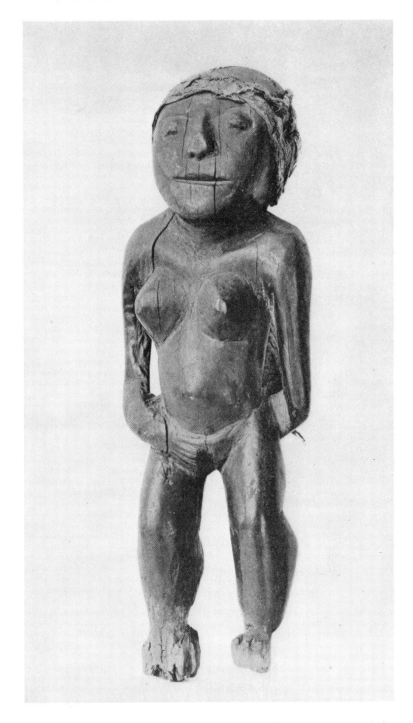

Female figure from the Fiji Islands. 14″ high. Collection United States National Museum, Washington,
D. C. (2998)

The deified ancestors of Fijian clans were represented by small images carved from wood or, rarely, ivory. These images were kept in the temples wrapped in bark-cloth and were exhibited only at the time of ceremonies.

Polynesia: Fiji **21**

CENTRAL POLYNESIA

The line of island groups extending east and west from Tonga to the Tuamotus is the heart of Polynesia. Here the earliest Polynesian migrants found at last rich lands which were free from ferocious black aborigines and from a vastly more dangerous enemy, malaria. Here also, after these migrants had become well established, came those adventurous sailors, worshippers of the sea god Tangaroa, who were the ancestors of most of the historic Polynesian aristocracies. These invaders had traveled from the Indonesian homeland by way of Micronesia and had lost many of their original arts and crafts during their sojourn in the low islands. However, they had acquired a genius for organization which made it possible for them to weld the little independent tribal groups of the earlier Polynesians into kingdoms and to rule these kingdoms successfully. Out of the fusion of these two peoples there emerged a rich and complex culture which found no parallel in any other part of Oceania. During

the second millennium A.D., migrants from Central Polynesia carried this culture to such remote outposts as Hawaii, New Zealand and Easter Island and imposed it upon the sparse and culturally impoverished populations which they found there. However, the bulk of the Polynesian population continued to live in Central Polynesia and the distinctive aspects of Polynesian culture reached their highest development there.

The Central Polynesians never lost their skill as seamen and there was always much travel back and forth between the various groups. Nevertheless, these groups retained significant differences in physical type and culture. In Tonga and Samoa, which received the full impact of the second wave of migrants, the population was predominantly round-headed with more than a hint of Mongoloid blood. In the eastern groups the population was predominantly long-headed and showed so many Caucasic characteristics that these Polynesians are

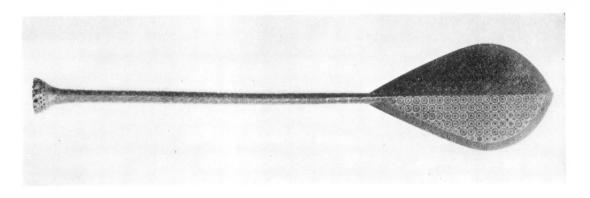

Ceremonial paddle from Mangaia, Cook Islands. 66″ long. Collection Chicago Natural History Museum, Chicago. (91.414)

usually classed as members of the white race. The population of the intervening region shows all degrees of mixture between these two types. The culture of Central Polynesia is, similarly, a mixture of the cultures of the two waves of migrants plus innumerable local developments. The various groups differed so much that most of them should be described separately.

The two westernmost groups, Tonga and Samoa, were strikingly similar in their arts and crafts. There were differences in house types and each group showed a preference for certain club forms and certain designs in bark-cloth decoration, but most manufactured objects were so much alike that they cannot be distinguished. This similarity in material culture was linked with strong differences in social and political organization and even in the character of the people themselves. The Tongan group was united under a single king with autocratic powers. There had been changes of dynasty in the course of Tongan history, but the hereditary principle was always maintained. Lines which had been deposed from political power retained high social prestige and were surrounded by a sanctity which debarred them from taking an active part in politics. The situation was much like that in Japan

under the Shogunate, when the Mikado was so sacred that he had to let others rule for him. Tonga was also comparable to Japan in the strict discipline of its subjects and in their ability to cooperate in long-range plans. Cook named the Tongan group the Friendly Islands and his writings are full of accounts of the cordiality with which he was received. It is known from unimpeachable Tongan sources that, at the time of his last visit, the Tongans planned to capture his ship and wipe out his crew and failed to do so only because he left ahead of schedule. This plan was known to the whole population but no hint of it reached the English.

The Tongans were the most determined fighters in the Pacific as well as the most daring navigators. They were as self-reliant as the Norsemen and their attitudes toward the supernatural are well illustrated by the story of a Tongan king who, to test the power of the gods, invited them to guard his back in an impending battle. He would take care of his front himself. As luck would have it, he was wounded in the back and his low opinion of the gods was confirmed. Organized religion could scarcely flourish in such an atmosphere and the Tongans had no separate priesthood, no temples except the tombs of chiefs and no cult objects

except a few small images which were carved in a convention much like that of Micronesia. The only important religious ceremonies were the funerals of chiefs and a first-fruits ceremony which was essentially a payment of tribute to the king from his subjects.

The Samoans, like the Tongans, lacked a priesthood, temples and any but the simplest cult objects. Most of their energy seems to have been devoted to the manipulation of a highly formal socio-political system. Where the Tongans were disciplined warriors the Samoans were adroit politicians. Each village had its *fono,* not too accurately translated as council, made up of the men who held certain titles. These titles were rigidly graded and each title carried with it a seat at a certain place in the council house and the right to be served after the holder of one title and before the holder of another in the ceremonial *kava* drinking. A young man would be awarded a low title by his family group and would then work up to successively higher ones. The two highest titles in the *fono* were held by the true chief, who

had to be of high descent, and the speaker chief, who might be a self-made man. The latter had to have a good voice, a huge appetite, and the ability to memorize the title series of numerous other villages so that he could act as master of ceremonies at the time of formal visits and gift exchanges. The high titles of a series of village *fonos* were also arranged in regular order to constitute a district *fono* and the high titles of the district *fonos* were again arranged to form a national *fono*. The holder of the highest title in this was theoretically high chief of the whole of Samoa, but the distinction was a social rather than a political one since no chief ever exercised authority over the entire group.

The importance of the *fono* system was reflected even in Samoan material culture. The care and labor expended upon sacred objects elsewhere in Polynesia was here lavished on those intended for social use: the fine mats and decorated bark-cloths which were the basis of gift exchanges, the bowls and cups used in *kava* drinking and the staffs and fly whisks which were the insignia of the speaker chiefs. Even

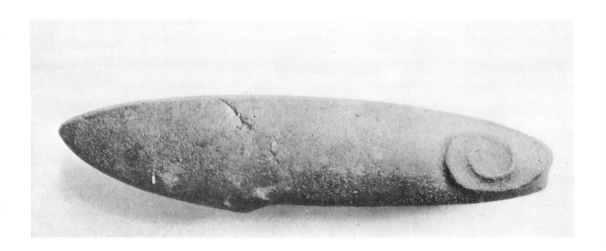

Stone fetish made in the shape of a large adze, from Tahiti. 19″ long. Collection United States National Museum, Washington, D. C. (178579)

Polynesia: Central Polynesia

house forms reflected the all pervading pattern. The original Samoan house, like the Tongan one, was an oblong structure with rounded ends. The most honorable seats were those in the ends of the house. As the *fono* system developed and more and more honorable places were needed, the house was broadened and shortened until the historic Samoan house was almost circular. The three posts which originally supported the ridge pole of the oblong house were retained, but they were placed side by side to form a single central support.

The *fono* system found no close parallel elsewhere in Polynesia and must be regarded as a local development. It reflected a situation in which no one clan or tribe really dominated or exploited another. In the Central Polynesian groups lying to the east of Samoa the conditions were quite different. Here the invaders of the second Polynesian wave had conquered the earlier population without replacing it. Their descendants ruled as an hereditary aristocracy in states whose pattern of organization revealed their origin in conquest. In each state there was a dominant clan which had the highest prestige and whose hereditary chief was regarded as king of the entire political unit. The members of this clan constituted a sort of nobility, being socially on a par with the chiefs of the subject clans. The king exacted tribute from the subject clans and lived in royal state with a numerous retinue of servants and courtiers. He toured his domain from time to time exacting "gifts" and allowing his followers to do polite plundering. The existence of a palace group and the wealth which the king acquired from the subject clans strengthened his position and made his rule more autocratic than that of any clan chief even where his own clansmen were concerned. The only check on his powers lay in his need for his subjects' support in wars with other kings. He could not afford to make

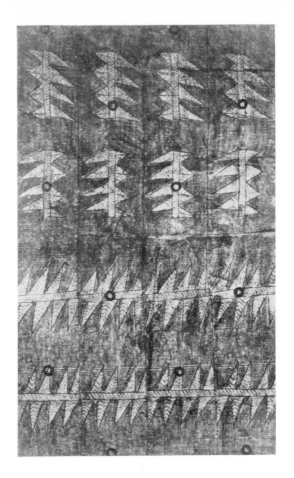

Tapa cloth from the Tonga Islands. 57 x 152". Collection Peabody Museum, Harvard University, Cambridge. (55360)

himself too unpopular or his subjects would desert him in time of need. In Tahiti when the king projected a war he sent out the priests, dressed in a special costume, to observe the omens and the worst of all omens was for the common people to jeer at the priests.

Coupled with this strong political organization there was a high development of the formal aspects of religion. Innumerable gods were recognized and worshipped. At the bottom of the scale stood the gods of various activities who were worshipped by professional craftsmen or, as in the case of the fishing gods, when their help was needed. Next came the clan deities,

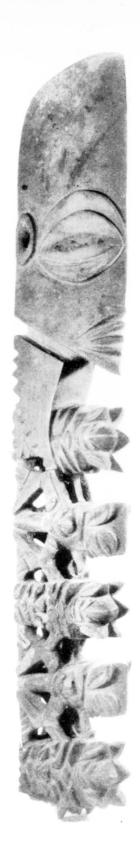

really deified ancestors in most cases. Each clan had its sacred place, usually a stone walled enclosure, large enough to accommodate the assembled clan members, with a platform at one end and one or more small houses in which the sacred objects were kept when not in use. At the time of ceremonies the sacred objects were unwrapped and exhibited on the platform and sacrifices were made in front of them. Lastly, there were national sacred places where the great cosmic deities were worshipped together with the gods of the ruling clan.

The worship of these deities by members of the subject clans was an expression of political loyalty, much like the cult of Shinto in Japan. The national deities received the largest offerings, including human sacrifices, usually selected from among the more troublesome commoners. The clan and national deities were cared for by professional priests who were graded in importance, the high priest of the national deities often being a close relative of the king. The rituals connected with all worship were highly formal and had to be performed with exact attention to detail, any slip invalidating the entire ceremony. In addition to the ritual priests there were, in some cases, inspirational priests who became possessed by the deity and served as his mouthpiece, but the ritual priests held the higher social rank.

All deities who received worship were represented by objects of one sort or another. A few of these symbols were derived from actual tools or weapons. Thus the finely carved adzes from the Cook Group were, appropriately enough, symbols of the god of the carpenters. However, most of the cult objects have no such obvious derivation. In view of the distribution of hu-

District god from the Cook Islands. 25″ high. Collection Peabody Museum, Harvard University, Cambridge. (1390)

Polynesia: Central Polynesia

man figures in Polynesia it seems certain that the early inhabitants of this region represented many of their deities in human form and this is borne out by the presence of a considerable number of crude stone statues in ancient sacred places. However, by the time Europeans arrived, human figures were used mainly for minor deities. In Tahiti they had gone so completely out of fashion that wooden images are said to have been used only by sorcerers. The human figures which have survived are all highly stylized: squat, potbellied figures with half-bent legs and disproportionately large heads. The features are highly conventionalized with large oval eyes, emphasized brows and ears, small noses and open mouths, usually with lips and tongue indicated. A curious feature of the art of this region is the frequent use of large numbers of small human figures, made like the images, which are carved in high relief on the surfaces of larger objects, even statues. In the latter case the whole figure was said by the natives to represent a god and his progeny.

Clan and national deities were usually represented by highly abstract wood carvings most of which bear no recognizable relation to the human figure. One of the commonest forms for clan deities was a long staff with a large conventionalized human head at one end. Below this were carved a series of small human figures, also highly conventionalized. The upper part of such a staff is shown opposite. The center of the staff was smooth and was covered by a thick roll of bark-cloth while the lower end terminated in a phallus. Such a staff probably symbolized the clan ancestor, his progeny and his procreative powers. Some of the other sacred figures seem to be completely abstract with elaborately pierced loops and spurs and bands of vertical decoration consisting of simple angular designs repeated over and over. The projections on these objects usually end in small,

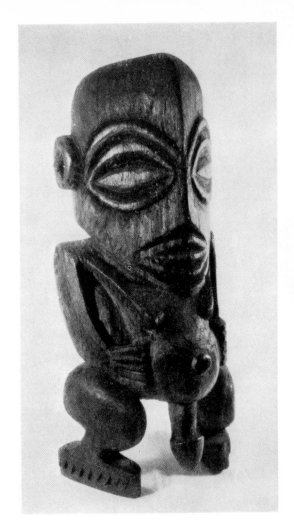

Fishermen's god from the Cook Islands. 17" high. Collection Peabody Museum, Harvard University, Cambridge. (53517) This type of effigy was placed on the prow of a fishing canoe.

highly stylized human heads while the angular designs were interpreted by the natives as highly conventionalized human figures. It seems probable that such objects are closely related conceptually to the images covered with smaller figures already mentioned and that the designs on them are an integral part of the symbolism rather than merely surface decoration.

Except for the cult objects just discussed, the art of Central Polynesia was not particularly

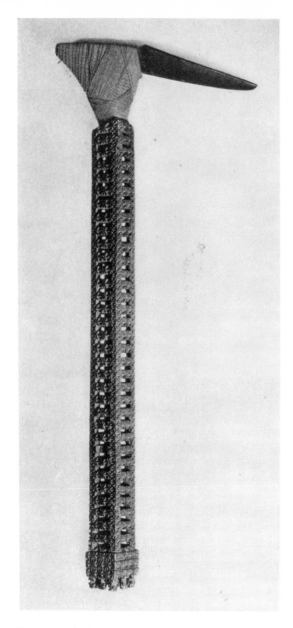

Ceremonial adze from the Cook Islands. 34″ long. Collection United States National Museum, Washington, D. C. (3719)

all organization but even this sort of decoration dies out in the eastern groups. The carved adzes from the Cook Group and the carved paddles from Mangaia (p. 23), both of which are common in museum collections, were originally cult objects although they were later turned out in quantity for souvenir trade to Europeans.

Bark-cloth was decorated everywhere in Central Polynesia (p. 25). In Samoa and Tonga the usual method was to spread the cloth over a surface bearing raised designs, then rub it with red earth or soot, thus transferring the design to it. The rubbing was later touched up and altered with paint, usually a dark reddish-brown varnish. Designs were mostly geometric with a few conventionalized plant and flower forms. The rubbing plates originally used in tapa decoration were made by women from pandanus leaves and coconut midribs and were rather fragile. Later, in response to demands for mass production, these were replaced by wooden rubbing plates which were carved by the men and this resulted in a more angular style of design. East of Samoa most tapa decoration was by freehand painting while in the Society Group tapa was frequently stamped with flowers or fern leaves dipped in dye. In general, the eastern tapa decoration lacks boldness in either design or execution.

One other art remains to be dealt with, that of tatooing. This was present everywhere in the area but was not highly developed outside the Society Islands. In general, small, rather widely spaced geometric designs were used in the western islands. No good records of Society Island tatooing designs exist, but early accounts mention the use of large designs including more or less naturalistic plant and animal figures. Since this art reached its highest development in other parts of Polynesia, discussion of the techniques may be postponed.

rich or varied. Utilitarian objects reveal a strong feeling for form and craftsmanship but surface decoration was rarely applied to them. Samoan and Tongan clubs were frequently carved with shallow, angular, geometric designs applied in small panels with little over-

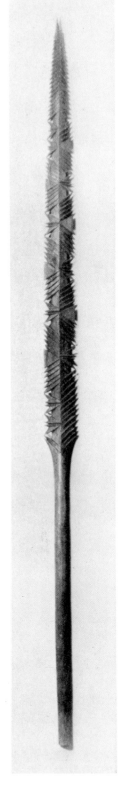

Carved spear from the Samoa Islands. 74″ long. Collection Peabody Museum, Harvard University, Cambridge. (63047)

The complex system of geometric decoration can be seen in the enlarged detail above.

Polynesia: Central Polynesia

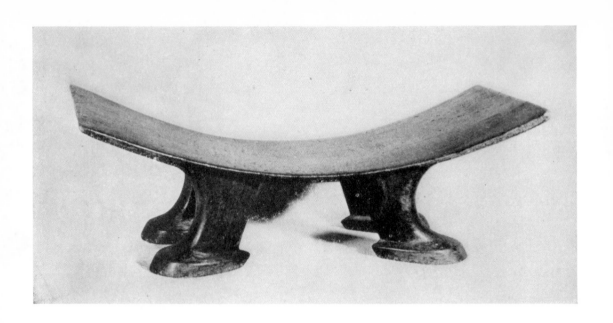

Neck rest from the Samoa Islands. 18″ long. Collection Buffalo Museum of Science, Buffalo. (C-13532)

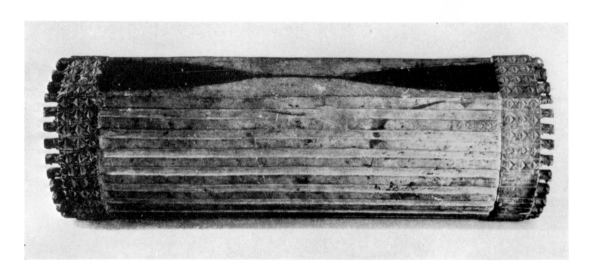

Drum from Mangaia, Cook Islands. 27¼ x 9″. Collection American Museum of Natural History, New York. (S/4762)

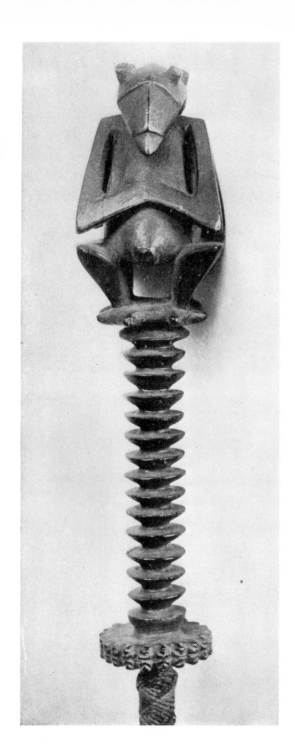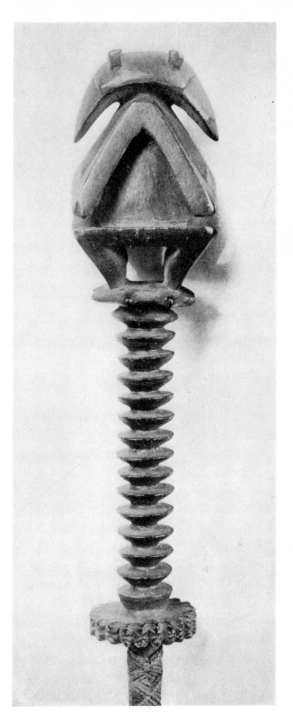

Fly whisk handle from Tahiti. Front and profile. 13¾″ long. Collection Peabody Museum of Salem, Salem, Mass. (E 13.216)

Polynesia: Central Polynesia

THE MARQUESAS ISLANDS

Most of the Marquesas Islanders were descendants of the first wave of Polynesian migrants. There is linguistic evidence that some groups belonging to the second wave reached these islands but they were unable to conquer the older population or to build kingdoms of the Central Polynesian sort. By the time Europeans arrived they had taken on the culture of their aboriginal neighbors. This culture had a number of peculiar features which seem to have been directly linked with the local environment.

The Marquesas Islands were far from being the tropical paradise pictured by romantic writers on the South Seas. The islands themselves were inhospitable; incredibly rugged with steep narrow valleys running back to a central core of impassable mountains. Even adjoining valleys were frequently separated by ridges too steep to be scaled. The group as a whole lay too close to the Equator to have a regular rainy season and large areas on all the islands were too arid for human occupation.

Food was always a serious problem. The absence of barrier reefs and lagoons made fishing arduous and uncertain. The only crops which could be grown profitably were breadfruit and coconuts. To make matters worse, the islands were periodically visited by terrible droughts which might last as long as three years. At such times the breadfruit crop failed and even drinking water became a serious problem. The natives prepared for these droughts by storing fermented breadfruit paste in great communal pits, but severe famines occurred at least once in every person's lifetime.

Even in good seasons the labor of several men was required to support a household.

Moreover, the households within a tribe competed for social prestige, obtained by liberal contributions to community feasts and gift distributions. The more men in a household, the greater its chances for social advancement. These conditions were reflected in a peculiar type of social organization.

The first-born child in a household, whether boy or girl, was considered of higher social rank than its parents and the contributions by which the household raised its prestige were ostensibly made in this child's honor. First-born children were carefully tended but younger children were neglected and girls were often allowed to die in infancy. As a result there were many more men than women. The eldest son,

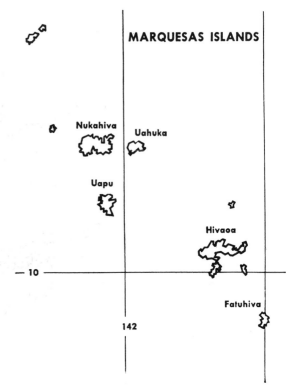

MARQUESAS ISLANDS

Polynesia: The Marquesas Islands

who inherited the household property, married and established a new household. Younger sons attached themselves to one or another of these households in the role of secondary husbands. They worked for the household, receiving in return food, shelter and a share of the wife's favors, but they could leave whenever they wished. Each head of a household tried to bring into it as many secondary husbands as possible.

Since the main attraction for secondary husbands was the wife's favors, women who were expert in the arts of love were in great demand. Sexual play in children was not only permitted but encouraged. The first Catholic Fathers who tried to convert the natives found it necessary to coin a word for virgin since there was none in the language. Adolescent girls were expected to accord their favors to all unmarried men who were not close relatives and it was during this period that they established the reputations which determined whether or not they could make good marriages.

The Marquesans had a respect for physical beauty which was much like that of the ancient Greeks. Actually, they were the handsomest of the Polynesians, but they did their best to improve on nature. They had a great admiration for light skins and before feasts the young girls went through an elaborate process of bleaching which made their skin scarcely darker than that of south Europeans. Both sexes were proud of their tatooing, which was more elaborate here than in any other part of Polynesia. Women were tatooed from the waist down and on the arms, the upper torso being left unmarked. Men were completely tatooed with heavy and intricate designs, the decoration extending even to the scalp under the hair and, in some cases, the gums, tongue, and head of the penis under the foreskin. The operation was exceedingly painful and was, to some extent, a test of cour-

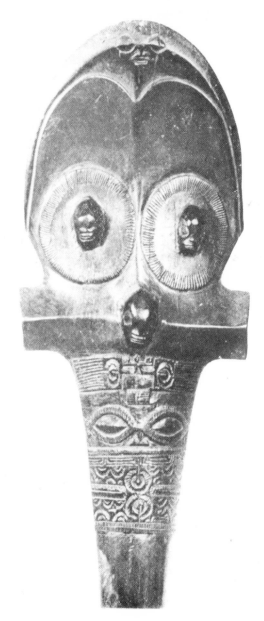

Carved head of a club from the Marquesas Islands. Collection Peabody Museum of Salem, Salem, Mass. (E 21854)

age as well as a tribute to esthetics. Older men and famous warriors frequently had the open spaces in their tatooing filled in until the entire body was colored a solid bluish green.

Boys were tatooed in groups, the cost of the work being met by some rich family whose eld-

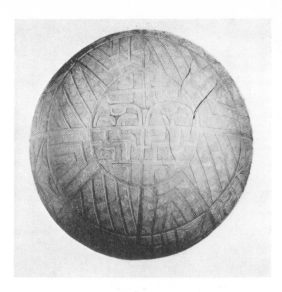

Carved wooden bowl from the Marquesas Islands. 28½″ diam. Collection Peabody Museum of Salem, Salem, Mass. (E 19.288)

est son was undergoing the operation at the time. No more than a square foot of skin could be tatooed at a single operation and the victim then had to be allowed four or five days to heal. During this interval, the tatooer worked on the poorer boys in the group. The tatooer was a highly paid specialist who had to learn his art from a master and beginners would often pay a poor boy to let them practice on him. Many of the professionals had samples, life size wooden limbs on which various designs were carved so that the client could choose the sort of decoration he wanted. It was also a common practice for the tatooer to etch some of the designs which he had used on a piece of bamboo and give it to the client after the operation as a souvenir. Women were tatooed without ceremony, but the work was done by male professionals.

The Marquesans lived in innumerable small tribes each of which was habitually at war with its neighbors. The high development of cannibalism and human sacrifice kept such wars going indefinitely. The Marquesans were genuine

man-eaters who regarded human flesh as the finest of all foods. They ate any member of an enemy tribe whom they could catch, including even infants, and frequently raided neighboring groups simply for meat. A long heavy club, carved at the upper end into a highly conventionalized human face, was a regular part of every man's costume. He carried this whenever he went out much as a European gentleman carries a cane. This club was also used as a convenient rest to lean on when chatting with friends and its upper end was broadened and hollowed to accommodate the armpit. Temporary truces were declared at the time of great feasts so that several tribes could be assembled to admire the hosts' generosity, but such truces frequently ended in a pitched battle. There was no mechanism for settling feuds or establishing permanent peace. The relatives of a person who had been eaten were socially under a cloud until they could capture and eat someone from the offending tribe. Men who were under such a revenge obligation kept one half of their heads shaved and early European visitors record this as the normal style of masculine coiffure.

Marquesan religion was strictly a tribal affair. Each tribe had one or more sacred places, usually a series of stone-faced platforms running up the crest of a steep ridge. The uppermost platform bore images of wood and stone, often of very large size, while on one of the lower platforms there was usually a small house with a very high roof used for the storage of sacred objects. The sacred place always stood in a grove.

The deities worshipped in such places were the souls of deified chiefs. Proper deification required nine human sacrifices while additional victims had to be offered from time to time to maintain the dead chiefs' powers. Such sacrifices were known as "fish of the gods" and were

34

suspended from trees in the sacred grove by a hook passed through the jaw. Each tribe had its ceremonial priest who directed the ritual of sacrifice, and inspirational priests who were possessed by the dead chiefs and spoke in their names. The approach to these tribal deities was pragmatic. A newly deified chief would be worshipped, but if he failed to answer prayers the worship would revert to some older, proven deity.

In addition to the tribal worship there was a general cult of the dead. The dead were mummified and kept in the village, often in the dwellings, until the time of a final funeral. This was given for several dead at a time and was one of the great occasions for wealth display. The number of pigs contributed by the relatives at this feast was believed to determine the place of the deceased in the next world. After the final funeral the bodies were taken to the sacred place and left there to be disposed of by the ceremonial priest and his assistants. The skulls of more important men were usually kept while the other bones were hidden in caves.

The peculiar patterns of Marquesan social organization were reflected in the local arts and crafts. Women were valued mainly as sexual objects and their manufactures were all of the simplest sort. Mats and baskets were crude and coarsely woven and bark-cloth was undecorated. The men's products, on the other hand, showed a technical skill and industry scarcely equalled elsewhere in Polynesia. They were especially skilled in quarrying and stone construction. Even ordinary dwellings were raised on great stone platforms, a new platform being built whenever an eldest son married. Each village had one or more assembly places, a level dance floor surrounded by platforms which served as seats for spectators. Some of these assembly places were over four hundred feet long

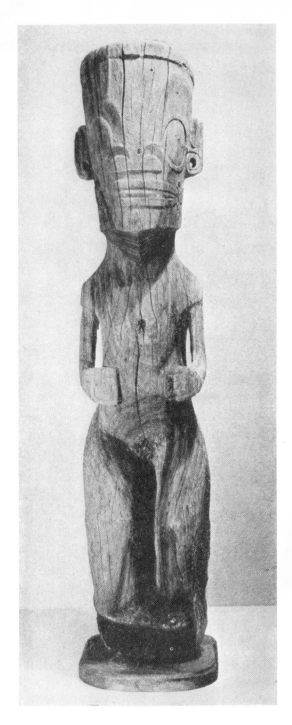

Large wooden figure (*tiki*) from the Marquesas Islands. 42½" high. Collection American Museum of Natural History, New York. (S/5126)

Polynesia: The Marquesas Islands

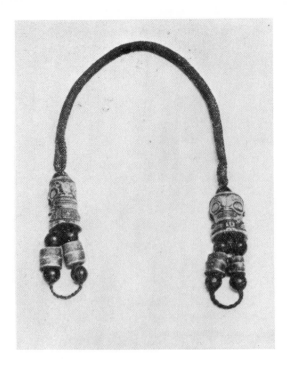

Strangling cord from the Marquesas Islands. Collection Brooklyn Museum, New York. (38.638)

with retaining walls twenty feet high. It was a point of honor with the builders of all structures to use the largest stones obtainable since such stones would remain as mute witnesses to the number of men employed in the building and the wealth expended in feasting and rewarding them. Slabs of tufa as much as twenty feet long and five feet wide and weighing up to fifteen tons were quarried and transported for miles over broken country. Stone images up to three or four tons in weight were similarly quarried and transported.

All implements and utensils were carefully made and frequently decorated with carving. Even food pounders of hard volcanic rock were laboriously carved with rats' teeth, the only material hard enough to cut the stone. It is said that the decoration of such a pounder might require six months of labor. Wooden objects were decorated with exceedingly elaborate

carving. Most of this work was done by professionals who had their own distinctive styles within the broad limits set by the native artistic conventions. The handsomest objects received individual names and increased in value with age.

Different designs were considered appropriate for different types of objects such as canoes, house posts or bowls. An outstanding feature of Marquesan art is the constant recurrence of small human figures or, more frequently, faces introduced as a part of larger designs. This is probably related to the Central Polynesian technique of carving numbers of small figures in high relief upon a surface to be decorated. Other motifs include the spiral, here given a rectangular form, various frets, pointed ovals and a horseshoe-shaped figure. Surfaces to be decorated are usually divided into sections, but these and the designs used in them are balanced to produce an all-over pattern. The endless repetition of small simple designs which characterizes most Central Polynesian decorative carving is lacking and the general effect is that of a once free and vigorous curvilinear art which has been repressed and modified toward angularity. Design analysis reveals many similarities between Marquesan art and that of the Maori of New Zealand.

The Marquesans excelled in the carving of images. These were used not only for religious purposes but also as simple decoration for dwellings and house platforms. Images range in size from statues ten feet high to little figures a few inches high. The latter, frequently carved from hard volcanic stone, were probably used by sorcerers as receptacles for the trapped souls with which they carried on their nefarious activities. Stone images follow closely the conventions of the wooden ones and appear to have been developed locally in imitation of wooden prototypes (p. 39).

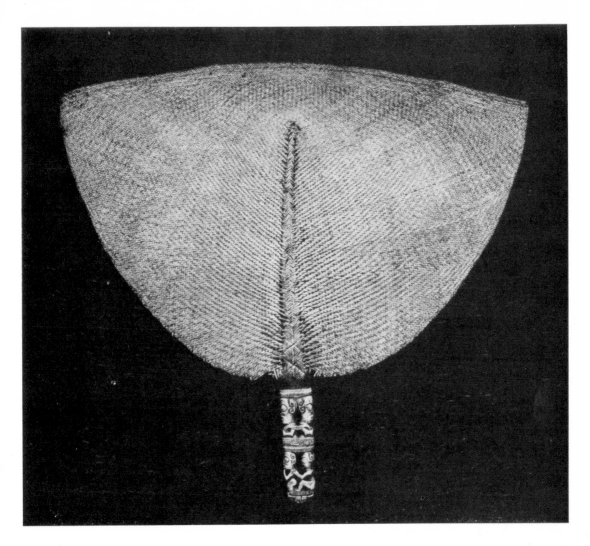

Fan with carved bone handle from the Marquesas Islands. 20″ high. Collection University of Pennsylvania Museum, Philadelphia. (18035)

The body treatment of Marquesan images follows closely that used in the eastern part of Central Polynesia but the treatment of the head is distinctive. In all cases the artist's emphasis is upon the head and face. In many images the top of the head is flat and roughly finished, suggesting the use of a headdress of some perishable material. The features are carved in very low relief with huge eyes and emphasized brows, spiral scrolls for ears and short noses with broad nostrils. Eyes, nose and ears together form a compact pattern identical with that of the faces used in decorative carving. The mouth is shown as a horizontal oblong shape with lips, teeth and sometimes tongue indicated by a series of ridges. This facial convention as a whole may derive from the sunken eyes and shrunken lips of a mummified head.

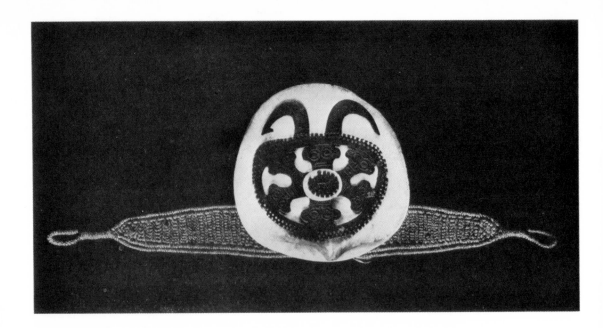

Headband from the Marquesas Islands. Collection University of Pennsylvania Museum, Philadelphia. (P 3282)

The shell disk in the center of the headband is decorated with a carved tortoise-shell ornament.

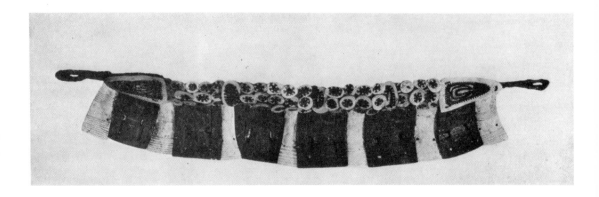

Headband from the Marquesas Islands, made of alternating carved pieces of sea-shell and tortoise-shell. Collection Peabody Museum of Natural History, Yale University, New Haven. (20482)

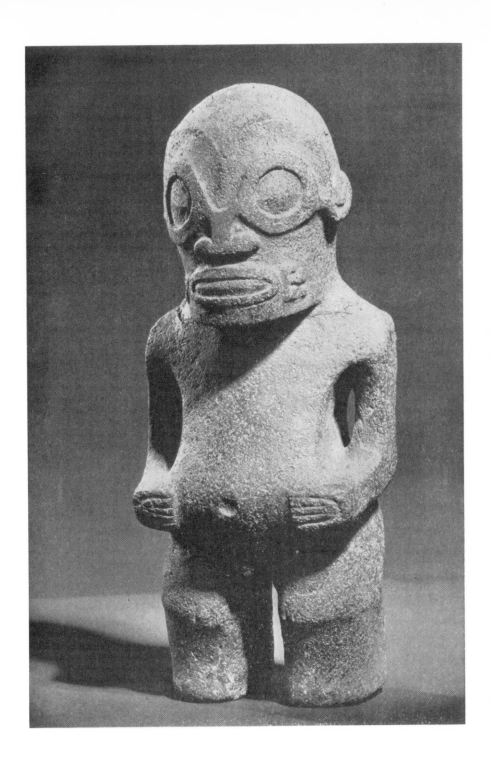

Stone *tiki* from the Marquesas Islands. 8″ high. Collection University of Pennsylvania Museum, Philadelphia. (18030)

Polynesia: The Marquesas Islands

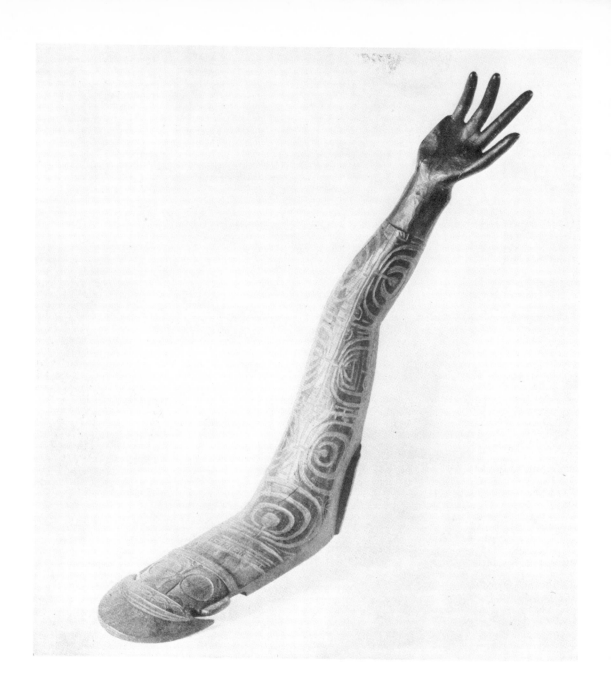

Carved arm from the Marquesas Islands. Collection Peabody Museum of Salem, Salem, Mass. (E 16.063)

This carving was probably a tattooer's model and is an accurate reproduction of the designs executed on the skin.

For over a century Easter Island has been a favorite with fiction writers of the time-machine school and with members of those esoteric cults which claim to be the inheritors of ancient wisdom. Lovers of the marvelous have been thrilled by this tiny spot of barren land, lost in the wastes of the Pacific, where great stone statues brood and the natives treasured tablets written in a mysterious script. Even scientists have not been immune to this romantic atmosphere and those of the last century wrote their full share of solemn nonsense about the mystery of Easter Island. Today, this mystery has gone the way of most mysteries when subjected to cold scientific analysis. Easter stands revealed as merely another volcanic island of the familiar Pacific type, no relic of a lost continent, and its people as merely another group of Polynesians, not very different from their relatives to the west.

There are a number of questions about Easter Island culture and history which can never be answered. In 1862 Peruvian slavers raided the island and carried off the king, his son and most of the learned men, all of whom died laboring in the guano islands. Here, as elsewhere in Polynesia, the native lore in its entirety was known to only a few and by the time modern investigators arrived much of it had been lost beyond recall. However, on the basis of surviving legends and of much linguistic and and cultural evidence it seems certain that the ancestors of the Easter Islanders came from either the Marquesas Islands or Mangareva. The time of this migration cannot be fixed but it seems probable that it was a part of the great wandering to and fro which went on in Polynesia from the tenth to the thirteenth centuries. There are vague stories of occasional visits to Easter by voyagers from the west, but no indication of more than one migration.

The Easter Islanders themselves were kept at home by their lack of wood with which to build canoes. While there may have been some trees on the island when the first settlers arrived, it had been completely deforested long

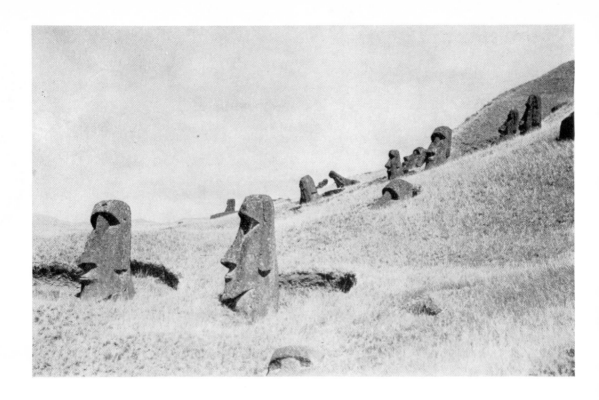

Colossal stone images on the outer slope of Rano-raraku. Photo courtesy American Museum of Natural History, New York.

before the Europeans came. Hard wood suitable for weapons and for carving into images was so scarce that it was regarded as a precious substance in itself. Most of the small wood carvings from Easter Island are really native jewelry, worn simply for their value and decorative effect. The strange postures and distorted forms which appear in many of these carvings can be traced to the artist's desire to make the largest possible object out of some morsel of hard wood which had come into his possession.

The larger, rigidly stylized wooden figures owed their value partly to the material and labor used in making them, partly to religious associations. Most households had a few of these images and the owner took pride in their number and in the excellence of their workmanship. The images themselves were never worshipped, but during feasts each man displayed the images he owned, hanging them upon his person. The more images a man could wear the greater chance he had of having his requests granted by the deity.

The grotesque male images with protruding ribs represented ancestral spirits. Their curious form was based on the appearance of mummified bodies (p. 48). The significance of the flat-bodied female figures and of the lizard-shaped figures is unknown. Images showing both human and bird characteristics, usually with bird heads, represent the God Makemake (p. 44). This deity, who was unknown elsewhere in Polynesia, received most of the islanders for-

42

mal worship. He had inspirational priests who became possessed and spoke in his name demanding sacrifices, usually food which the priests consumed.

The God Makemake was associated with the sooty tern, a sea bird whose eggs and young were an important article of food. The terns nested on a rocky islet offshore and one of the most elaborate native ceremonies was associated with getting the first egg each nesting season. The man who obtained this egg became for a year the incarnation of the God Makemake. He lived in a special stone house and was subject to numerous taboos some of which were far from pleasant. However, he could demand offerings of food from everyone and acquired a social prestige which lasted for life. The year of his incarnation was ever after known by his name and at death he was buried with other "bird men" in a special sacred place.

The daily life of the Easter Islanders was much like that of the other eastern Polynesians. They raised the same crops with the exception of coconuts and breadfruit, which would not grow in this latitude. They were expert farmers and the first European visitors found much of the island under cultivation. The paper-mulberry, from which bark-cloth was made, did not thrive and never reached a height of more than three or four feet. Bark-cloth cloaks had to be made from many small pieces quilted together. They were often stained yellow, but were never decorated with designs. Clothing was scanty, but both sexes were elaborately tatooed with large curvilinear designs.

Social organization followed familiar Polynesian patterns. Although all but the first European visitors mention the great preponderance of men over women in the population, marriage was monogamous. The natives were

Breast ornament from Easter Island. 21″ wide. Collection Buffalo Museum of Science, Buffalo. (C 12753)

Polynesia: Easter Island **43**

Figure of "bird man" from Easter Island. 17″ long. Collection American Museum of Natural History, New York. (S/5309)

divided into clans each of which held a definite territory and owned one or more image platforms, used for the disposal of its dead. There was a king of the entire island, but his functions seem to have been mainly religious. Most of the ceremonies in which he took part were directed toward increasing fertility and insuring the food supply. There was also a group of learned men who knew the ancient chants and directed ceremonies. Real power lay in the hands of famous warriors. These warriors were as competitive and as jealous of their reputations, as the bad men of our Old West and their bickerings kept the clans in constant turmoil.

The most publicized feature of Easter Island is its great stone images. These are made of a soft tufa, easily cut with stone tools. Practically all of them were taken from a single quarry in the crater of an extinct volcano, Rano-raraku. This quarry still contains figures in all stages of manufacture including one giant sixty feet long. Unfinished images indicate that the ancient sculptors carved the face first, then the front and sides of the body. Lastly, the image was undercut and detached.

A great number of images were set up on the slopes of Rano-raraku, apparently along the lines of ancient roads which radiated from the

Figure of lizard from Easter Island. 15½″ long. Collection Peabody Museum, Harvard University, Cambridge (53601)

crater to the different districts of the island. Other images were set up on the mortuary platforms of the various clans. These platforms were built along the shore and the images were originally provided with cylindrical caps of red tufa obtained from a different quarry.

The natives had names for many of the images but they did not regard them with any reverence. It was a regular practice for the members of a victorious clan to overthrow the platform images of a defeated one and only a few of these images were still standing when the Europeans arrived. There can be no question that the images were made by the ances-

tors of the present natives. These have forgotten how the images were transported and erected, but surprisingly large weights can be handled by very simple methods, given sufficient man power. The stone from which the Easter Island images was made was comparatively light. The largest images removed from the quarry weigh twenty to thirty tons, but all these were set up near the crater. The platform images, although often twelve to fifteen feet high, weigh only three or four tons and their size diminishes regularly with the distance to which they had to be transported. Most of the way from the quarry was down hill and the

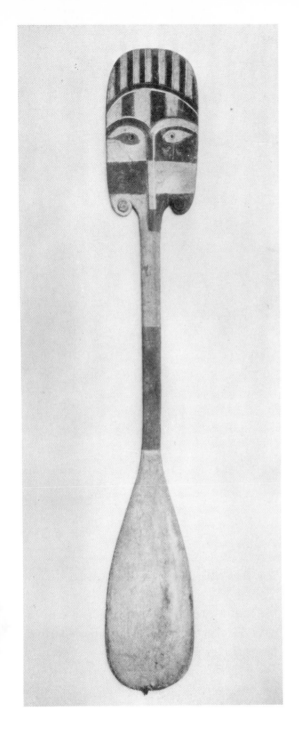

images were probably pulled along on wooden skids or simply on their own backs. There is good evidence that the backs of figures were carved after they had been set up, thus obliterating any scars received in transport.

The inscribed tablets of Easter Island have excited quite as much interest as the images. They are roughly oblong pieces of wood which bear rows of carefully incised figures. None of them appear to be of great age and several of them are made from wood obtained from European ships. The rows of characters run from end to end of the tablet and usually cover both sides. The characters are executed with great precision and although they show many minor variations in detail about a hundred different characters can be recognized.

These tablets were the property of the *rongorongo,* learned men and professional chanters, who were the keepers of the native lore. These held the tablets and referred to them while reciting the long chants which were a necessary part of many ceremonies. At certain times groups of *rongorongo* would get out their tablets and chant together to show their skill. All attempts to get satisfactory interpretations of the tablets from the natives themselves have failed, but it seems certain only the maker of a tablet, or one whom he had instructed, could interpret it correctly. Apparently the characters were pictographs, but pictographs whose form and meaning had not become completely formalized. They were on the way to developing into a genuine system of writing but had not yet done so. Their makers used them as memory aids, much like the pictographic records which certain American Indian tribes used as a help in singing long series of ceremonial songs. Although memory aids of various sorts were used by chanters in other parts of Polynesia, the Easter Island tablets remain unique.

Painted paddle from Easter Island. 80″ long. Collection United States National Museum, Washington, D. C. (129749)

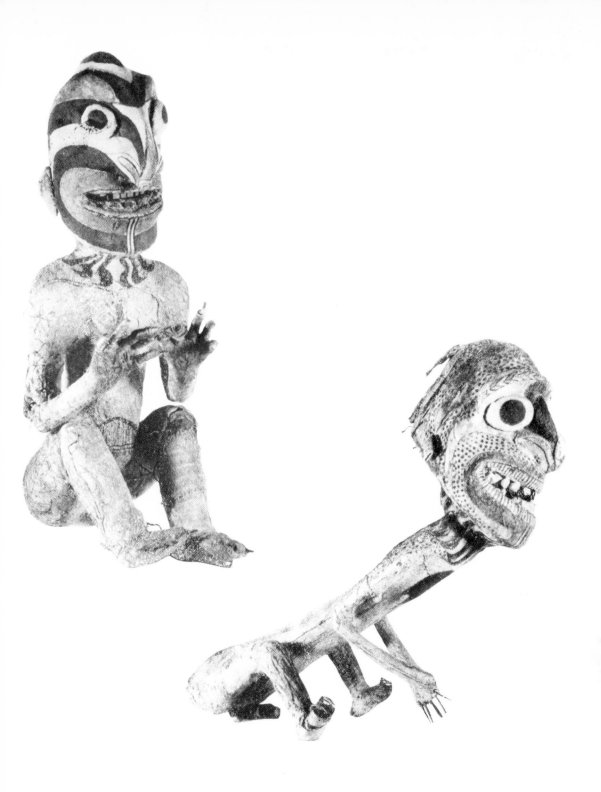

Figures covered with painted tapa cloth from Easter Island. 15″ and 12″ high. Collection Peabody Museum, Harvard University, Cambridge. (53543 and 53542)

Polynesia: Easter Island

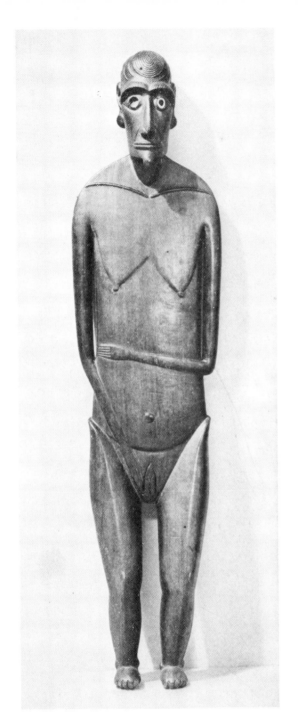 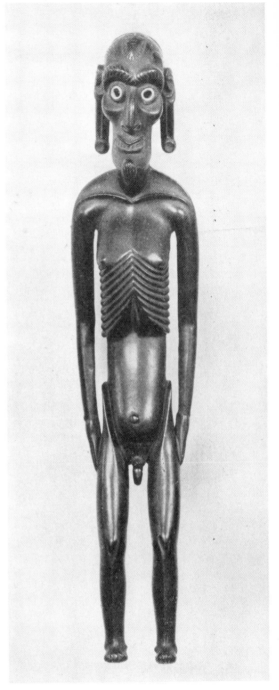

Left: Carved female figure from Easter Island. 23″ high. Collection Peabody Museum of Harvard University, Cambridge. (47752)

Right: Ancestral male figure from Easter Island. 17″ high. Collection University of Pennsylvania Museum, Philadelphia. (18059)

The history of the New Zealand natives, commonly called Maori, is better known than that of any other people who were ignorant of the art of writing. All Polynesians had a keen interest in genealogies and in the deeds of ancient chiefs, but in most regions the knowledge of these things was confined to a small group of learned men with semi-sacred functions. Among the Maori the same sort of knowledge was widely disseminated. Each tribe had a sort of college in which the ancient lore was taught to all young men of any social position. The chants in which this lore was embodied had to be learned verbatim and students who failed to pass the final examinations lost heavily in prestige. While the historical records were, quite naturally, designed to show the tribe in a good light, they were as accurate as much of the American history taught in our own schools fifty years ago.

According to these traditions, the first Polynesian explorers to leave a record reached New Zealand about the year 900 A.D. Some of the legends say that they found there a few people who could speak their language, but most of the great island seems to have been uninhabited at that time. The explorers brought back to Central Polynesia tales of a great wingless bird, the moa, and samples of New Zealand jade, an unsurpassed material for ornaments and implements. A number of other Polynesian voyagers visited the island during the next three hundred years and a few local settlements were made. Finally, in the thirteen hundreds, there was a great migration from eastern Central Polynesia: mainly the Cook, Austral and Society groups. The names of the canoes in which these migrants came have been preserved as carefully as we preserve the name of the Mayflower and most of the modern Maori trace descent from the crew of one or another of them.

The settlement of New Zealand was something new in Polynesian experience. After many generations spent in small islands with strictly limited resources, the immigrants found themselves in a rich, wide land where there was room for all. However, the new land was much colder than anything they had encountered before. Most of their familiar crops would not grow and many of their familiar materials were

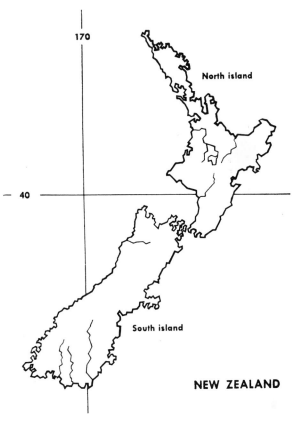

NEW ZEALAND

lacking. In the course of time they developed a new and distinctive culture with arts and crafts differing markedly from those of the other Polynesians.

Traditions tell that the voyagers of the great migration came in double canoes or canoes with outriggers. Both were abandoned by the later Maori who did most of their water travel on rivers or close to shore. The native kauri pine provided gigantic logs and the Maori replaced the plank canoes of their ancestors by huge dugouts sometimes as much as eighty feet long and wide enough to seat two paddlers abreast. These canoes were provided with projecting figure-heads and a high, upward-curved stern piece intricately carved (pp. 54, 55).

The airy thatched houses of Central Polynesia were unsuited to the damp and cold climate of New Zealand. Ordinary dwellings became little more than hastily constructed hovels, but each village had one great house on the building of which the skill and wealth of the villagers were concentrated. This house was used for all sorts of ceremonies and also served as a dormitory in which all the villagers slept in cold weather. It was oblong with a projecting porch at one end and, under the porch, a single door and window. The gable, door and window frames and sometimes the entire house front were decorated with elaborate carvings (p. 56). The walls inside were made with alternate carved panels and thick, rigid mats woven in bold red, black and white designs. The posts supporting the ridge pole were also carved and the rafters were painted with elaborate scroll designs. At the bottom of the central house post there was usually a naturalistic human figure, but the figures on the carved panels were highly conventionalized with a wealth of surface decoration in fluid, curvilinear style (p. 52). All figures were supposed to represent ancestors.

Since the paper-mulberry could not be grown in New Zealand, the bark-cloth garments of other parts of Polynesia were replaced by heavy cloaks made from New Zealand flax. Skeins of this soft, strong fiber were placed side by side and fastened together with pairs of slender cords which were given a half turn between each pair of skeins. This technique, which is known as twined weaving, was widely used in Polynesia in the making of fish traps but only here was it applied to fabrics. Cloaks were shaped so that they would hang smoothly on the wearers' shoulders and the better ones were

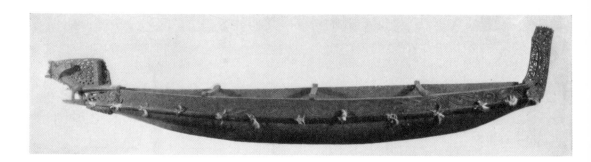

Carved canoe model of the New Zealand Maori. Collection Peabody Museum of Salem, Mass. (E7,319)

Polynesia: New Zealand

often covered on the outside with feathers or provided with closely woven borders decorated with simple angular geometric designs.

New Zealand jade was prized both for its utility and for its beauty. It was exceedingly tough and hard so that cutting implements made from it were little inferior to those of metal. Small implements of finely colored jade were often worn as ornaments. The most prized of all native decorations was the *hei tiki* (p. 59), a small grotesque human figure carved from fine green jade. The making of such an ornament required months of labor and *hei tiki* were handed down in chiefly families as heirlooms. In some cases they were worn only in alternate generations, being buried with the owner, then dug up and worn again by a grandchild. There was also a regulation that the wife of a captured chief had to send her *hei tiki* to the wife of his captor.

The art of tatooing was highly developed, but this sort of decoration was practically limited to men. Women were marked only upon the lips, but men had the entire face tatooed, and also the thighs. Maori tatooing was really flesh carving. The designs were cut into the skin with a small, chisel-like blade. Pigment was made from the dung of dogs which had been fed on very fat meat until over-secretion of bile colored their dung black. This was rubbed into the cuts so that they healed as a series of grooves. Since the grooves became obliterated in time, a man who was careful of his appearance would have his tatooing gone over and deepened from time to time. No two face tatooings were identical, and in early days chiefs drew details of their face tatoo on treaties with the whites by way of signature.

Although the ancestors of most of the Maori came from a part of Polynesia in which religion and government were both highly organized, the historic Maori lacked such organization. They had no sacred structures, no images toward which worship was directed and no distinct class of priests. Their only sacred objects were small carved pegs upon which the spirits were summoned to alight so that they could receive offerings and hear prayers. In government, each tribe stood alone under the rule of its hereditary chief who was bound to all the tribesmen by ties of blood. Slavery was fairly common, the slaves being prisoners of war who had been temporarily reprieved from being eaten, but defeated tribes were usually wiped out. Conquest kingdoms of the Central Polynesian sort were unknown in New Zealand.

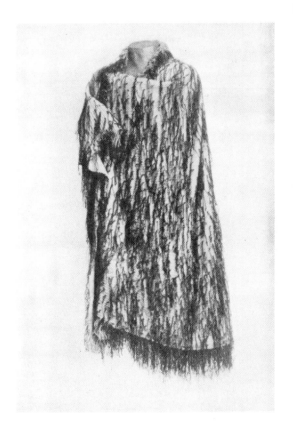

Flax cloak decorated with twisted black cords, of the New Zealand Maori. 65 x 43". Collection Chicago Natural History Museum, Chicago. (50741)

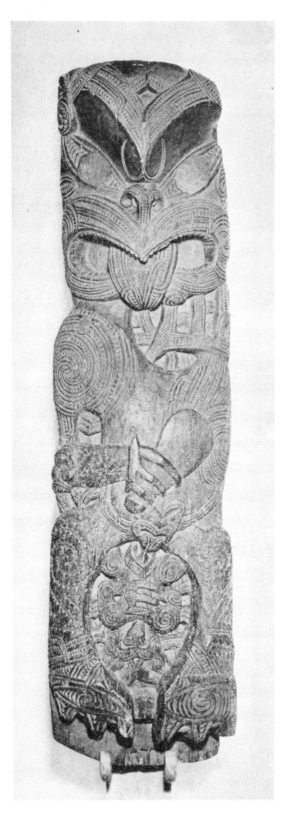

The Maori were the most warlike of the Polynesians and their courage and determination won the respect of Europeans. Villages were built on hill tops or ridges for defense and were elaborately fortified with ditches and palisades. Attacking parties carried on regular siege operations. Chivalrous behavior was admired and in some cases a besieging force would draw off the night before a final assault and even send supplies to the besieged so that the defenders would be well rested and fed and able to put up a good final battle. Cannibalism was regular. The flesh of slain enemies was an important part of the spoil after a successful battle, and captives, irrespective of age or sex, were usually eaten. Just as in the Marquesas, the relatives of a man who had been eaten were under a revenge obligation until the account could be squared, but the ultimate insult was to cook an enemy and then discard him as unfit for food.

As with most really determined fighters, the Maori warrior's equipment was comparatively simple. Staves pointed at one end so that they could be used as either clubs or spears were made in two standardized forms, but the favorite weapon was a short club, never more than two feet long. This was made from stone, preferably jade, or whalebone, or hard wood. The end of the weapon was ground to a sharp edge and it was used for stabbing rather than striking. The favorite thrusts were those delivered at the temple or just below the ribs. Apparently this weapon was developed from a stone adze blade or chisel held in the hand.

Carved house post of the New Zealand Maori. 47" high. Collection Royal Ontario Museum, Toronto. (HB 1278)

Polynesia: New Zealand

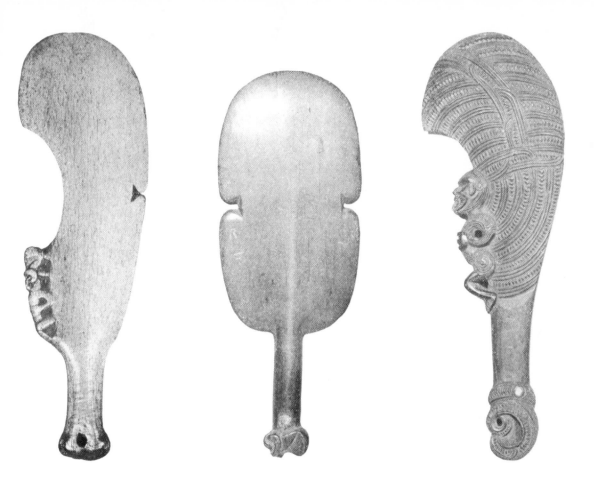

Carved war clubs made of bone and wood, of the New Zealand Maori. Collection Peabody Museum of Salem, Salem, Mass. (E 21901, E 21900, E 23543)

The Maori, like many other primitive groups, had two quite distinct art styles. Robes, baskets and mats, all of which were made by women, were decorated with simple angular geometric designs. This held even for such articles as feather robes, where there were no technical limitations on the sort of designs which might have been used. In wood carving, rafter painting and tatooing, which were men's arts, only curvilinear designs were employed. Highly conventionalized human faces and figures were extensively used in wood carving for decorative effect but never appeared in painting or tatooing. A few simple, semi-naturalistic images were carved to commemorate men and women of high rank. In these the poses are static, in sharp contrast to the vigorous action portrayed in many of the conventionalized figures. The Maori regarded such commemorative figures as portraits, but the portraiture consisted in an accurate reproduction of the individual's facial tatooing (p. 57).

Maori decorative carving finds no close parallel elsewhere in Oceania. Its vigorous, sweep-

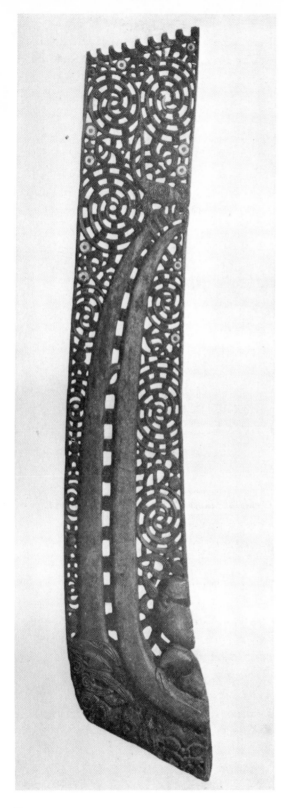

ing curvilinear style and organization of design in terms of the entire surface to be decorated contrast sharply with the art of other Polynesians. These tended to use small angular geometric motifs and to divide the area to be decorated into numerous zones or sections. These differences have led many writers to seek the origins of Maori art in some sort of Melanesian influence, perhaps the presence of a Melanesian substratum in the New Zealand population. However, there are no indications of such a substratum and the few art objects which have been found in archaeological work in New Zealand differ sharply from the work of the historic Maori. Moreover, the historic Maori style has little in common with any Melanesian style as regards either its designs or its techniques of execution.

A careful analysis of the motifs which the Maori used as design elements and especially of the conventions employed for depicting human beings reveals many similarities between Maori art and that of the Marquesas Islands. Marquesan culture seems to have been a survival of the type of culture which existed in Central Polynesia prior to the arrival of the second wave of Polynesian immigrants. Since the ancestors of the Maori came from eastern Central Polynesia, they probably brought these design elements and conventions to New Zealand with them, then developed their distinctive art on the spot. While Maori art evolved in the direction of all-over design and sweeping curvilinear composition, Central Polynesian art, under the influence of the migrants of the second wave, evolved in the direction of in-

Carved canoe stern of the New Zealand Maori. 54″ high. Collection University of Pennsylvania Museum, Philadelphia. (P 3223)

creased angularity and the division of the surface to be decorated into zones or sections.

The Maori master carver trained himself to visualize his design in its entirety before he began to carve, then worked without the aid of sketches or guide marks. This ability to visualize designs and carry them in the mind was reflected in certain forms of virtuosity. In some objects it is clear that the design was conceived in terms of a field larger than the object to be decorated and even different in shape. The object was super-imposed upon the imaginary design field and only those parts of the total design which fell within the area covered by the object were reproduced upon it. Other objects are decorated with two or more designs, each complete and coherent in itself, which have been superimposed upon each other. The artist's audience, who understood the skill required for compositions of this sort, were able to draw esthetic satisfaction from designs which seem, to the European, incomplete or confused. This appreciation of technique for its own sake resulted in the production of some exceedingly rococo pieces, especially after the introduction of steel tools. However, many Maori carvings deserve to rank among the art masterpieces of the world.

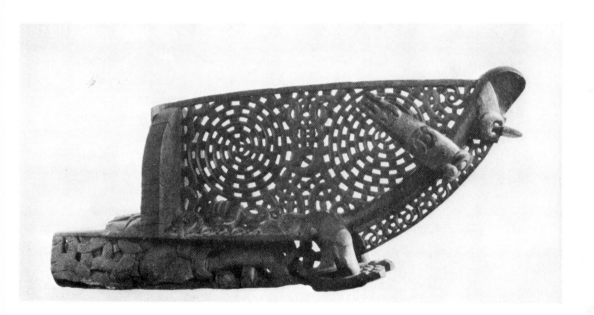

Carved canoe prow of the New Zealand Maori. 36″ high. Collection University of Pennsylvania Museum, Philadelphia. (18128)

Polynesia: New Zealand

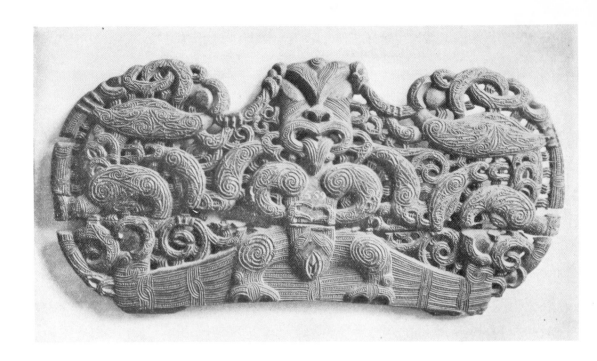

Carved lintel of the New Zealand Maori. 36" wide. Collection Peabody Museum of Salem, Salem, Mass. (E 5501)

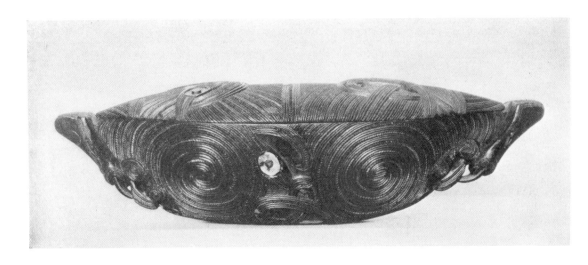

Carved feather box with shell inlay, of the New Zealand Maori. 24" long. Collection Chicago Natural History Museum, Chicago. (91.412)

Polynesia: New Zealand

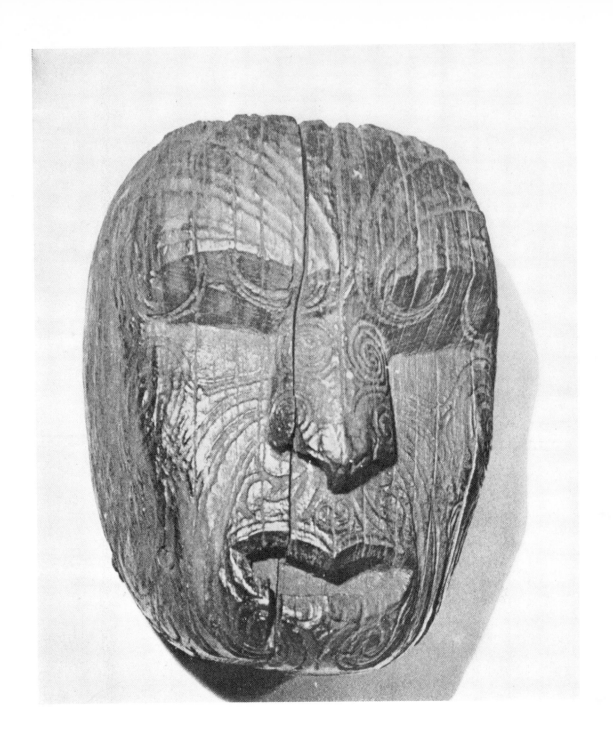

Carved head made by the Maori of New Zealand. 9″ high. Collection Chicago Natural History Museum, Chicago. (90.026)

Polynesia: New Zealand 57

Carved feather box of the New Zealand Maori. 16″ long. Collection United States National Museum, Washington, D. C. (3786)

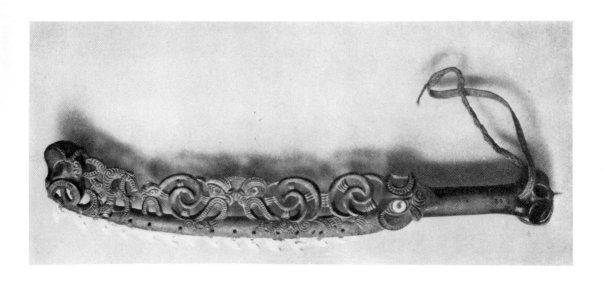

Carved knife with cutting edge made of shark's teeth, of the New Zealand Maori. 20″ long. Collection Peabody Museum of Salem, Salem, Mass. (E 5509)

Polynesia: New Zealand

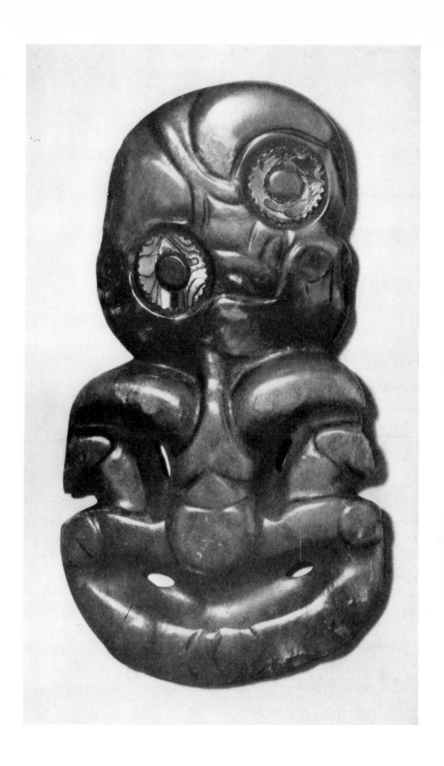

Carved jade breast ornament (*hei tiki*) of the New Zealand Maori. 6″ high. Collection Peabody Museum of Salem, Salem, Mass. (E 5523)

Polynesia: New Zealand

HAWAII

The Hawaiian group, like Easter Island and New Zealand, was a remote Polynesian outpost but its history differed from that of either of these localities. It lay closer to eastern Micronesia than to most of Polynesia and its first settlers came from that region. In the course of their slow migration through the Micronesian coral islands these settlers had lost most of the Polynesian food crops. They were able to bring with them only the pandanus and coconut and even the coconut did not flourish in Hawaii. As they found few native food plants and no animals in Hawaii, they continued to live there much as they had lived in the low islands. Extensive stone fish wiers and artificial ponds in which fish were fattened are pointed out by the present natives as the work of these *Menehune,* but they have left few other traces of their presence. Probably their population was always small and confined to the coast.

Later, apparently in the thirteenth and fourteenth centuries, Hawaii was reached by a new group of migrants who came, for the most part, from eastern Central Polynesia. These immigrants brought with them the full series of

Polynesian crops and domestic animals. They subjugated the *Menehune,* apparently as much by their prestige and rapid increase in numbers as by force of arms, and became the ancestors of much of the later Hawaiian population. They also established their own culture which was predominantly that of the second wave of migration into Polynesia plus a few old Central Polynesian elements.

The outstanding feature of historic Hawaiian culture was the high development of aristocratic patterns and political organization. The whole population was divided into an hereditary nobility and an hereditary proletariat, although proletarian women often found favor with noblemen and their children were given minor rank in the noble group. Great pains were taken to maintain the purity of the higher noble lines and brother and sister marriage was common in chiefly families. Chiefs who were the offspring of several generations of such marriages were so sacred that, when taken prisoner in war, they could only be slain by someone of equally high descent. Legends tell of one captive for whom no executioner of equal rank

60

could be found. His captors hemmed him about with long spears, to avoid touching him, and kept him until he starved.

The usual patterns of Polynesian tribal organization had given place in Hawaii to a feudal system. During the eighteenth century Kamehameha I succeeded in conquering the entire group but even before his time there were several large kingdoms. The king owned all land and divided it among vassal chiefs who in turn allotted it to smaller chiefs or proletarian tenants. All grants could be revoked at will. Vassals had to render service and pay taxes, the tax records being kept by special officials who used knotted string records as memory aids. In addition there were frequent royal progresses which were a calamity for the common people since neither their property nor their women were safe from the rapacity of the royal followers. An unusual feature of the Hawaiian system was the presence of large estates which the king had granted to temples for their support. Such temple lands were cultivated by a special order of priests, lowest in the ecclesiastical hierarchy.

As might be expected under such conditions, the objects used by the proletariat were few and simple. They lived in grass-thatched houses without decoration and their household equipment was limited to a few gourds and round wooden bowls. The latter were usually well proportioned but were never decorated. Each household also had a stone pounder for crushing taro. It is said that in some districts the pounders were made very small so that the meals could be prepared as quietly as possible. If a palace servant heard the sound of food pounding he would come and take the food away. At night the family slept under blankets made from several sheets of bark-cloth which were sewn together along one edge, like the pages of a book. The sheets could be thrown

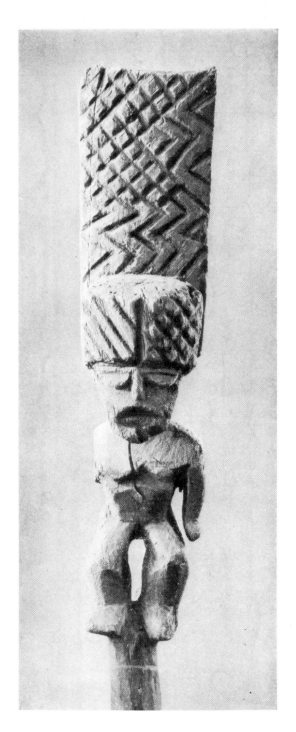

Small figure from Hawaii. 13″ high. Collection Academy of Natural Science, Philadelphia. (10550) Figures of this type were often used to represent personal or family gods.

Tapa cloth from Hawaii. Collection United States National Museum, Washington, D. C. (3533)

back or drawn up to get the proper temperature. Only the outermost sheet was usually decorated.

Hawaiian bark-cloth was the best made in Oceania. It showed various watermarks, produced by designs carved on the beaters, and was decorated with a wide range of colors. The designs were predominantly angular and geometric. There were no representations of men or animals and even floral forms were extremely rare. Stripes and a few large designs were painted freehand, but most of the decoration was applied with small stamps made of bamboo. A single stamp design rarely covered more than a square inch of surface and hundreds of stampings were required to decorate a tapa robe or blanket. Large figures were often built up by grouping a series of stamp designs close together.

The household equipment of chiefs was much like that of commoners except for the larger number of objects and their better workmanship. However, it always included a slop bowl and spittoon. It was believed that any enemy who obtained the chief's excreta could work magic against him, so these receptacles were cared for by a specially trusted servant. The food dishes used by chiefs were sometimes decorated with small human figures carved in the round. These were intended to represent rival chiefs or their wives and were deliberately made grotesque. Since cooked food was considered ceremonially unclean, to bring the figure of an enemy into contact with it not only shamed him but also injured his *mana* or spiritual power.

Chiefs were entitled to wear certain insignia of rank. The most important of these was a curious necklace consisting of a large hook carved from whale ivory which was suspended from a thick bundle of human hair cord. The cord, which was braided flat, was less than a

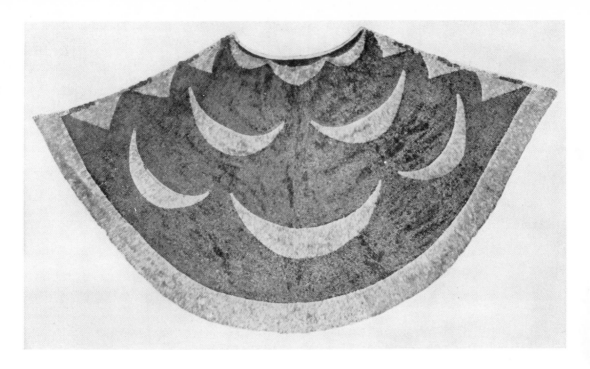

Feather cape from Hawaii. Collection American Museum of Natural History, New York.

sixteenth of an inch across and several hundred yards of it were required to make one necklace. In addition, chiefs wore feather cloaks and crested helmets of wicker work, covered with small, closely spaced feathers which concealed the basketry base.

The feather cloaks were made from a small meshed net into the knots of which bundles of feathers had been caught. The feathers were arranged so that they overlapped from top to bottom of the garment giving it a smooth outer surface, like the breast of a bird. The favorite colors were red and yellow, with a little black used in borders and to outline designs. Decoration was simple, the favorite design being one or more large crescents of solid color placed horizontally. Hundreds of birds had to be caught to provide the feathers for a single cloak and its manufacture required months of careful work. Such garments were exceedingly

light, soft and warm, but were far too valuable to be used as ordinary clothing. They were worn at ceremonies and especially in battle, where the tall helmet and brilliant cloak of the chief provided a rallying point for his own men and a challenge to the enemy.

The Hawaiians had the usual family and occupational cults, but each kingdom also had its state religion which centered in the worship of Ku, the War God. This deity was worshipped under many names and in various local forms. His temples were usually large oblong stone enclosures surrounded by walls six to eight feet high with an entrance at one end. Across the center of the enclosure ran another high wall which screened off the sacred part of the temple. During ceremonies the commoners sat in the non-sacred half of the enclosure, while a priest standing on the wall told them what was going on and when to make the responses required

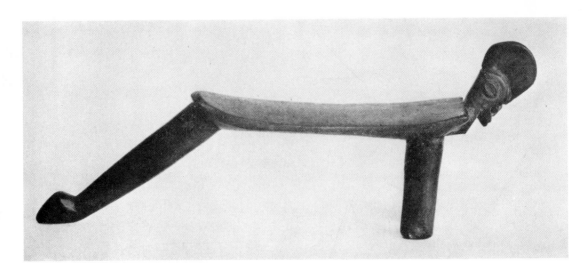

Stool in human shape from Hawaii. 20" long. Collection Chicago Natural History Museum, Chicago.
(91375)

by the ritual. Only priests and chiefs could enter the sacred half of the temple. The walls of the sacred enclosure were often topped by a row of posts whose upper ends were carved into grotesque human heads with gaping mouths.

Inside the sacred enclosure there were a wooden platform, used as an altar for sacrifices, numerous large wooden images, usually set up in rows, and a curious obelisk made from a light wooden frame covered with bark-cloth. The priest climbed up inside this obelisk when he gave oracles. There were also one or two small houses which were used for the storage of sacred objects. The large wooden images seem to have been little more than stage properties. The most important representation of the god and focus of his power was usually some small object, perhaps a roll of bark-cloth decorated with feathers. Next in sanctity were the portable images. These were made from wickerwork covered with red feathers. Some of them were quite large, as much as six or eight feet high. They were made as terrifying as possible, with large staring black and white eyes and gaping mouths frequently edged with shark teeth. Such

images were regarded as deputies of the god. They were carried to war by priests of a special order who also hurled spells against the enemy.

In spite of the great number of images mentioned by early visitors, very few examples have survived. For once, this was not due to the zeal of Christian missionaries. The old state religion imposed heavy burdens upon the common people and subjected women to many restrictions. In 1819 two of the widows of Kamehameha I persuaded the then reigning king to break the religious taboos. The priests tried to reassert their authority, but their army was defeated and the common people destroyed the temples and their contents. The simple family and occupational cults survived until a much later time, being carried on to some extent long after the islands had become officially converted to Christianity.

Hawaiian images present certain interesting problems. The body treatment resembles that of figures from Micronesia and western Central Polynesia. The heads, however, are of two distinct types. One of these, found only on the smaller images which presumably represent

family or occupational deities, is simple and naturalistic, thoroughly congruous with the body treatment. Heads of the second type are usually disproportionately large for the figure and are highly conventionalized. They have gaping figure-eight mouths, short noses with well-marked nostrils, greatly elongated oval eyes, and fantastic headdresses. This sort of head treatment finds no parallel in either Micronesia or western Central Polynesia, but it is closely related to the facial conventions employed in Maori and Marquesan carvings. It seems to have been the only treatment employed for the heads of temple images, although it also occurs in some of the small wooden figures which were probably associated with family cults.

The most probable explanation for all this would seem to be that the first settlers of Hawaii brought with them the restrained, static style of image carving which was dominant in Micronesia and western Central Poly-

nesia. The later migrants, ancestors of the Hawaiian aristocracy, brought with them from eastern Central Polynesia a different set of conventions. These were characterized by great emphasis upon the heads of images, with elaborate stylization of the features, treated almost as decorative details. In Hawaii, the eastern Central Polynesian conventions, with some local modifications, were applied to images associated with the aristocratic cults while the older Micronesian head conventions survived in images associated with the family cults. Since body treatment was of secondary importance in eastern Central Polynesian image carving, the older Micronesian type of body treatment came to be employed even for temple images. The grotesque and violent quality of the heads of the temple images is so much at variance with the simplicity which characterized Hawaiian wood working in general, that it is difficult to believe that their conventions could have been developed spontaneously.

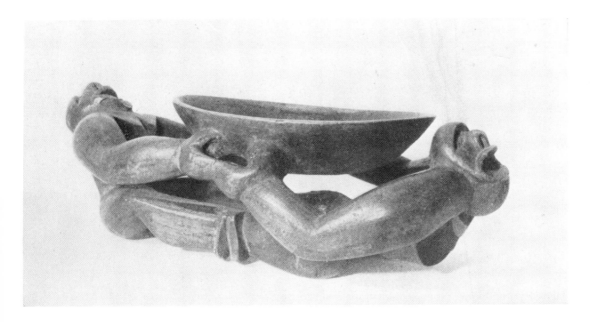

Food bowl supported by two human figures, from Hawaii. 12" long. Collection Peabody Museum, Harvard University, Cambridge. (53571)

Polynesia: Hawaii

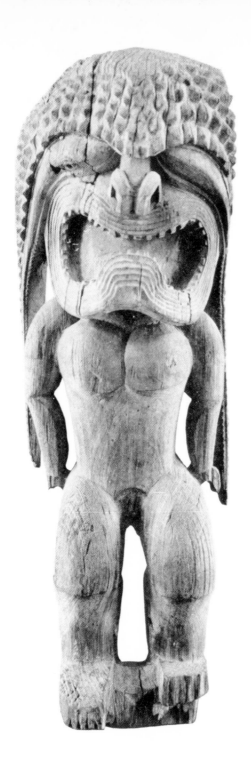

Large war god from Hawaii. 79″ high. Collection Peabody Museum of Salem, Salem, Mass.

This is one of the three surviving images of this type. A number of such large figures were set up in the sacred portion of Hawaiian temple enclosures.

Polynesia: Hawaii

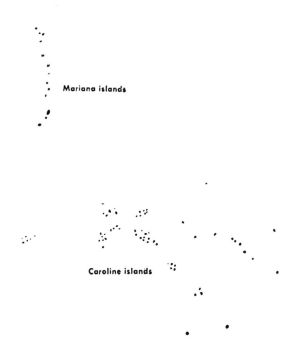

Mariana islands

Caroline islands

Marshall islands

Gilbert islands

Micronesia means "little islands" and this division of Oceania is well named. It is a region of atolls and the few volcanic islands which do occur are small and widely scattered. There are no compact groups of large, rich islands such as exist in various parts of Polynesia. This fact has had an important influence on the development of Micronesian culture. The lack of such foci of population has retarded the development of distinctive patterns of culture comparable to those found in Polynesia. Other factors have been the comparative poverty of natural resources throughout the area and the natives' skill in sea travel which made it possible for them to voyage back and forth between islands hundreds of miles apart and maintain long-distance trade relations. As a result, Micronesian culture as a whole is much more uniform than that of Polynesia and infinitely more so than that of Melanesia.

The Micronesians have no written records and no traditions of the first settlement of the region. However, the islands are so widely

Navigation map from the Marshall Islands. 42 x 33″. Collection Chicago Natural History Museum. The map is said to represent the region of Jalnit, Namork, Kili and Ebon Islands in the Marshalls, and Makin in the Gilberts.

Canoe model from the Matty and Durour Islands. 76″ long. Collection Peabody Museum, Harvard University, Cambridge. (75.445)

spaced and lie so far from other land that they could only have been discovered and occupied by people who were already expert sailors. Everything indicates that the first settlers came from Indonesia and were much like the present eastern Polynesians in physical type. Migrations into the region from Indonesia have continued into recent times and have resulted in the introduction of the Malay physical type. This type is strongest in the western and northern islands, the Polynesian type in the eastern islands. Negroid physical characteristics appear in the present populations of some of the islands but are probably a result of recent mixture with Melanesians.

The continued migrations from Indonesia resulted in the introduction into Micronesia of various elements from the later Indonesian cultures. Thus the loom, an appliance of Asiatic origin, was carried as far east as the Carolines while rice, a typically Asiatic crop, was brought as far as the Marianas. Micronesian tools and weapons often show the influence of metal prototypes. In spite of this, Micronesian material culture and art remained the simplest in Oceania. The region must be regarded as a marginal area in which the local conditions

rendered most of the Indonesian arts and crafts useless.

Life was harder in Micronesia than in any other part of Oceania. To the atoll dwellers even food was a serious problem. The lagoons provided a fair supply of fish and coconuts and pandanus flourished, but in order to grow any other crops it was necessary to make soil. The native gardens were deep rectangular pits, like swimming pools, which were laboriously cut into the coral bed rock. Into these pits vegetable refuse of all sorts was thrown year after year and allowed to rot until a thin layer of humus had accumulated. Right to the use of such gardens was the most valuable native property and was handed down through many generations. Wood suitable for canoes and utensils was so scarce in the atolls that in the Gilbert group the breadfruit tree was grown for its timber. The young shoots were planted in pockets painstakingly pecked in the coral rock and fertilized with sea-born pumice which was collected on the beaches and crushed to powder. It took thirty to fifty years for such a crop to mature. The atolls not only lacked metallic ores but even lacked stone from which cutting implements could be made. The adzes and

chisels needed for wood working had to be laboriously ground from the shells of the giant clam. Life on the low islands was thus a constant struggle for existence. It bred a hardy and self-reliant people, but it left little time for the arts or for crafts which did not contribute directly to survival.

Among these crafts the most important was that of the canoe builder. The large canoes used for inter-island voyages were marvels of skill and ingenuity. Since no large timber was available, they were built up from an intricate patchwork of small pieces which were fitted together so closely that the joints were nearly watertight. These pieces were bound to each other and to the ribs by lashings of coconut fiber and the joints sealed with gum from the breadfruit tree. There was a single outrigger, a mast and a large lateen sail of matting. A curious feature of these craft was that the hulls were deliberately made asymmetric, being flattened on the side away from the outrigger. This was supposed to increase the speed and these Micronesian canoes actually were among the world's fastest sailing craft.

The native skill in canoe building was equalled by their skill in navigation. Long before the Europeans arrived, they had acquired a good knowledge of the geography of the area and had worked out an ingenious system for locating distant islands with the help of the stars. In several regions there was a brisk inter-island trade which involved open sea voyages of hundreds of miles. In the Marshall Islands pilots had regular maps made from thin strips of wood fastened together to form a grid. Shells were fastened to the grid at certain points. Each pilot made his own map but the method of use is not clearly understood. It is known that the shells did *not* represent islands. Apparently they stood for nodes of high water caused by ocean currents. Since the sea currents among

Canoe prow ornament from Truk, Caroline Islands. 16″ long. Collection United States National Museum, Washington, D. C. (206.261)

these islands are the fastest in the world, navigators had to pay great attention to them.

The Micronesians were almost as skillful in house building as they were in canoe making. Even ordinary dwellings were roomy and well constructed while ceremonial houses were often large enough to seat several hundred people. House timbers were carefully smoothed and finished and accurately fitted. In the Carolines the fronts of ceremonial houses were often decorated with painting or carving. Elsewhere the decoration was limited to lashings of sennit (braided coconut fiber) which was dyed in different colors and laid on in intricate designs.

The Gilbert Islanders were the most warlike of the Micronesians and were famous for their vicious weapons made of coconut wood and edged with shark teeth. As defense against these they had developed complete body armor consisting of a sort of union suit woven from heavy strands of coconut fiber, a corselet and helmet. This armor not only protected the wearer but also served to catch and break the teeth on his

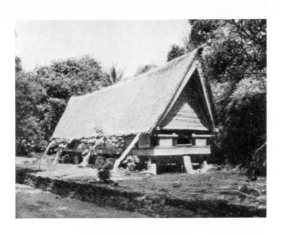

Assembly house at Kayangel, Caroline Islands. Photo courtesy Captain Sheldon A. Jacobson, U.S.N.R.

antagonists' weapons. In battle each armored man was accompanied by one or more unarmored squires who acted as skirmishers until the battle was joined, then stood behind their armored lord to pass him new weapons as needed.

Social and political organization varied from group to group, but in most places there was a well-developed class system with social prestige based, at least in theory, on birth rather than wealth. The population was divided into clans each of which occupied a definite territory. Each clan had an hereditary chief who functioned mainly as an administrator and organizer of group activities. He was accorded many marks of respect, including special terms of address, but his actual powers varied both with the region and with the chief's personality. In general, chieftainship was strongest in the Marshalls and Gilberts; weakest in the Carolines. Even the most autocratic clan chiefs found their powers checked in practice by the claims which their clansmen had upon them as relatives.

Several clans were usually organized into a single political unit within which they were graded in social position. There were noble and common clans and even, in some places, servile clans which were regarded as the property of one of the higher groups. There was no chattel slavery and, except in the case of the servile clans, little direct exploitation of the lower groups by the higher ones. The chief of the highest clan was the head of the whole political unit and all its members were expected to make gifts to him on certain occasions, but even the noble clans worked their own land and the individual property of all classes was safe from seizure. At the same time, high rank carried great prestige. Nobles were distinguished from commoners by their costume. Thus in the Marshalls a woman's rank was indicated by the number of coils of a particular kind of decorated cord which she wore as a girdle. A man's rank was indicated by the length of the fibre bundles which were attached to his belt in front and rear; the longer the bundles the higher his rank.

In contrast with this complexity of social organization, religion was everywhere exceedingly simple. There was a fairly extensive mythology including creation myths of evolutionary type, but the cosmic deities mentioned in these myths had been "gently relegated to the abyss of first causes." They had no sacred places or images and no worship was paid to them. Worship was directed toward the clan deities who seem to have been beings of diverse origin. Some were nature spirits connected with special localities, others were birds or animals (species rather than individuals), while still others, probably the majority, were deified human beings. These might be clan ancestors, famous chiefs or simply men of outstanding ability, remembered after death for their accomplishments. There was no distinct class of priests; clan chiefs or even household heads per-

forming the priestly functions when required. The clan deities were represented by cult objects. Many of these seem to have been small wooden figures, but staves, shell trumpets or other objects might serve as well. The cult objects were unwrapped and exhibited from time to time and small offerings of food were made to them, but there were no elaborate rituals in connection with them.

The Micronesians seem to have found their esthetic expression in fine craftsmanship and functional design rather than elaborate decoration. Simple angular geometric figures appear on the borders of mats in the Marshalls and on baskets and corselets in the Gilberts, but even these objects derived their value mainly from the fineness of the strands and the evenness of the weaving. The sennit lashings employed in house construction were also amplified to give a decorative effect. Tools and utensils were rarely carved or painted, but they were usually well proportioned and finely finished. The human figures used as cult objects show an accurate observation of bodily proportions coupled with a static, unemotional technique of presentation. The style might be termed a simplified naturalism. No part of the figure is stressed at the expense of the rest. It is almost as though they were attempting to show a human figure as seen at a distance great enough to eliminate minor details and individual differences. In their general treatment these cult figures are strongly reminiscent of the sculptural style of some of the more primitive Indonesian groups, those whose art has not come under strong Hindu or Chinese influence.

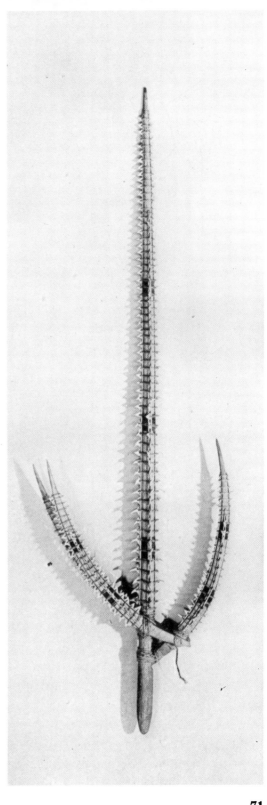

Sword made from coconut wood with cutting edges of shark's teeth, from the Gilbert Islands. 40½″ long. Collection American Museum of Natural History, New York. (S/1308)

Micronesia

71

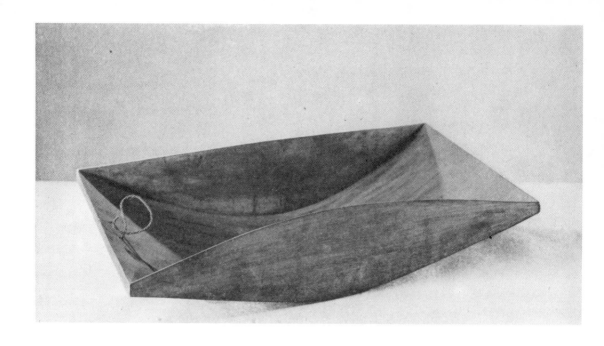

Wooden dish from Matty Island. 18½″ long. Collection University of Pennsylvania Museum, Philadelphia. (P 3482-b)

The people of Matty and Durour were the descendants of metal-using immigrants who had adjusted themselves to life on these coral islands. Although all cutting tools were made from shell or bone, many of them were clearly copies of metal originals, while the favorite weapons were wooden swords identical in form with iron weapons used in Borneo and the Philippines. These people were the best woodworkers in Micronesia and the only people in Oceania to use accurate joinery in making tools and utensils. Many of their objects could not be improved upon by a European cabinet maker. In spite of these indications of early high culture, they did not do decorative carving and were ignorant of both weaving and pottery making. They cooked in earth ovens and their wooden utensils show no influence of pottery forms.

Micronesia

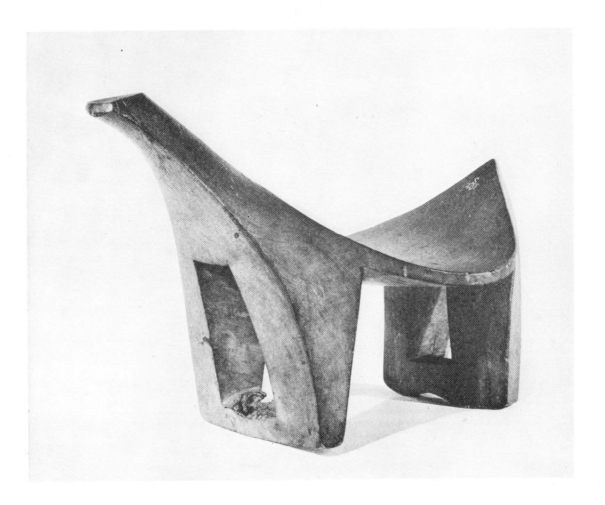

Coconut grater from the Marianas Islands. 24½″ long. Collection American Museum of Natural History, New York. (S/401)

The Micronesian coconut grater was a stool with a projecting arm to the end of which a shell or piece of rough coral was lashed. This is missing in the example shown. The operator seated himself on the stool and rubbed a half nut rapidly back and forth over the end of the arm, the grated coconut falling into a bowl placed below. Water was then added, the mixture stirred, and the coconut strained out with a hank of fiber. When the resulting rich, creamy fluid was to be used as a condiment a little sea water was added. At meals a half coconut shell filled with this mixture was placed beside each person and morsels of solid food dipped into it.

In making oil the coconut cream was allowed to stand in the sun for a few hours, when the oil rose to the top and could be skimmed off. This oil was used to anoint the body, and kept the skin soft even after repeated immersion in sea water. That used for festive occasions was often scented by soaking flowers in it.

Micronesia 73

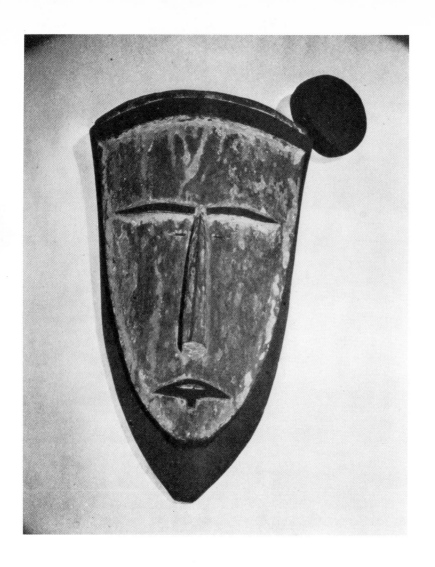

House mask from Mortlock Island. 36″ high. Collection University of Pennsylvania Museum, Philadelphia. (18240)

In the Caroline Islands each village had a "men's house," a large, elaborately decorated building which served a variety of purposes. It served as a council house and as a place for ceremonies. The men also used it as a clubhouse and a place in which to work. Older boys and unmarried men slept in it. Except at the time of certain ceremonies, such houses were taboo to the women of the village. However, one or more girls from other villages were kept in each house for the convenience of the unmarried men. These girls were theoretically captives, but actually they were usually bought from their families and then carried off in a mock raid. After a few years of service they were returned to their families with numerous gifts. The position was an honorable one and was no obstacle to a later marriage. The mask shown here is a gable ornament from a house of this sort.

Melanesia

INTRODUCTION

Melanesia was given its name, which means the black islands, because most of its inhabitants are of Negroid stock. Two races, the Papuans in the southwestern part and the more numerous Melanesians in the other regions, make up the greater part of the population, although in the east there are some Polynesian admixtures and in the west a number of negroid pygmies. Large and small islands, many of them grouped in great archipelagoes, spread over a vast area extending more than three thousand miles along the north coast of Australia and out into the South Pacific in a northwest-southeast direction. The population of Melanesia, estimated at over two million before the coming of the white man, supported itself chiefly by primitive agriculture, hunting and fishing.

A hot humid climate produces dense jungles, fetid swamps and a luxuriant flora, but the big mammals of Indonesia and the Asiatic mainland are not found here. The crocodile is the largest animal and a variety of other reptiles and brilliantly feathered birds exists. Volcanic eruptions, tidal waves and storms give to many parts of this region a melodramatic, violent quality that has strongly affected the lives and beliefs of its inhabitants.

In discussing the cultural characteristics of Melanesia as a whole, it must be remembered that local accents and interpretations often make for great variations from one island to another and sometimes even within the limits of a single small island. Generally speaking, religious practices center in the belief in two kinds of very powerful spirits: spirits of the dead, who are the subject of a wide-spread ancestor cult, and spirits that represent natural forces or mythological and legendary beings. The latter are frequently of totemic nature and are often the "property" of the clan claiming to be their dependents. In some areas communal rites, prolonged, elaborate, dramatic spectacles, were performed to venerate and to gain the favor of these spirits while in other places similar ceremonies were conducted by restricted secret societies. Many of these performances were staged when a new member was initiated into the practices and secrets of the society. These ceremonies played an important role in the social as well as the religious life of the people and each one of them called for the making of objects such as clubs, paddles, drums, shields, figures, staffs, personal ornaments and masks. In many regions, elaborate men's clubhouses were built on the open spaces used for dances and dramatic spectacles.

A number of carvings and personal ornaments were made for use in secular dancing. Among the most lavishly decorated objects were the utensils used in betel-nut chewing, a wide-spread habit producing a mild stimulation. The areca (betel) nut was ground and mixed with slacked lime, placed in the mouth on a pepper leaf and chewed. Carved and sometimes painted containers were made to hold the lime, mortars and pestles to grind the nut, and a great variety of spatulae to transfer the lime from the container to the mouth.

In some regions the economic importance of fishing and trade gave rise to a number of

canoe types, some of them elaborately carved and decorated. Warfare called for bows and arrows, spears and clubs.

Materials from which objects in the round and in relief were carved included wood, shell, bone, bark, and, in a few areas, stone. The common tools were various-sized adzes and knives made from stone, shell, and animal and fish teeth. Despite the fact that metal and metal tools were unknown in Melanesia before European contact, some of the carvings were of gigantic size. Although geometric designs of every description were extensively employed, a preoccupation with the body and particularly the head resulted in the widespread use of human forms as design motifs.

In looking at Melanesian objects one must remember that they were often made to be seen only at ceremonials where they formed part of a dramatic group and that they were decorated with feathers, leaves, tusks, teeth, shell and other materials that added to their meaning and fantastic effect.

At least two major traditions can be discerned in Melanesian art. One of these achieves dramatic effects through distortion, strong color contrasts and sometimes huge dimensions. A bold interplay of curved lines and surfaces gives a violent driving force to most ceremonial sculpture. Its sensuous organic forms seem imbued with a powerful magic. This trend is most evident in the central regions of Melanesia, in sections of the Sepik River area and the Gulf of Papua in New Guinea, in the New Hebrides and in parts of New Britain.

The other tradition seems strongest in the outlying archipelagoes such as the Solomons and Admiralties, but it is also found in the Massim area of New Guinea. The sculptures of these latter regions are usually of moderate or small size. In the Massim area and in most of the Solomons polychromy is rare and in the Admiralties the use of color is purely decorative. Dignity and elegance distinguish the figures which are frequently quite life-like in their proportions. Wherever emotion is expressed, it seems controlled by the restrictions of formal treatment.

One or the other of these two traditions, or a combination of some of their elements, can be found throughout Melanesia even in regions like New Ireland where spectacular local developments almost obliterate the basic traditions.

Occasionally there occur sculptures such as the mask from New Britain on page 158 or the head from the Sepik area on page 119 that surpass in their monumental realism any known Melanesian style. It is possible that such pieces are the work of exceedingly independent and gifted artists, but since they probably antedate most of the typical examples from these areas, they may also suggest the existence of an early "classic" phase of art in Melanesia.

As in so many regions of the South Pacific, art remains the only tangible evidence of the native culture of New Caledonia. The southernmost and one of the largest of all the Melanesian islands, New Caledonia is two hundred and forty-eight miles long by thirty miles wide and lies about one thousand miles east of northern Australia. It was discovered and named in 1774 by Captain Cook, and shortly thereafter the discovery was completed by the Frenchman d'Entrecasteaux. The island was annexed as a colony in 1853 by France which used it as a penal colony from 1864 to 1894. During this period the natives, who are Melanesians of a bellicose and cannibalistic nature, staged a series of organized revolts against the French. These were completely suppressed. Meanwhile traders, planters and missionaries had come to the island and, despite the prolonged hostility of the natives, continued contact with Europeans brought about a gradual but complete destruction of their culture. Some of the islanders who live in the mountains of the interior are said to be still hostile, but in no part of the island does much of the old culture survive.

New Caledonian economy followed the usual Melanesian pattern—cultivation of crops in addition to some fishing. The people lived in villages, worshipped ancestral spirits and supernatural beings and performed dramatic ceremonies. The survival of carved masks of several types suggests the existence of secret societies.

Aside from masks, these people made architectural carvings to be attached to or form part of a house, figures in the round, and a number of tools and utensils. In every case a durable material was used, indicating that the objects were meant to be used over a long period of time. Painting was comparatively unimportant and limited to only two colors, red and black.

Unlike the rectangular structures predominating elsewhere in Melanesia, the New Caledonian house was circular in plan, with a high, conical roof. The structural members consisted of a center post and a ring of side posts with roof beams lashed to them. A complete covering of thatch was laid over this frame. The houses were surmounted by spire-like carvings, sometimes more than six feet high, lashed as an extension to the center post. Large carved planks (talé), about five feet high by eighteen inches wide, formed the jambs of the only entrance. The lintels, sills, and some of the side posts (giroués) in the interior were also carved. Only the roof spire was a non-structural part. Throughout a heavy, coarse-grained, cedar-like wood was used.

The roof spires are believed to have been family crests, and after the death of the head of the family they were set up and revered as ancestor symbols. Considerable variety in design is found among them, but the general plan is always similar. Carved from one piece of wood, slender horizontal strips, parallel one to the other, are arranged along and radiate around

NEW CALEDONIA

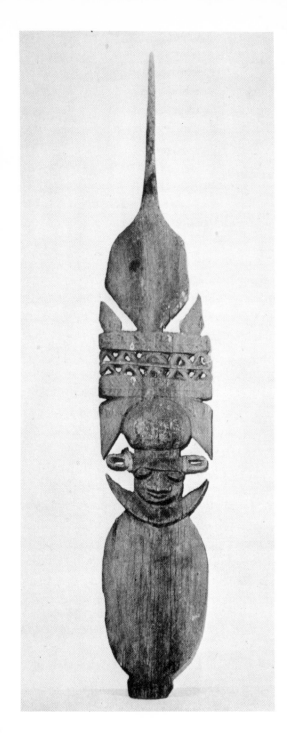

a slim vertical axis. In some examples human features appear although generally the design is purely geometric. These decorated spires are unique in South Pacific art.

Impressive rectangular-shaped faces appear on the four structural parts forming the door or entrance. Sharp pointed oval eyes set back under low beetling brows, a large-nostriled, hooked nose suggesting a bird beak, and a wide tight-lipped mouth from which, in some examples, a tongue protrudes, give these faces an alert, aggressive, somewhat bellicose expression. The sculptural forms are heavy but vigorous, large in scale, and forceful in execution. The upper fifth to third of the *talé* accommodates one of these faces, and the lower portion is covered with an all-over geometric pattern. A slight curvature of the surface shows that the *talé* are in reality segments of large tree trunks. Evidences of black paint have been found on the carved faces in most cases, and traces of black and red in the geometric carving of the lower part. Series of these faces placed side by side decorate the outer surfaces of the sill and lintel. All the door carvings are in high relief.

The small posts in the interior have the upper part carved with a human head of a long rectangular shape. Parallel deep vertical incisions below the mouth represent a long beard. In type the features of these heads differ somewhat from those of the faces of the door carvings: the hooked nose is replaced by a smaller straight nose, the mouth is a long open oval with teeth showing, and the expanding volumes are not so pronounced.

Architectural carvings are said to have provided protective ancestral spirits, perhaps of a totemic nature, with a residing place. Upon the death of the head of a family the house was destroyed and the carvings "killed" through mutilation. Most of the carvings still in existence today are therefore badly damaged.

Wooden roof spire from New Caledonia. 84" high. Collection Chicago Natural History Museum, Chicago. (132673)

Melanesia: New Caledonia

New Caledonia house showing carved door jambs and spire. Photo courtesy Chicago Natural History Museum, Chicago.

than the large masks which, in all probability, represented powerful sea spirits. The large masks are executed in a heavy wood and their features—huge hooked nose, open mouth with large teeth and protruding rounded surfaces—combine most of the typical style elements of

New Caledonian figures in the round measure from six inches to fourteen feet. Comparatively life-like in proportion, the major parts of the body have bulbous shapes. The features of the faces are bulbous too, but do not have the hooked nose or the open mouth of the architectural carvings (p. 82). These figures have vitality and vigor, but not the dynamic, pent-up fury of the architectural carvings. They were made to honor ancestors and supernatural spirits and to secure their aid and protection.

Two types of masks were used on this island. Both have the rounded curvature of a section of a log. The smaller, carved with a handle and painted red and black, is long and narrow. Its features are similar to those of the smaller house posts with perforations around the sides and at the bottom for the insertion of fibers. It is believed that these were a more common type

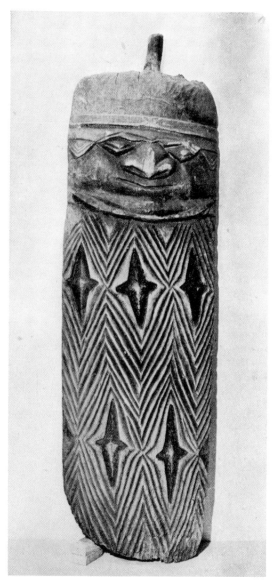

Carved door jamb (*talé*) from New Caledonia. 56" high. Collection Chicago Natural History Museum, Chicago. (132.662-1)

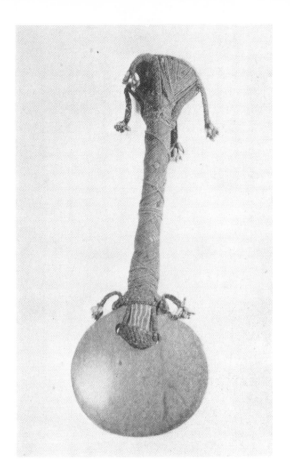

Ceremonial adze from New Caledonia. 23″ high. Collection Peabody Museum of Salem, Salem, Mass. (E 21850)
Its blade is made of jadeite and its handle terminates in a rattle made of coconut shell. This type of adze was used as a symbol of authority by clan chiefs for rain-making ceremonies and in cannibalistic rites.

hard wood, is particularly interesting. A long sharp point projects at right angles to the handle, the upper end of which is shaped to suggest the head of a bird. As the insignia of the head of the house, a length of bamboo decorated with burnt in or incised geometric or naturalistic designs was carried as a baton.

The art of New Caledonia is, with the exception of the roof spires, one of few forms and little variety. But it is a sculptor's art of controlled volumes and compactly integrated parts with color used sparingly as a means of emphasizing form. The impressive scale of many of these carvings heightens the effect of menacing but restrained power.

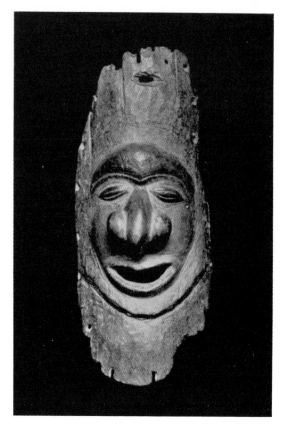

the art of this island. Surmounted by a cylinder of woven cane, the mask has a long stringy wig and a beard of human hair. A thick black feather costume reached to the knees of the wearer. These huge masks, painted a dull black, are the most distinctive of New Caledonian carvings, and are among the most impressive of South Pacific masks.

Of the decorative carvings the finely shaped "bird-head" club, made from a single piece of

Small mask from New Caledonia. 11″ high. Collection Brooklyn Museum, New York. (42.243-19)

Melanesia: New Caledonia

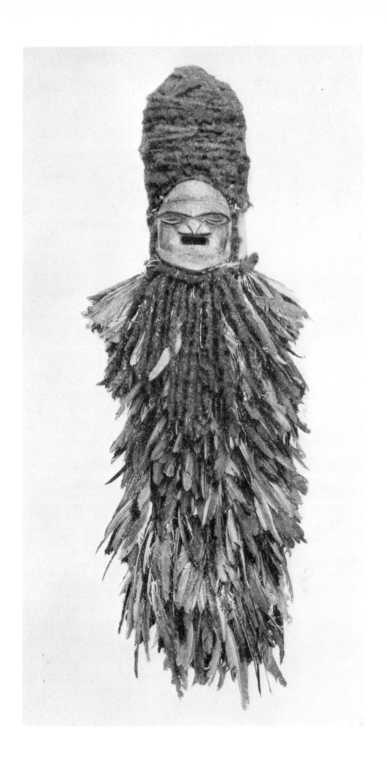

Mask with feather cloak from New Caledonia. 50″ high. Collection Chicago Natural History Museum, Chicago. (37713)

Melanesia: New Caledonia

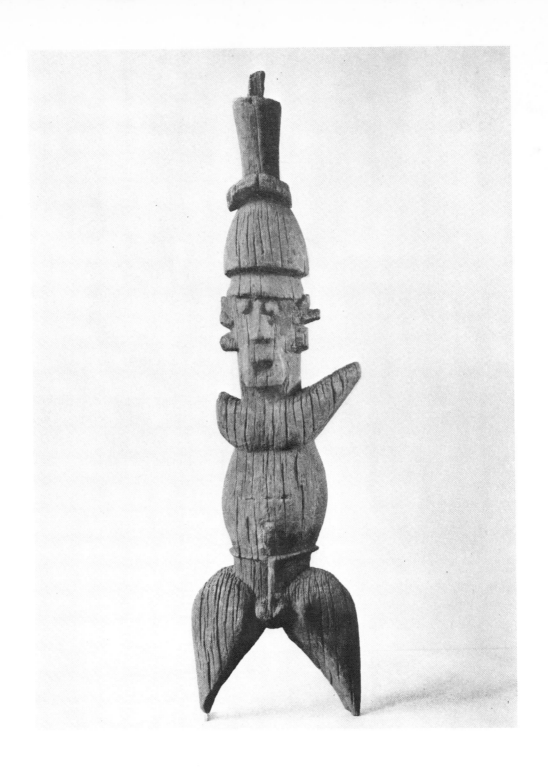

Male figure from New Caledonia. 45″ high. Collection University of Pennsylvania Museum, Philadelphia. (P 3151)

Melanesia: New Caledonia

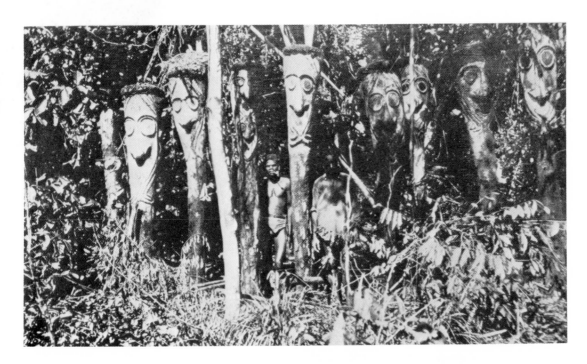

Ancestral figures carved in tree fern, standing on the edge of a dance ground on Ambrym Island, New Hebrides. Photo courtesy Chicago Natural History Museum, Chicago.

The New Hebrides are a group of several large and a great number of small islands that lie about two hundred and fifty miles northwest of New Caledonia and extend in an uneven double row in a northwest-southeast direction. The entire group is more than five hundred miles long.

Captain Cook named the islands when he discovered some of the southern ones in 1774, although the Spaniard de Quiros had visited the northern portion as early as 1606. No islands in the South Pacific have suffered greater demoralization, culturally and physically, from contacts with unscrupulous and depraved Europeans. Traders, renegades and whaling ship crews introduced gunpowder, liquor and disease; and later the ruthless "blackbirders"

NEW HEBRIDES

Malekula

Ambrym

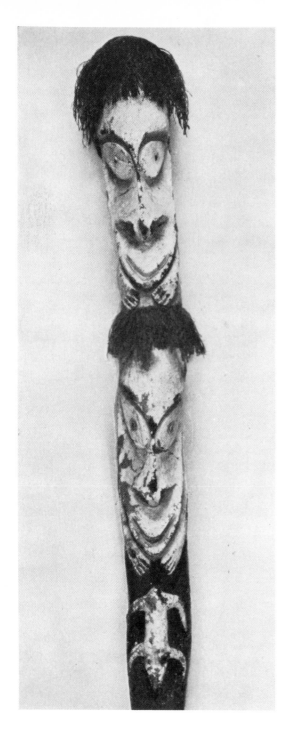

Ancestral figure carved in tree fern, from Ambrym, New Hebrides. 120″ high. Collection Chicago Natural History Museum, Chicago. (37716)

raided the group for slave labor to work in Australia and Fiji. Conditions were somewhat improved in 1887 when France and England took joint possession of the group and governed it through a naval commission. Since 1907 the islands have been ruled as a condominium by these two countries. Little of the old culture has survived in the southern New Hebrides, but in the rough interiors of the larger central and northern islands a good deal of it still remains unchanged. It is from these islands, particularly from Malekula and Ambrym, that the finest examples of the art of the New Hebrides have come.

The people of this group are Melanesians who live in villages and cultivate small gardens along the coast or in clearings in the midst of dense jungle. A hot, humid climate and a very heavy rainfall produce a lush growth—giant trees, brilliant foliage, and multicolored flowers—inhabited by innumerable species of magnificently feathered birds. But the New Hebrides are also a region of violence where man is constantly threatened by nature: they are lashed by frequent hurricanes and huge tidal waves and rocked by almost daily earthquakes. These rich and terrible lands have left a deep imprint on the life of the natives, as their religious beliefs, social customs and art reveal.

New Hebrides art is inextricably connected with socio-religious ceremonies which constitute a fundamental factor in this culture. In a society made up of rigidly graded social levels, these ceremonies mark a man's constant, endless progression from one grade to another. Position is not hereditary. Every man through his own efforts must accumulate the wealth necessary to advance from grade to grade. Social prestige demands that he make this constant effort since his importance and position as an ancestor after death depend upon the grade he

has succeeded in reaching during his lifetime. As part of every grade ceremony, figures or masks are made that must conform in design, size, color and materials to the tradition established for every level. The execution of these objects is very uneven since they are not the work of professional artists but are made by the man or men who act as sponsors for the candidate.

For the making of these objects and for the performing of all of the many rites associated with every ceremony, the candidates must make a payment in the form of pigs, which constitute the most important item of wealth. These animals are bred and tended carefully, and when they are young the upper incisors are knocked out so as to allow the tusks to grow unimpeded, since their value depends upon the development of the tusks. In pigs of great value the tusks show two or three complete revolutions. As symbols of wealth and prestige tusks are frequently attached to many kinds of objects.

Three main types of objects are made by these people: carved or fabricated figures, masks and carved slit-gongs. Within each of these groups there is considerable variety. Figures, measuring from five to twelve feet in height, are carved from an inverted tree-fern trunk or in hard teak wood. Some are built of palm spathes and covered with clay. Carved images vary from full-length standing figures in the round, to half-figures which retain much of the shape of the original tree trunk, or to posts surmounted by heads or faces. In many of the large carvings the heads or faces are greatly enlarged. These figures are set up by the candidate at his grade ceremonies at the edge of the large ceremonial ground in front of the men's house. They are made to honor and to solicit the aid of revered ancestors whose spirits they temporarily house during the rites.

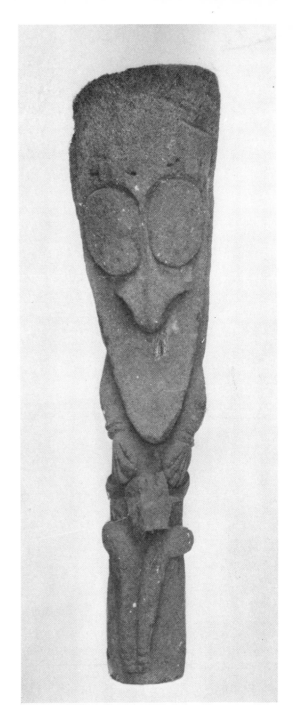

Ancestral figure carved in tree fern, from Ambrym, New Hebrides. 90″ high. Collection Chicago Natural History Museum, Chicago. (133522)

Melanesia: The New Hebrides

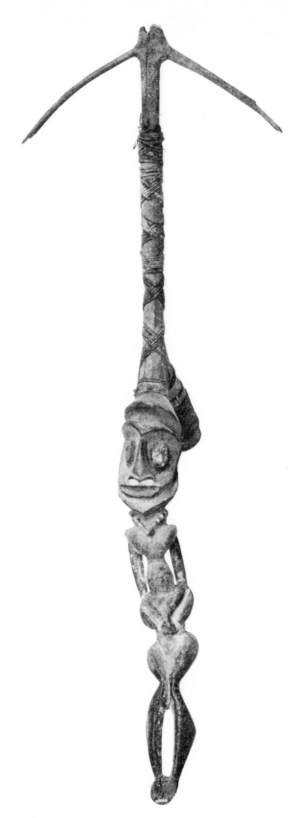

Masks are made of similar materials, some of them having conical tops covered with spider webbing. Some are diamond-shaped, some oval, others are conical or of the helmet type with flat, rectilinear sides on each of which a face may be carved. Frequently curved boar's tusks are inserted in the corners of the mouth. Masks seem to be associated with mythological and legendary personages and are used by grade societies of a more strictly religious character than those which use the figures.

All objects are richly painted in earth pigments—light brick red, pink, light green, black and white. Color was in fact so important that the coarse texture of tree-fern carvings was covered with clay to provide a more receptive surface for paint. Unfortunately many of the earth colors have faded and some tree-fern carvings have even lost their clay surfacing.

The slit-gongs which are instruments made from hollowed-out logs are somewhat related in meaning to the masks. They are more uniform in style but vary considerably in size. The carved face or faces at the top of the slit-gong are usually oval with concave surfaces from which the features project in high relief. Like masks and figures, these gongs also mark advancement within a grade society. They are set up in batteries, dominated by the very large

Opposite: Ancestral figure made of bark-cloth over a bamboo frame, from Malekula, New Hebrides. 55" high. Collection Chicago Natural History Museum, Chicago. (133108)
The conical cap is made of spider-webbing.

Carved ceremonial object of uncertain use from the New Hebrides. 42" high. Collection Chicago Natural History Museum, Chicago. (133040)

Melanesia: The New Hebrides

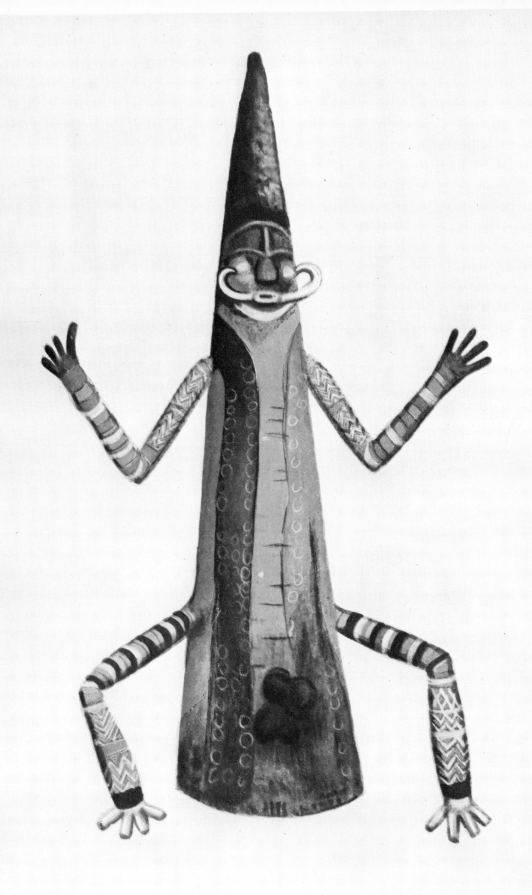

"mother" gong in the center of the dancing or ceremonial grounds, and are used in all ceremonies, both sacred and profane. These gongs also serve as "talking drums" to send messages from village to village.

Images somewhat similar to those made for the rites of grade societies are also used in secret society ceremonies. At the death of an important man commemorative figures are made signifying his importance and decorated with symbols of his eminent social position. These figures are life-size. The body is modeled in clay over a palm spathe armature and painted, and the skull of the deceased, with features modeled in clay, is attached as a head. The figure is set up near the gongs in the center of the dancing ground where memorial rites are performed. Afterwards the effigy is stored in the men's house where it remains until it rots away.

New Hebrides religion is a combination of ancestor worship and animism. Sacrifices and prayers are made to ancestors, mythological and legendary beings, and to a number of spirits and ghosts identified with the forces of nature. Only a few objects were made for religious purposes alone since most of them were also used in daily life or in secular dances.

In the culture of the New Hebrides, as in that of many so-called primitive countries, it was as difficult to differentiate between religious and secular art as it was to determine the limits between an individual's natural and supernatural life. Here was an unbroken progression, carefully graded and yet alike in essence: nature, man, ancestors, ancestral spirits, supernatural spirits, forces of nature. Violence

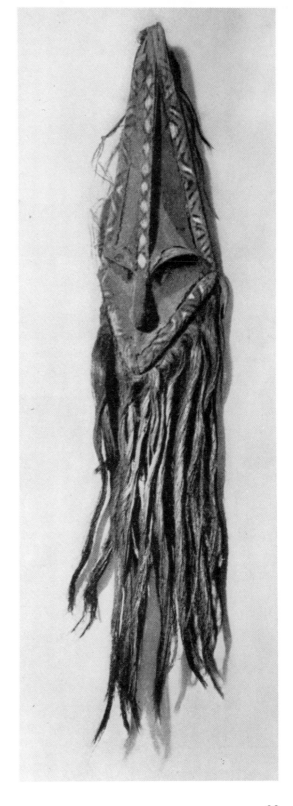

Bearded mask from Ambrym, New Hebrides. 17" high. Collection Chicago Natural History Museum, Chicago. (37682)

Melanesia: The New Hebrides

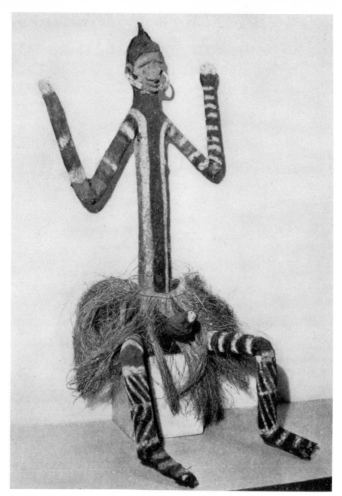

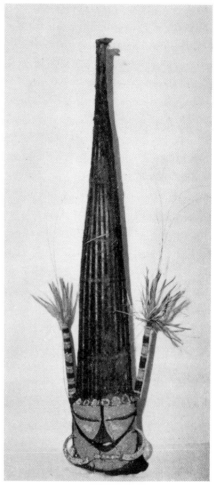

Left: Male figure made of split bamboo covered with painted clay, from Malekula, New Hebrides. 33″ high. Collection Chicago Natural History Museum, Chicago. (133.105)

Right: Mask with cap covered with spider webbing, from Malekula, New Hebrides. 45″ high. Collection Chicago Natural History Museum, Chicago. (133090)

and impermanence were basic to both the land and culture of the New Hebrides. Death and destruction were ever present, nothing was made to last. Only the gongs and a few of the sculptures and masks were used in more than one ceremony. The spider-web and bark figures soon rotted away and even the carvings in hard teak-wood lost their life and meaning when they lost their color.

Yet men kept on dancing by the fire in the jungle night and there were always brilliant colors on their bodies and masks and on the great faces of the ancestral figures that watched them from the edge of the clearing.

Melanesia: The New Hebrides

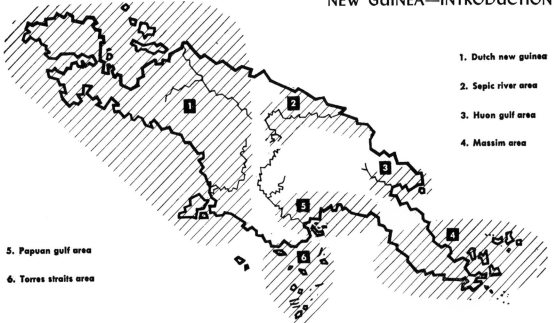

1. Dutch new guinea

2. Sepic river area

3. Huon gulf area

4. Massim area

5. Papuan gulf area

6. Torres straits area

The second largest island in the world, thirteen hundred miles long, New Guinea resembles a tortoise, with its small head to the northwest and its tail, formed by a series of archipelagoes, to the southeast. The northwestern part extends into the ethnic region of Indonesia, while the southernmost part projects towards Australia, from which it is separated by the comparatively narrow Torres Straits. A rugged spine of very high mountains divides the island into northern and southern parts and from it stem three important river systems: the Sepik, flowing to the north near the center of the island, and the Fly and Purari to the south, emptying into the Gulf of Papua. Nature has therefore divided the island into a number of clearly defined areas.

New Guinea has been known to Europeans since the sixteenth century when the Portugese and the Spanish, who gave it its name, first discovered it. Thereafter it was touched upon by a number of explorers, many of whom gave their names to various sections and to islands

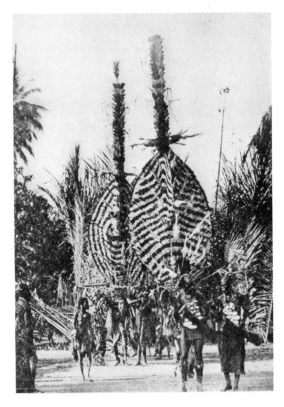

A ceremonial procession at Awar on Hansa Bay, New Guinea. Photo courtesy Chicago Natural History Museum, Chicago.

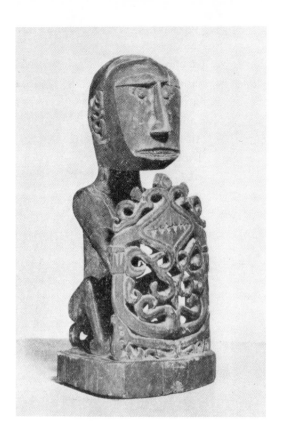

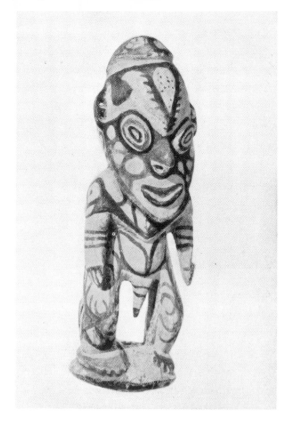

Mortuary figure (*korowaar*) from Dutch New Guinea. 10″ high. Collection Newark Museum, Newark, N. J. (45.158)

Carved and painted male figure made by the Mundugumor tribe on the Yuat River, Sepik River area, New Guinea. 19¼″ high. Collection American Museum of Natural History, New York. (80.0-8248)

off its coast—Geelvink, d'Entrecasteaux, Moresby, for instance. In 1884 the northern part of the eastern half of the island was annexed by Germany and the southern portion, including the extreme southeastern part and the nearby islands, was claimed as a protectorate by Great Britain. The Dutch, many years earlier, had acquired the entire western half of the island. In 1906, British New Guinea was turned over to Australia and re-named the Territory of Papua, while in 1920, after the First World War, the German portion was mandated to Australia and now forms part of the Territory of New Guinea. Until recently certain sections along the western coast were but little known

and a large portion of the interior still remains to be explored. Only the native cultures of the deep interior now remain free of European influences.

The native population of New Guinea can be divided into three major racial groups: Negritos, Papuans and Melanesians. The Negritos are of small stature and resemble the pigmy tribes of the Upper Congo in Africa. Most of them live in the high central mountains of the island and have little contact with the two other groups. Only a small number of types of objects, such as stone axes, slate knives, net bags, bows and arrows, are made by the known Negrito tribes. Many of these implements are

Melanesia: New Guinea, Introduction

well executed but have little distinction of shape or decoration.

The well-developed styles that have made New Guinea an important center of Oceanic art come from the eastern and northern regions inhabited by the Melanesians and from the western part of the island occupied by the Papuans.

The island can be divided into six broad areas of aboriginal culture: in the west, Dutch New Guinea; in the north, the Sepik River and the Huon Gulf; in the south, the Torres Straits and the Papuan Gulf; and in the east, the Massim area. Of these, Dutch New Guinea is a political division and includes many diverse cultures; but the five other areas follow clearly defined geographic and ethnic divisions. With the exception of the Huon Gulf, many local variations occur within the broad cultural pattern of each area, and in some regions the appearance of objects from distant localities adds to the apparent confusion. Often specific stylistic features are shared by groups that live far apart. Thus a style kinship is found between northern Dutch New Guinea and coastal Sepik River carvings; between coastal and upper Sepik objects and between upper Sepik and Gulf of Papua designs. A similar correspondence exists between other New Guinea styles and those of other areas of Melanesia.

The cultural characteristics and art styles of the Massim area differ widely from the rest of New Guinea, a division which parallels the distribution of the two races peopling the island. In the Massim area there are Melanesians and people of mixed Papuan and Melanesian blood, while in all the other areas of New Guinea the inhabitants are Papuans. The latter carve figures, masks and other objects for use in dramatic ceremonials. Many of these carvings are painted and decorated with various materials such as rattan, bark-cloth, shell and feathers.

The size of Papuan sculpture is often considerable and the designs used are bold and large. In contrast, art of the Massim area is exceedingly delicate and systematic. With few exceptions, objects are small, designs are composed of small units and color is absent. The human figure as a motif is comparatively rare. Instead, geometric and conventionalized bird forms are frequently used. Great care is taken in the technical execution of detail and in the refinement of the surfaces and forms.

Papuan and Massim arts of New Guinea rep-

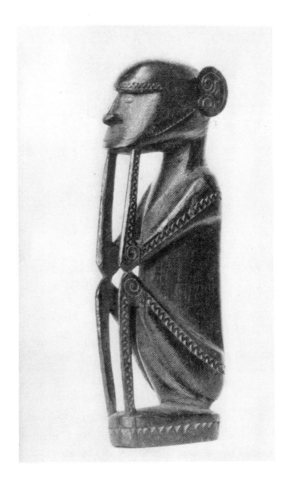

Seated figure from the Massim area, New Guinea. 9½″ high. Collection Chicago Natural History Museum, Chicago. (143.957)

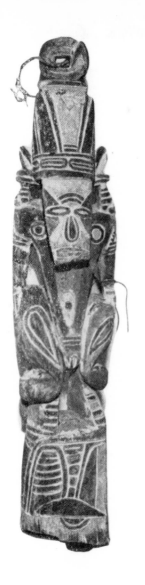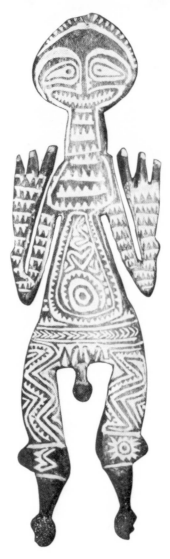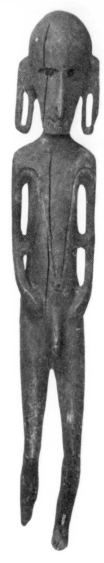

Left: Carved and painted figure from the Huon Gulf, New Guinea. 25″ high. Collection Chicago Natural History Museum, Chicago. (138.440)

Center: Male figure from the Gulf of Papua, New Guinea. 25″ high. Collection John and Margaret Vandercook on loan to the Brooklyn Museum, New York. (34139 L)

Right: Carved figure from the lower Fly River, New Guinea. 36″ high. Collection Chicago Natural History Museum, Chicago. (142.785)

resent two distinct traditions. The Papuan belongs to the tradition dominant throughout most of central Melanesia while that of the Massim appears related to styles of marginal regions, particularly the eastern Solomon Islands.

The basic styles of New Guinea art are few but the number of local variations is staggering. It is not too much to say that its dramatic intensity is unexcelled in any other primitive region in the world.

Melanesia: New Guinea, Introduction

A communistic culture has produced along the humid, swampy shores of the Gulf of Papua and in the adjoining regions a wealth of carved, painted and fabricated objects of unique character and excellent quality. Enormous houses, ceremonial and communal; a variety of elaborate, painted bark-cloth masks; carved and painted wooden plaques and decorated shields of unusual shape are common to this region. From the Fly River in the west to the southeastern shore of the Gulf of Papua a single art style prevails. This vast area forms the western portion of the Territory of Papua, a province under Australian administration, and only recently have the beliefs and practices which stimulated and provided an outlet for the artistic energies of these peoples begun dying out. Traditional objects are still being made in some areas—even by those who have accepted Christianity—but their lack of content is very noticeable. As an art area in New Guinea the Territory of Papua is second only in importance to that of the Sepik River, with which it appears to share certain cultural features and design elements.

Comparatively little is known about the tribes living in the interior of the Papuan region. It is rough, mountainous jungle country and is believed to be well populated. The coastal peoples, all of whom are Papuans, may be divided on the basis of cultural and linguistic similarities into two broad groups, those who live in the delta country of the Purari River and to the west, and those who inhabit the region to the east. Cannibalism, head-hunting, and the importance of the spirits of the dead are marked cultural features of the westerners. In contrast, the easterners are not cannibals or headhunters,

Frame of men's clubhouse from Maipua, Gulf of Papua, New Guinea. Photo courtesy Chicago Natural History Museum, Chicago.

and prolonged dramatic ceremonies, a belief in innumerable mythological, supernatural spirits and a form of totemism characterize their culture. Despite these differences, the art styles of both groups are the same and objects of similar kind and shape are found in east and west, although their content and function may differ.

The art of the Papuan Gulf is essentially one of line and color. Whether the object has religious implications or is simply decorative in character, less care is taken in shaping it than in fitting a design to its surface. In these surface patterns, a conventionalized human face, and occasionally an entire human figure, serve most commonly as central motifs, while the rest

of the design is composed of geometric elements such as concentric circles, dentates or sharp-toothed designs, chevrons, segments of circles, and weak spirals sometimes of angular shape. These patterns are carved in low relief or incised on flat or slightly curved surfaces. In the rendering of the faces only a few details, the nose and occasionally the forehead and the mouth, are carved in high relief or have any degree of projection. The human figure in the round occurs rarely and it is always four-sided in conception, a characteristic line pattern being carved on the flat surfaces. With few exceptions, objects are large and the design units of the decorative patterns are in a scale that creates the illusion of even greater size. The common tendency to outline the design areas and all essential elements in the pattern makes for clarity of statement and boldness of effect. This is accentuated through a profuse use of color: white, varying shades of red and grey, black and yellow. Lines frequently delineate the design in color on a white ground. The same basic patterns and conventionalized forms appear in a variety of materials and in various media—on wood, bark-cloth, or the surface of bark or coconut-shell; in low relief, incised relief, or appliqué, or paint.

By far the greater proportion of Papuan Gulf objects were for use in elaborate spectacles. Ceremonies were always highly dramatic in nature and in the east consisted of long cycles which sometimes took a full decade or more for completion. Many of these were observed some years ago by F. E. Williams in the village of Orokolo, situated to the east of the Purari Delta. His description and interpretation of the ceremonies and of the objects used in them is invaluable for an understanding of this art.[1]

1 Williams, F. E.—Drama of Orokolo, Oxford, 1940.

Characteristic of the entire Papuan Gulf region, Orokolo is a very large village. Typical also is the huge size and design of its men's ceremonial clubhouses. Built of massive timbers lashed together and covered with thatch, these houses are rectangular in plan and are raised off the ground on heavy posts. They have a towering front gable, sometimes fifty feet high, while the back one may be only twelve feet high—a house design which suggests a comparison with a somewhat similar one in the Sepik River region. Parallel rows of great posts form a central aisle on either side of which the space is divided into large compartments, the front ones reserved for lounging and work, and the others for sleeping. Throughout the house a large number of objects are in evidence—huge bark-cloth masks, large carved and painted wooden plaques and bull-roarers. They are considered the true occupants of the house who, because of their magic powers, can be seen by women and children only upon special occasions. Patterns of similar nature, dominated by the motif of a conventionalized grimacing human face, appear on all of these objects.

The building of a men's house (eravo) in Orokolo, a communal effort formerly climaxed by a human sacrifice, marked the first stage of their most important cycle of ceremonies, the final stage of which might take place from ten to fifteen years later. Governed by strict taboos and ritualistic, often magical procedures, the making of huge, elaborate bark-cloth masks (hevehe) absorbed about all but a month of this time. In every respect they were the focal point of these ceremonies and they were entirely made in the dimly lighted interior of the eravo. It was a slow and painstaking task. Measuring from nine to ten and sometimes as much as thirteen feet, these masks have the shape of a narrow oval and are made of a cane

and palm-wood frame over which bark-cloth is stretched. At the top, a long spike, tipped with feathers and fiber streamers, accentuates the height. Near the bottom a large mouth is attached which is carved in wood and somewhat resembles that of a crocodile, its long open jaws filled with many sharp teeth. The characteristic facial design above the mouth, and the elaborate pattern and border which cover the upper portion of the front and much of the back of the mask, are outlined on the surface of the bark-cloth with thin strips of cane stitched in place. These are worked straight on the bark-cloth without any preparatory outline. Just before the mask is used the designs are painted on it. A wickerwork helmet-like frame inside the mask fits over the head of the wearer, while bast and frayed palm leaves cover his body to the knees. A similar technique and style are found in all of the masks from this area. They are not made by professional craftsmen in our sense of the word but by or under the direction of those men who by birth have the right to make masks of one or more specific designs.

When the masks are finally completed, there begins a month-long series of dramatic ceremonies and feasts. Many of them are held in the open space in front of the *eravo,* some along the beaches, and a few in sacred areas. Everyone attends and participates in these performances. One of the most dramatic moments in the entire series occurs when the masks, averaging nearly twenty feet in height when worn, emerge from the *eravo,* slowly one by one, through the tall rectangular door originally built in its façade for this purpose. They begin to appear at dawn, each one pausing for a moment in the doorway to receive jubilant cheers and shouts from the assembled crowd. Sometimes more than a hundred masks are used in this ceremony.

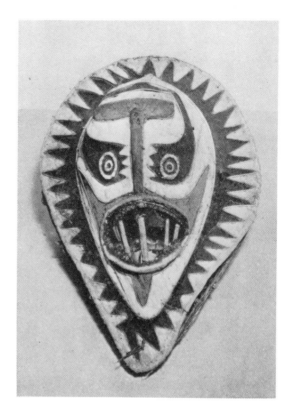

Dance mask covered with bark-cloth from the Gulf of Papua, New Guinea. 27″ high. Collection Newark Museum, Newark, N. J. (25.492)

Each mask has its own name which is that of the supernatural spirit it represents. Most of the spirits are of mythological origin, recalling episodes from myths, and they are the property of the patrilineal groups into which this society is divided. Membership in a group is determined entirely by descent. In the decoration of the large masks, the conventionalized face represents the spirit, while the design above it indicates the group to which the wearer belongs. These designs have specific names which are often those of totems of the group. In secret preparation for the ceremonies, young men are initiated to the masks and instructed in the proper dance steps and ritual surrounding their use. In the actual ceremonies and dances, everyone accompanies the mask or masks of his own group.

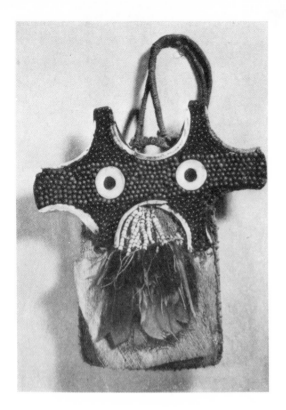

Fighting charm made of coconut fiber and decorated with shells, seeds and feathers, from the Gulf of Papua, New Guinea. 11½" high. Collection Buffalo Museum of Science, Buffalo. (C-10985)

As an adjunct to the ceremonies involving these huge masks, a great many smaller ones (*eharo*) are used in supplementary dances. Also made of bark-cloth and in a similar manner, they show an almost unlimited variety of form. Some of them also represent mythological spirits; others totem forms such as birds, insects, fish, snakes, trees; and still others are purely fanciful improvisations. Practically all of them are worn over the head and have the front painted with the characteristic conventionalized face. Some have a second face or form impaled on the point of a conical top (p. 101). Although they also are made in the *eravo,* these masks involve no initiation, nor have they the sacred character of the larger ones. Their name simply means "dance mask." They appear to be entirely secular in nature and many of them were meant to be comical. When they have served their purpose, they are discarded and allowed to rot, but the large masks, being sacred, are ritualistically burned, at which time the spirits represented by them are thanked for having participated in the ceremonies and are promised that they will be invited back again. It seems likely that the *eharo* masks were also at one time sacred, although their role now is largely one of entertainment.

With the burning of the *hevehe* masks, the long cycle of ceremonies is virtually concluded. The magnificent men's house, with its vast cathedral-like interior, now loses its significance. It has lived its ceremonial life, and is now neglected and allowed to fall into ruin. The ceremonial objects in it are transferred to a new *eravo* or to a smaller men's house.

This cycle of ceremonies is largely religious in character, since it involves so many sacred objects, but it has tremendous social and economic importance. Harnessing as it does the combined efforts of every one in the community, it becomes a civic expression and a means of integrating a society which recognizes no single leader or ruler. The cycle affords a powerful incentive to artistic efforts, plastic and dramatic, and an equally great incentive to food production since large communal gardens supply the food necessary for the accompanying feasts. It is an institution sanctioned by tradition which strengthens and enriches the social fabric of life and, through its perpetuation of the spirits of myths and totems, ties the culture of the present to the past. In every event of the cycle, contacts with the supernatural world are renewed and its dormant powers awakened, giving fresh vigor to the life and activities of the people.

The initiation of small boys is another ceremony for which specific paraphernalia are made

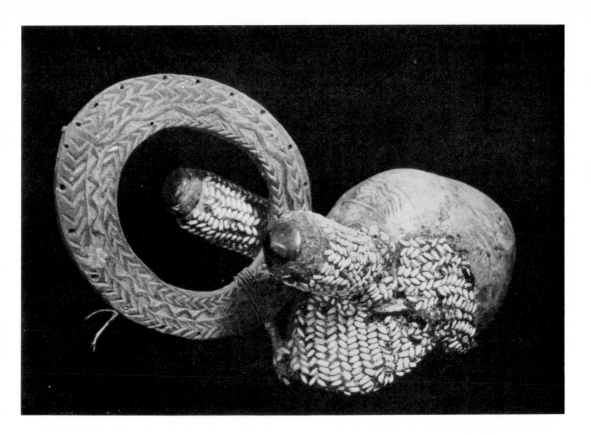

Trophy skull covered with shell mosaic, from the Bamu River, Gulf of Papua, New Guinea. 16″ long. Collection Buffalo Museum of Science, Buffalo. (C 11460)

including another bark-cloth mask *(kovave)*. This is a cone, topped by a tuft of feathers, that is worn with a thigh-length mantle of bast. As in the case of the large masks, particular designs belong to particular groups, but they all represent mythical supernatural spirits. Their appearance and the nature of the dances in which they were worn were meant to be weird (p. 102), even comical, for they were intended to terrorize only the small boys.

All the masks described above come from east of the Purari Delta. To the west a wickerwork or basketry type is made. These are covered with clay and painted red, black and white. Some of them have long noses and animal-like heads which resemble certain masks from the Sepik River. The shaping of the woven surface over the frame gives to this type volume and a sculptural quality lacking in the masks from east of the Delta.

Of the wood-carvings from the Papuan Gulf, the most numerous are bull-roarers and carved and painted plaques, often labelled in museums "ceremonial slabs." The plaques, decorated with conventionalized faces, are oval boards over an inch thick. Their slightly rounded surface is incised or carved in low relief and painted red, white and black. One end is usually pointed, the other cut to resemble a handle, and the oval outline slightly constricted at the center. Often on both sides of the plaques bits of shredded fiber are attached which seem to provide the face with ears. On some few examples an entire human figure is shown in a

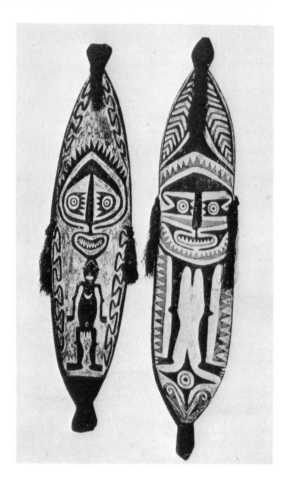

Carved and painted memorial tablets from the Gulf of Papua, New Guinea. 60″ and 63″ high. Collection Chicago Natural History Museum, Chicago. (142.178 and 142.128)

often the usual face motif, sometimes with fish, snake, or crocodile figures. They too are very sacred and offerings of food are at times made to them. They are also kept in the men's house and every male has to undergo an initiation to them.

The most interesting of decorative carvings are found on shields and bark belts. Rectangular in shape, the shields have a deep notch in the upper part through which the warrior thrusts his left arm in holding the bow. A variety of designs, conventionalized human features predominating, are carved in low relief on the outer face and painted red, black and white. The finest carvings appear on the wide belts worn by men on ceremonial occasions. They are decorated with compact, rich all-over patterns cut or incised in the surface of the bark. A prominent border, cut with a zigzag or toothed motif, surrounds the decorated field and red or white is rubbed into the carving to bring out the pattern. The decorative scheme consists mostly of a sequence of repeated designs. These belts produce an extremely rich effect, especially when seen against the dark skin of the people. Drums, combs, clubs, and coconut-shell spoons are among other decorated objects.

The art of the Papuan Gulf is the only truly two-dimensional art in Melanesia. Sculptured form is hardly ever used as an end in itself but serves primarily as a basis for surface carving and painting. In spite of this limitation, the work from the Papuan Gulf has great variety and dramatic force. Bilateral symmetry prevails in every instance. Patterns are carefully fitted into the space they decorate and a white background makes them stand out prominently. Grotesque human figures and faces, frequently used as central designs, are always large in proportion to the entire decorated surface and give this art its weird intensity.

flat surface design. These boards are very sacred. They are kept in the men's houses and, in the east, represent or even contain a supernatural spirit. Many of them have a secret name with magic properties known only to their owners. In the west, these "slabs" are associated with powerful spirits of the dead, and are often placed near the skulls of the enemy as protection against the spirits of the enemy dead. Papuan Gulf bull-roarers are large in size and are decorated with incised designs,

100

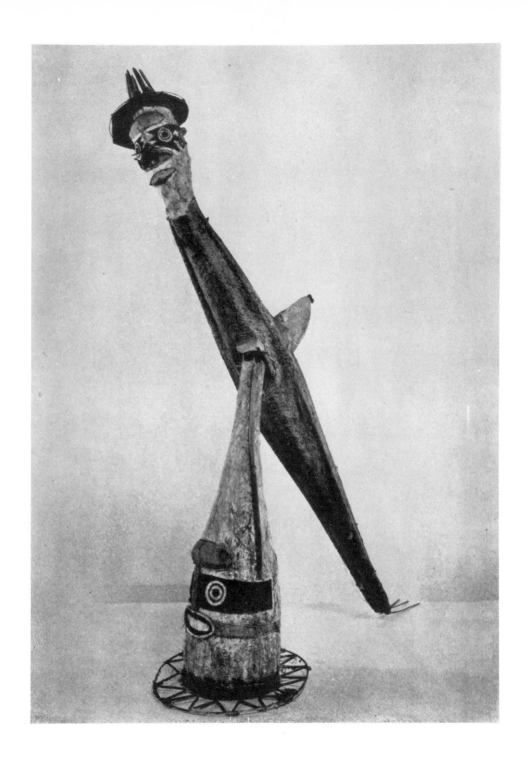

Dance mask covered with bark-cloth from the Gulf of Papua, New Guinea. 72" high. Collection Newark Museum, Newark, N. J. (25.466)

Melanesia: The Papuan Gulf, New Guinea

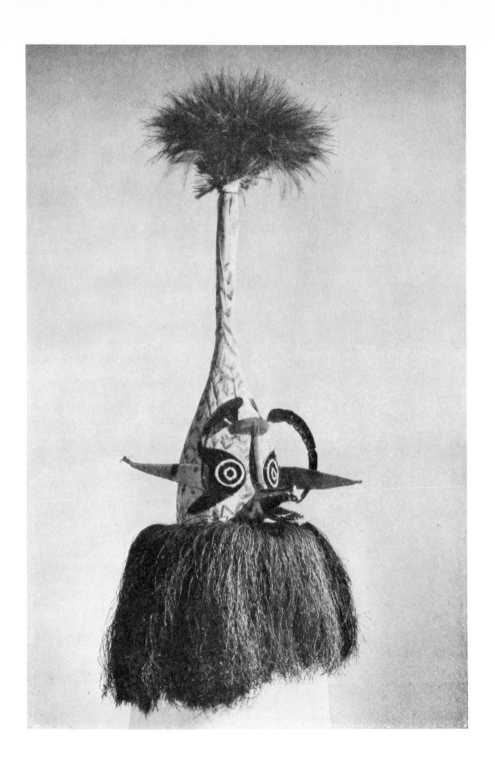

Contemporary dance mask covered with bark-cloth and commercial cotton fabric, from the Gulf of Papua, New Guinea. 36 x 24″. Collection American Museum of Natural History, New York. (80.0-8206)

Melanesia: The Papuan Gulf, New Guinea

The art of the Sepik River region has more variety and is richer than that of any other section of Oceania. This area includes the coast north and south of the mouth of the river and the areas bordering on both banks for a considerable distance up the large and meandering stream and its tributaries. Vast swamps are found along the coast and in many places along the shores of the Sepik. Grassy plains, high plateaus and high mountains make up the terrain along its length. Seasonal floods inundate parts of both banks along the middle and lower reaches. At these times great hard-wood logs are swept downstream and provide material from which houses and carvings are made, while up and down the Sepik the river itself provides a broad avenue for the distribution of objects from one region to another.

A number of Papuan tribes, each speaking a language unintelligible to the others, make up a rather extensive population. Village or group cultivation of crops forms the basis of their economy. Intermittent warfare is waged between many of the tribes and some of them, such as the Kwoma, are fairly isolated. Tribes from which important collections of objects have been obtained include the Iatmül, Arapesh, Mundugumor, Tchambuli and the Abelam.

All the cultures of the Sepik River region have certain basic elements in common that appear in many local variations. These are: the men's secret society, the men's clubhouse and the performance of spectacular ceremonies. The rites involve everywhere the use of a vast number of carved and decorated objects. These objects are of two kinds—sacred hidden ones which may be seen only by a particular group

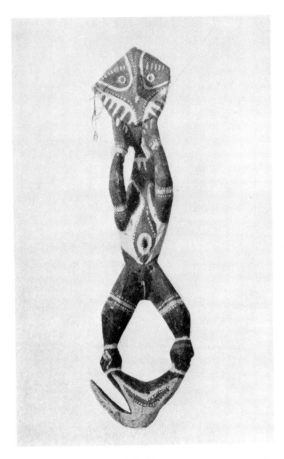

Hook surmounted by a female figure, made by the Washkuk tribe from the Sepik River, New Guinea. 36" high. Collection Peabody Museum of Natural History, Yale University, New Haven. (49991)

of persons, and others that are used and seen by everyone. In both categories, representations of supernatural spirits are frequent and the sense of the dramatic is very strong. There is a sharp division among the people marking off the initiates—those who can participate actively in the rites—from the uninitiates, usually women and children, who compose the audience. To impress this audience, the men will make great efforts and go to extraordinary

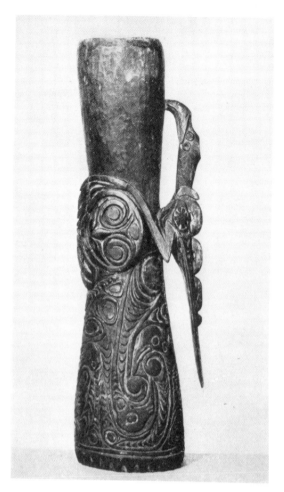

Drum with carved frigate bird from the Sepik River, New Guinea. 26″ long. Collection United States National Museum, Washington, D. C. (344.961)

made in many villages. On the coast and along the rivers canoes are built, some with prows shaped realistically in the form of large crocodiles. In some sections human skulls are painted and covered with clay modeling to represent heads. Even pottery, a craft that is but little developed in Oceania, is found here in great variety including painted and incised vessels, bowls, large jars and roof ornaments.

Every tribe produces a number of wood carvings of ceremonial and artistic importance and makes use of leaves, feathers, shells, furs, etc., for their decoration. The dominant color is red in all shades from pink to maroon. It is often combined with black, white, yellow and purplish gray. Many of the carvings are made of a heavy, close-grained wood and every time they are to figure in a ceremony they are decorated and painted anew.

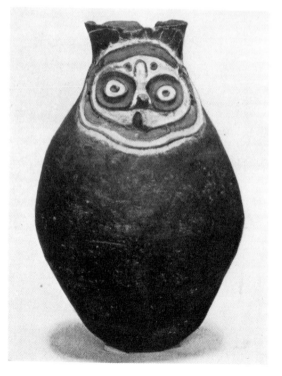

Large pottery jar from the Sepik River, New Guinea. 32″ high. Collection Chicago Natural History Museum, Chicago. (138.049)

trouble. This segregation is a fundamental factor in the social and ceremonial life of the entire region, but its enforcement varies considerably in degree from tribe to tribe.

The number of objects produced in the Sepik area is enormous. Among them are figures ranging from eight inches to eight feet and masks measuring from a few inches to several feet. Stools, neck rests, slit-gongs and shields are decorated with human or animal design motifs. Elaborate wooden hooks of all sizes, used to hang belongings out of reach of the rats, are

Melanesia: The Sepik River Area, New Guinea

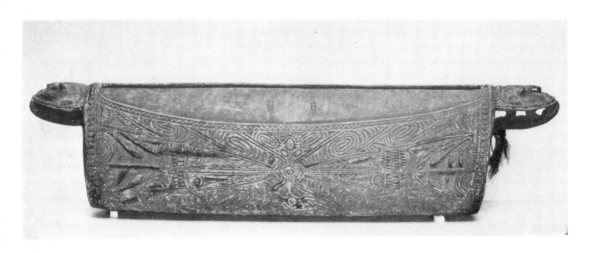

Large drum from the Sepik River area, New Guinea. 72″ long. Collection Chicago Natural History Museum, Chicago. (140.076)

Sepik River art is for the most part the work of professional artists, or at least men of recognized skill, and in some places tradition provides opportunities for the display of connoisseurship by tribal members. For instance, when cult figures are set up in the Kwoma men's house, they are formally appraised and words of appreciation are addressed to the successful artist. All kinds of objects are constantly traded. Sometimes they are acquired from a distant tribe together with the ceremonial dances, rhythms and songs for which they were made. Often the new owners do not understand the original meaning of the pieces or even the words of the songs pertaining to them. Such purchases seem to be motivated by a desire to enrich local ceremonies with new objects and forms. A ceremony whether religious or social remains, in fact, fashionable for a limited time only and is then superseded by a new one. It is therefore impossible for us to classify objects by function and meaning since an object may be considered sacred in one village while in the next village it may be used only for amusement.

The constant trading of objects among the tribes produces an often bewildering inter-mingling and diffusion of style elements. In some cases, as with the Iatmül tribe of the central Sepik region, this trading results in an eclecticism that incorporates alien form elements into the local traditions. With others it leads to large-scale importation of alien cultural elements and objects, reducing the local products to the status of mere copies. A good example of such a parasitic art is that of the Arapesh. Further inland are a group of small tribes, the Tchambuli, Abelam, Mundugumor, Kwoma and the Aibom, who have very distinctive styles of their own, although they too participate extensively in the inter-tribal trade of designs and objects. In the region around the mouth of the river a number of very fine woodcarvings are found that belong to still another culture which has long since disintegrated under European contacts.

Many ceremonial carvings are made specifically for secret rites attended only by men. The importance of these rites along the Sepik River is well indicated by the large size of many of the men's clubhouses. These houses are commonly used as storerooms for ceremonial objects and as meeting places for the male members of the

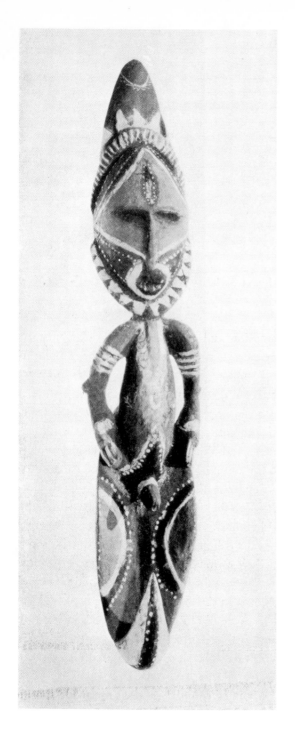

clan or village. They also serve as a focal point in the ceremonial life of the village where the most important rites of initiation are performed.

The most common type of men's house along the main river is rectangular in plan, with very high spire-like front and back gables between which the sagging roof forms a deep saddle. It resembles the roof types found in Sumatra. Other Sepik men's houses have an asymmetrical arrangement of gables, the front one being often very high, the back one comparatively low.

In some areas a special house was built to store secret objects. Among the Abelam this type of house has a very high triangular front covered with painted strips of bark. Access to any building housing secret objects is restricted to those who have undergone the proper initiation, and in some regions every object has its individual initiation rites.

Among the Kwoma carved and painted figures are set up in the men's house during these rites, and novices are at first led to believe that these figures are powerful supernatural spirits. Later they are told that the objects are but man-made symbols, a secret which must be kept from the uninitiated women and children who never cease to believe that the spirits actually dwell in the house. Carved figures play a somewhat similar role among other tribes. In some instances, they represent the totemic ancestors of the clan. In the coastal regions near the mouth of the river they were made to commemorate recently deceased members of the tribe. Sometimes carved figures were also used as house posts or kept near burial grounds.

Hook in shape of a male figure made by the Abelam tribe, from the Sepik River, New Guinea. 19″ high. Collection American Museum of Natural History, New York. (80.0-6643)

Opposite: Large female figure made by the Abelam tribe, from the Sepik River, New Guinea. 58″ high. Collection American Museum of Natural History, New York. (80.0-6723)

Melanesia: The Sepik River Area, New Guinea

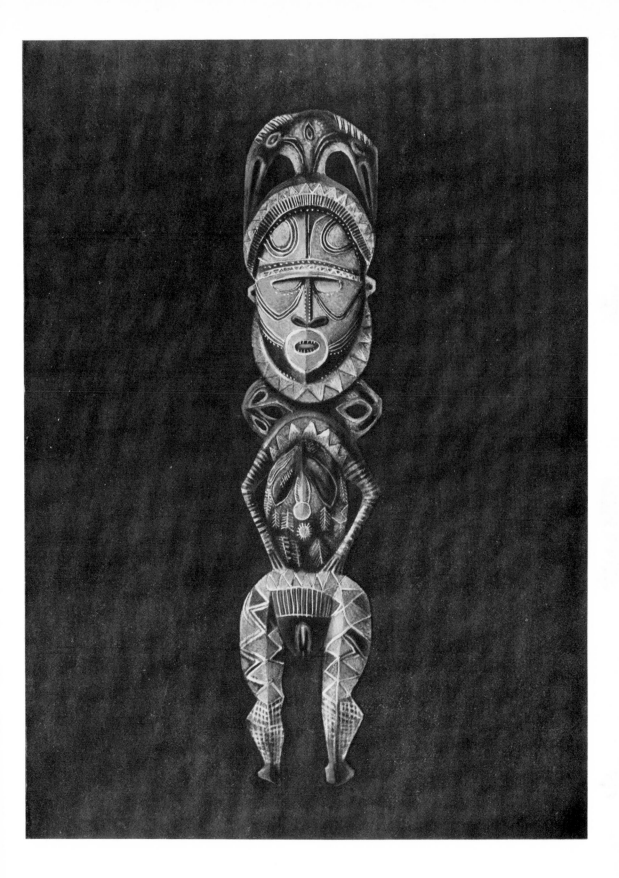

Many other objects from the Sepik region— neck rests, lime containers, mortars, pestles, spatulae, shields, drums, hooks, canoe prows and flute stops—show a richness and variety of style comparable to that of the figures and masks, and in many cases the figures, birds or other animal forms which served as the principal decorative motifs had a significance beyond that of mere decoration. The flute stops, for instance, sometimes represented supernatural spirits, and with some tribes, like the Mundugumor they are among the most secret and sacred objects in their possession. Sound-making instruments, such as the flute, drum and bull-roarer, are closely associated with the supernatural since they represent the voices of spirits, and are thus an important part of the initiates' secret paraphernalia.

The variety of Sepik River art is one of its chief characteristics. Since the elaborate religious and social ceremonies required a great display of carved and painted objects there was an ever-present need for new paraphernalia, and this gave rise to a technical proficiency and creative interpretation of traditional forms unsurpassed in any other area of Oceania.

The diversity of conventions used in the representation of facial features and parts of the human body is truly bewildering. Eyes, for example, appear as pin-points or as huge circles, as narrow slits or as wide ovals. Heads may be round, oval or diamond-shaped and arms and legs vary from long thin stems to massive stumps. These stylizations appear on figures in countless combinations and make it very difficult in some cases to ascribe specific styles to specific groups.

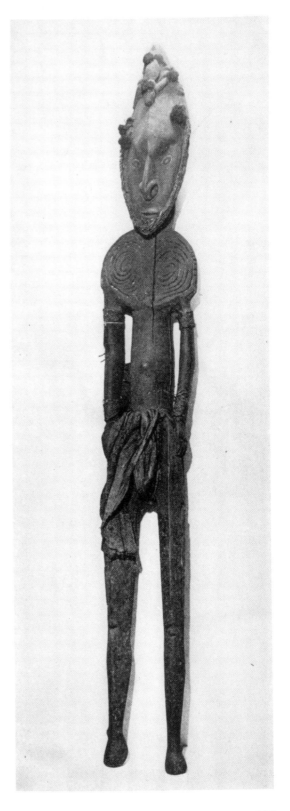

Ancestral figure of carved and painted wood, from the Sepik River, New Guinea. 84″ high. Collection Chicago Natural History Museum, Chicago. (147.769)

Melanesia: The Sepik River Area, New Guinea

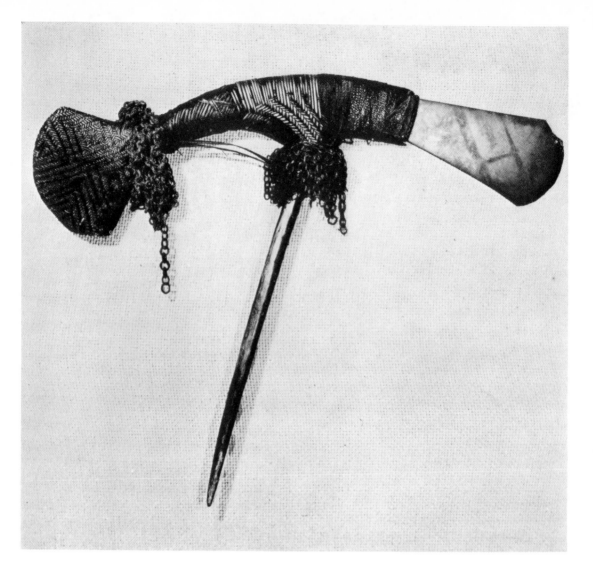

Adze with stone blade attached to the wooden handle with elaborate lashings, from Mount Hagen, Sepik River area, New Guinea, 24 x 29″. Collection American Museum of Natural History, New York. (80.0-8821)

Future study of the distribution of the most typical renderings of some characteristic feature such as the nose may help in tracing styles to their place of origin. The nose is by far the most prominent of all individual features in Sepik sculpture. No matter what its size or shape, it is always accentuated by plastic or color treatment and its various forms are clearly enough defined to make several basic types recognizable. The most spectacular type resembles a long trunk often touching the chin or even the breast, genitals or feet of the figure. Another type often extending way below the chin turns into the neck and head of a bird. Still others are short and broad with flaring nostrils, or straight, pointed and beak-like. The only element that all of these nose types have in common is the hole in the septum for the in-

Melanesia: The Sepik River Area, New Guinea

sertion of ornaments similar to those worn by the people themselves.

With the exception of the composite noses ending in birds' heads which are found in a restricted region of the Upper Sepik, all these other types appear in more or less pronounced form in many sections of the Sepik area. However it seems likely that a detailed study of these nose types will eventually reveal their various places of origin and greatly contribute to the clarification of the involved style problem of the entire region.

It is extremely difficult to single out features common to all the different styles of the Sepik River area because they are made up of such a vast number of design elements and combinations of design elements, and have so little homogeneity of proportions. There are certain tendencies such as the emphasis on noses and heads and the frequent use of organically curved surfaces, that appear in almost all Sepik carvings, but these are shared by other Melanesian styles. Sepik River art derives its unique character from its remarkable ability to make plastic forms the carrier of strong emotions. It lacks to a great extent the traditional, formal restraints that give uniformity to other regional styles. Based on human and animal shapes that are often distorted or combined to produce grotesque and fantastic effects, this intense, sensual, magic art depends for its plastic impact almost entirely on the bold integration of its design elements. Imagination ordered but not restricted by feeling for form makes the art of the Sepik River an ideal instrument for its main purpose—the release of magic power.

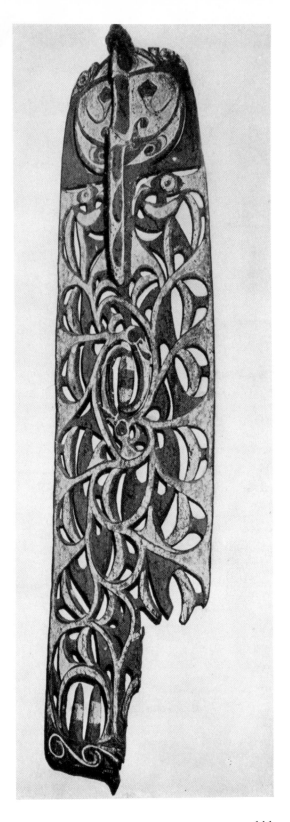

Ceremonial board made of carved and painted wood, from the Sepik River area, New Guinea. 60″ high. Collection Chicago Natural History Museum, Chicago. (141.179)

Melanesia: The Sepik River Area, New Guinea **111**

Dance mask made of rattan from the Sepik River area, New Guinea. 31″ high. Collection University of Pennsylvania Museum, Philadelphia. (29-50-663)

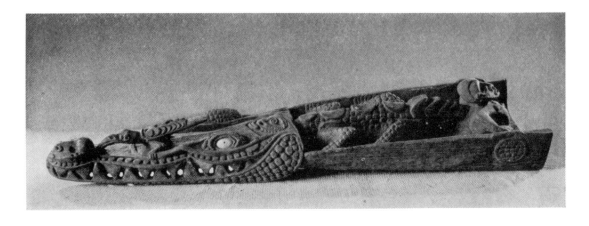

Canoe prow carved in the shape of a crocodile's head, from the Sepik River, New Guinea. 60″ long. Collection University of Pennsylvania Museum, Philadelphia. (29-50-625)

Melanesia: The Sepik River Area, New Guinea

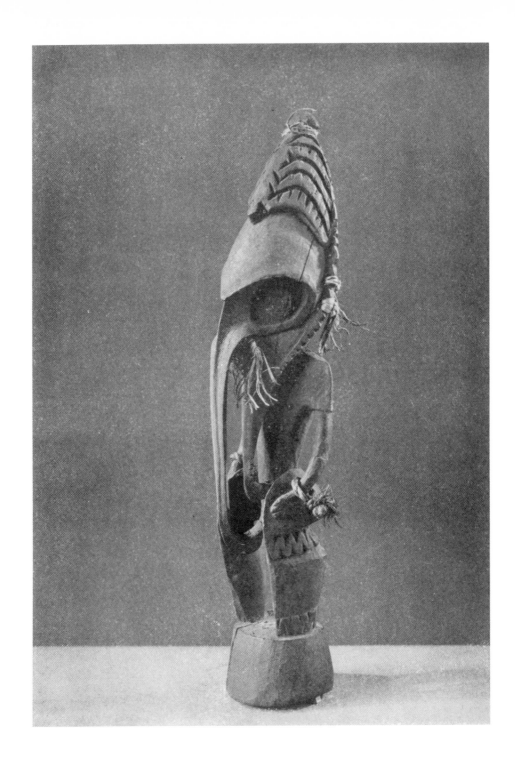

Small wooden figure from the Sepik River, New Guinea. 18½″ high. Collection University of Pennsylvania Museum, Philadelphia. (P 2666)

Melanesia: The Sepik River Area, New Guinea

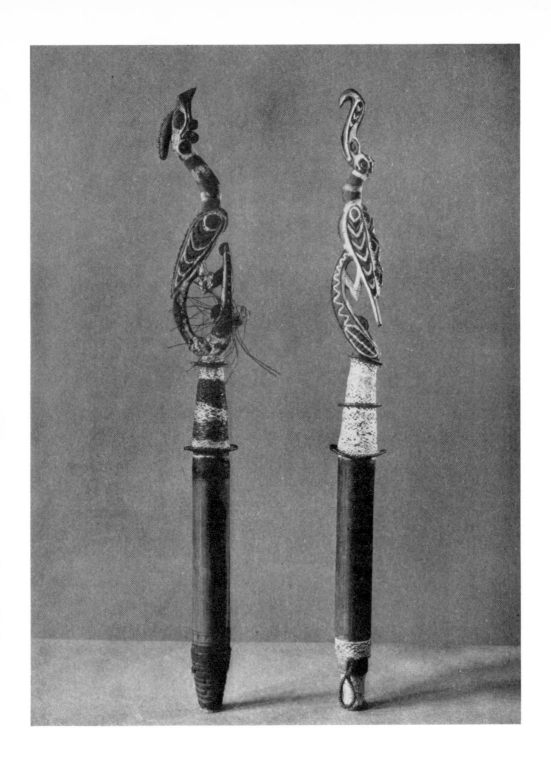

Bamboo lime containers with carved and painted tops, the Sepik River, New Guinea. Each 30″ high. Collection University of Pennsylvania Museum, Philadelphia. (29-50-552 and 29-50-557a)

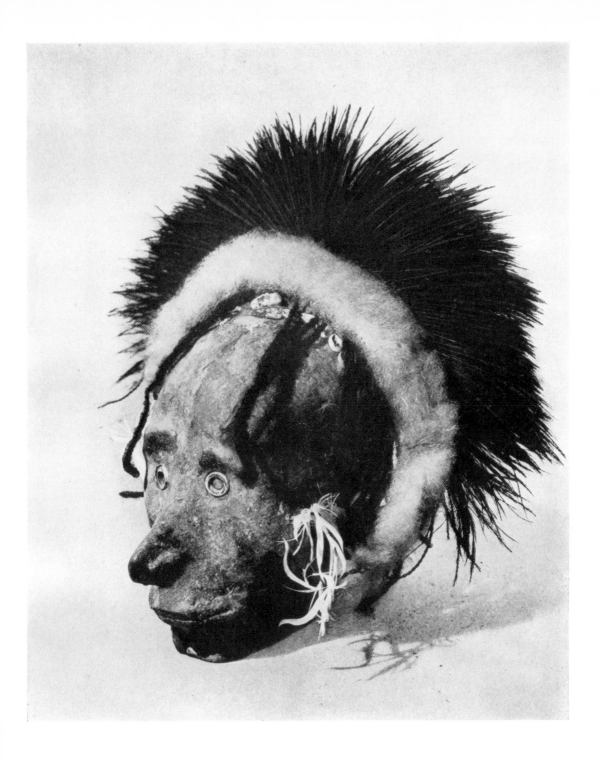

Head modeled in clay over a skull, from the Sepik River area. Collection American Museum of Natural History, New York. (80.0-7647)

Melanesia: The Sepik River Area, New Guinea

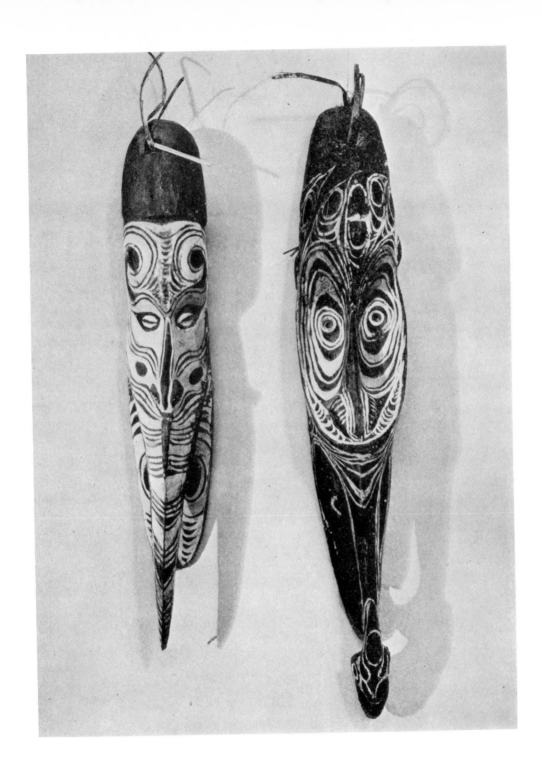

Masks of the Tchambuli tribe from the Sepik River, New Guinea. 19½″ and 23″ high. Collection American Museum of Natural History, New York. (80.0-7353 and 80.0-7352)

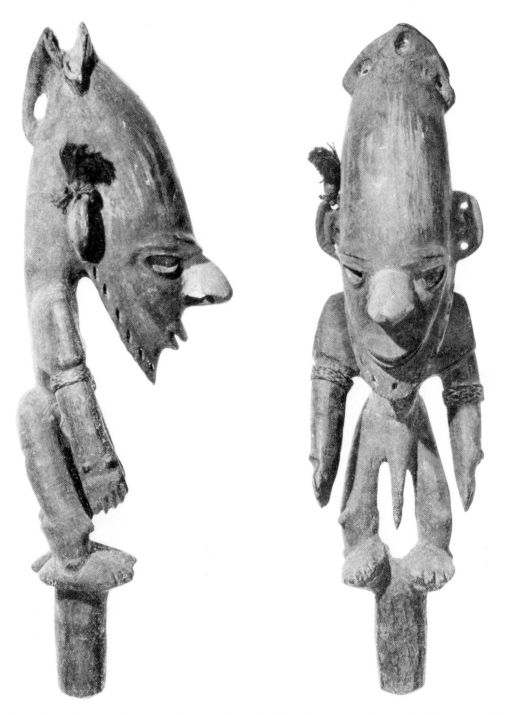

Male figure from the top of a sacred flute made by the Mundugumor tribe on the Yuat River, Sepik River area, New Guinea. Profile and front view, 21½" high. Collection American Museum of Natural History, New York. (80.0-8234)

This type of figure was made to be covered with shells and other decorations leaving only the face visible.

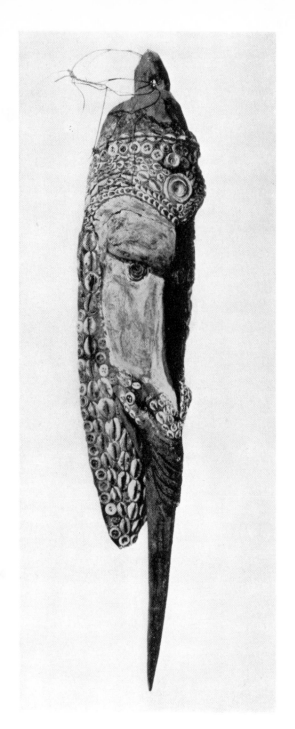 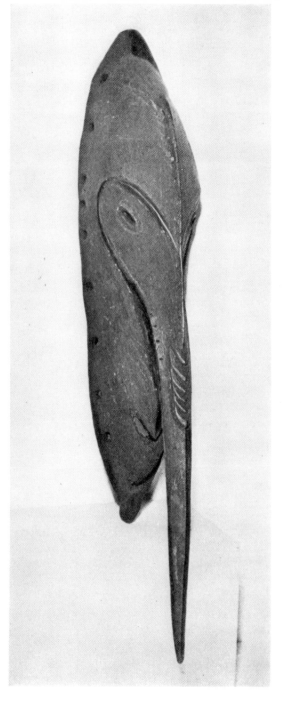

Left: Mask covered with shell, from the Sepik River, New Guinea. 24″ high. Collection American Museum of Natural History, New York. (80.0-8099)

Right: Mask from the Sepik River area, New Guinea. 22″ high. Collection Chicago Natural History Museum, Chicago. (140.950)

Melanesia: The Sepik River Area, New Guinea

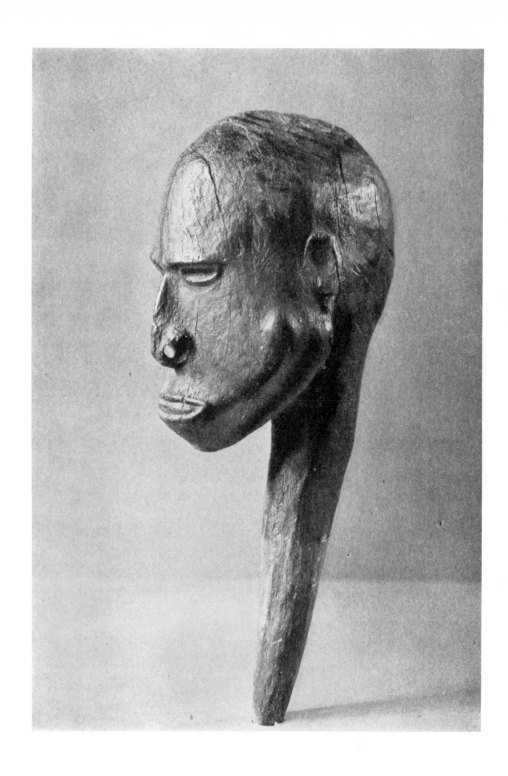

Carved head from the Sepik River, New Guinea. 12¾″ high. Collection University of Pennsylvania Museum, Philadelphia. (29-50-627)

Melanesia: The Sepik River Area, New Guinea

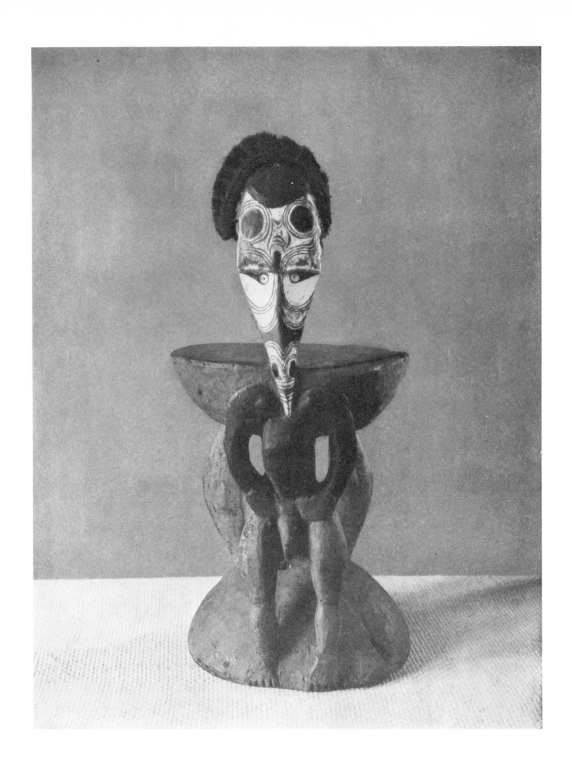

Carved stool from the Sepik River, New Guinea. 36¼" high. Collection University of Pennsylvania Museum, Philadelphia. (29-50-322)

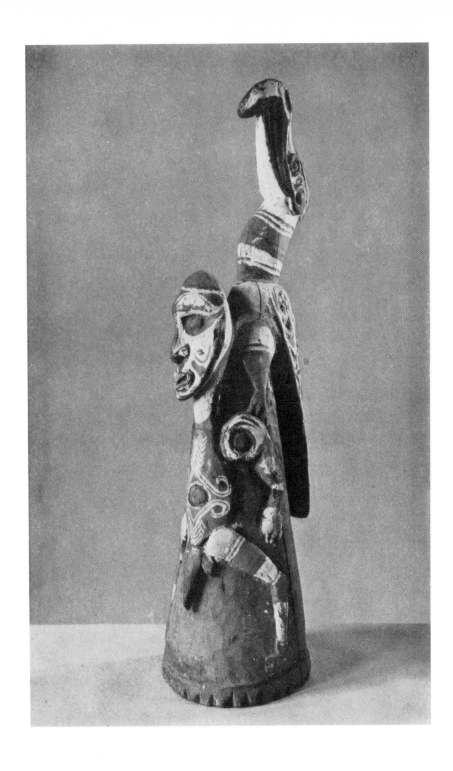

Carved male figure surmounted by frigate bird, from the Sepik River, New Guinea. 21½" high. Collection University of Pennsylvania Museum, Philadelphia. (29-50-678)

Melanesia: The Sepik River Area, New Guinea

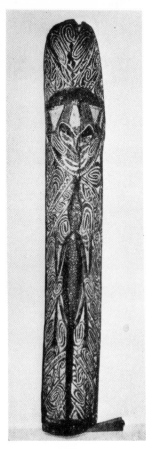 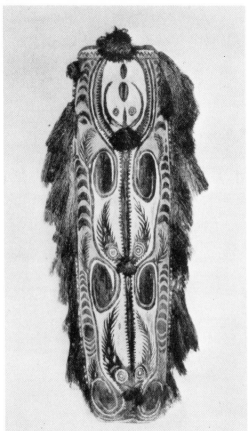 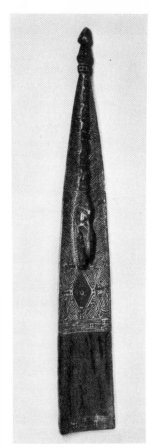

Left: Painted wooden shield from Mushu Island, Sepik River area, New Guinea. 63" high. Collection Chicago Natural History Museum, Chicago. (147.932)

Center: Shield with fiber fringe from the Sepik River area, New Guinea. 60" high. Collection Chicago Natural History Museum, Chicago. (145.296)

Right: Surf board from the Sepik River area, New Guinea. 60" long. Collection Chicago Natural History Museum, Chicago. (140.505)

Melanesia: The Sepik River Area, New Guinea

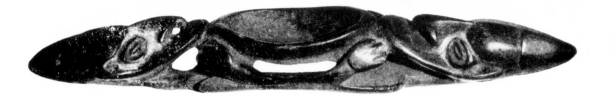

Betel mortar from the Sepik River area, New Guinea. 11″ long. Collection Chicago Natural History Museum, Chicago. (145.317)

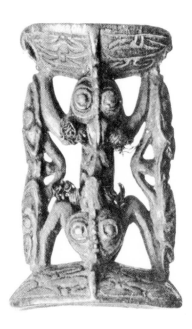
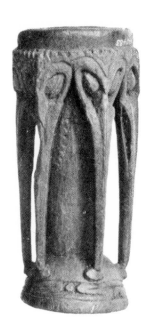

Left: Neck rest from the Sepik River, New Guinea. 24″ long. Collection Chicago Natural History Museum, Chicago. (140.876)

Right: Betel mortar from the Mabuk River in the Sepik River area, New Guinea. 6″ high. Collection Chicago Natural History Museum, Chicago. (140.483)

Melanesia: The Sepik River Area, New Guinea

THE TORRES STRAITS

Cannibalism, head hunting and elaborate funeral rites were important factors in the culture of the Papuans living on the many small islands in the Torres Straits. Under Australian administration, these peoples have now given up their old pattern of life. Schools, churches and even newspapers are the new elements in a quiet peaceful life which is still dependent upon the old economic basis of pearl, turtle and other deep-sea fishing. These profitable enterprises are largely in the hands of the natives, as is the general conduct of their life. From the now dead past, carved or molded objects testify to the existence of an art once firmly rooted in aboriginal religious beliefs and social practices.

In a clear blue sea the Torres Straits islands extend in a helter-skelter fashion from just off Cape York, the northernmost point of Australia, to the south shore of New Guinea. The Straits themselves are named for the Spanish navigator, Luis Vaez de Torres, who sailed through them as early as 1606. But it remained for Cook to discover and to name many of the islands, such as Murray, Tuesday, Wednesday, Thursday, Friday, Banks, etc., when he charted the Straits in 1774. For the most part the islands are healthful and beautiful, with sandy beaches, high mountains, cool valleys, fine lagoons and magnificent coral formations. Despite the nearness of many of them to Australia, the old culture was related to that of the south of New Guinea. Trade and head hunting raids were carried out extensively in efficient but simple outrigger canoes. The natives were very belligerent and for a long time strenuously resisted European encroachments.

The most interesting of the old objects from these islands are a series of masks made of tortoise-shell plates. In some specimens large pieces of shell were molded, presumably by heating, and bound together with fiber cord to represent human heads. The nose, the top of the head, and the sides of the face were molded separately and joined to the larger plates to form the forehead and facial planes. Eyes were represented by pearl shell set in black paste which was also used to indicate the pupil. The finest of these masks show a remarkable feeling for the bony structure of the human head and for carefully molded surfaces. A reddish paste simulated the lips of a narrow, open mouth showing the sharp outlines of teeth. The entire face is rimmed with a wide incised border, composed of short parallel horizontal lines, which also extend down the forehead to the bridge of the nose and along the tip of the nose. Similarly incised plates at the back of the head suggest hair or a hair ornament, while holes were cut around the face and over the head for the insertion of human hair.

Other tortoise-shell masks represent fish with wide open mouth, heavy beard, inset eyes and a delicate incised geometric surface decoration. All masks probably represented legendary and historic tribal ancestors—some, such as the fish, are seemingly totemic in character. Occasionally one finds large plaques made of small pieces of tortoise shell representing human faces (p. 128). The form indicates that they were not worn over the face, but were either carried or, more probably, worn on the head of a person who was completely concealed by an enveloping costume. They have the piercing expression that is so typical of the masks and are said to have been used in funeral ceremonies.

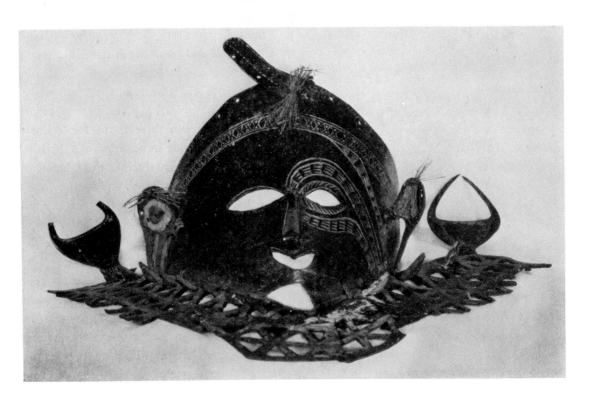

Tortoise-shell mask from the Torres Straits, New Guinea. 5½ x 15″. Private Collection, New York.

Not many tortoise-shell masks have survived and there are even fewer wooden ones. The latter are somewhat larger in size, and come from the western region of the Straits where they were used in a pre-harvest fertility ceremony to solicit good crops. They lack the alert expressiveness of the tortoise-shell masks, are more elongated and have greater angularity, but resemble them in the smoothness of surface planes, the length of the nose and the pervading naturalism of structure. These wooden masks are closely related to certain carved figures and heads that were collected on the New Guinea coast of the straits near the mouth of the Fly River. The drum in the shape of a human torso reproduced on page 126 and the figure shown on page 94 are excellent examples of

this style which has no counterpart on the mainland of New Guinea.

Among the wood-carvings from the islands, arrows are the most numerous. They were used as weapons, as ceremonial objects and as currency. Their points were made of wood, bamboo or bone and many of them were elaborately carved just below the barbs at the head, with either a human figure or a crocodile. Both types show considerable variation in the treatment of form, from realistic to stylized. Both have only the main proportions of the figures carved in the round while the details are incised. Their raised surfaces are painted black and their incised portions red and white. The realism is of a descriptive kind in which all parts of men and crocodiles are indicated even

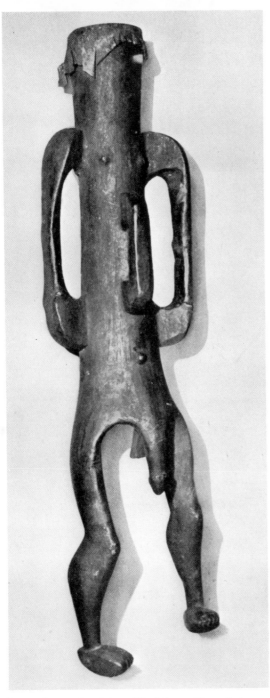

Drum from the lower Fly River; New Guinea. 36″ high. Collection Chicago Natural History Museum, Chicago. (142.777)

This drum is shown here because lower Fly River sculpture has greater affinities with Torres Straits art than with the work of the Papuan Gulf.

where they are reduced to angular geometric stylizations and rendered in straight lines, zigzags, chevrons and diamonds.

Characteristic features of the "man arrows" to be noted are: the long rectangular head, the large open mouth showing the teeth, the M-shaped incised line indicating the nostrils and the parallel vertical incised lines below the chin representing a beard, and similar lines at the back of the head, representing the hair. On the long neck a prominent "Adam's apple" protrudes in front and sometimes a like form appears at the back. The parts of the body are always compressed and schematically represented. "Crocodile arrows" usually show as recognizable parts the projecting valvular nostrils on the long snout, jaws and teeth, triangular eyes, and fore- and hind-legs. Common to all of these carved arrows are the decorative bands marking off certain surfaces or forms.

The incised decoration of the large hourglass and cylindrical drums is similar in style to that of the arrows. Realistic animals, fish and birds are combined with geometric forms. Most numerous of other decorated objects are the sections of bamboo which serve as tobacco pipes. Their smooth surface is etched with rich angular designs.

Thus, with but few exceptions, the art of the Torres Straits is a surface art limited to straight linear patterns. Design units are arranged between parallel lines, forming strips or bands of decoration. Most of the carving is carefully done while the variety of patterns to be found shows a creative approach in the handling of traditional motifs. In summing up one might say that the decorative carving from this region is of uniformly high quality, and that the finer specimens of the tortoise-shell masks have outstanding artistic merit. They are, in fact, extraordinary enough to deserve a place of honor among the creations of primitive peoples.

Melanesia: The Torres Straits, New Guinea

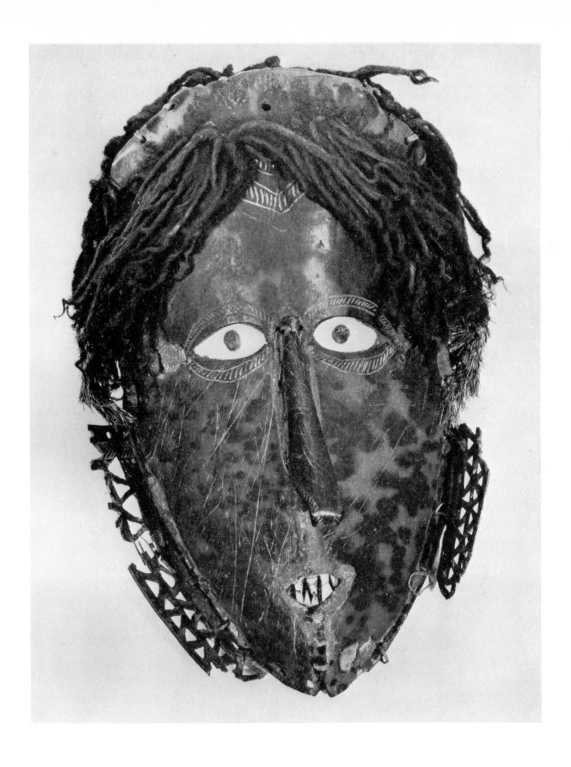

Tortoise-shell mask from Torres Straits. 14″ high. Collection Philadelphia Commercial Museum. (13468)

Melanesia: The Torres Straits, New Guinea

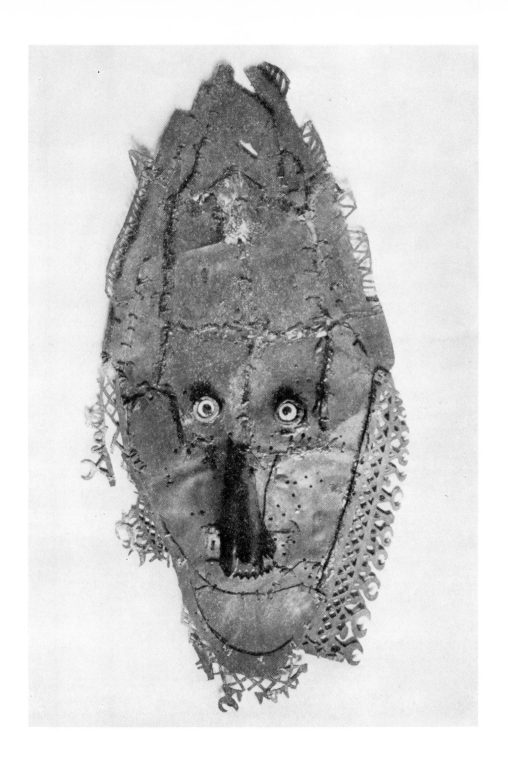

Large plaque in the shape of a face made of tortoise-shell plates, from the Torres Straits, New Guinea. 46″ high. Collection Peabody Museum of Salem, Salem, Mass. (E 2135)
This plaque was probably carried in funeral ceremonies.

In the extreme southeastern part of mandated New Guinea, over three hundred miles from the Sepik River, lies the large Huon Gulf. The western shore of the Gulf and the small island of Tami, lying a short distance offshore, comprise a culture area where one of the most homogeneous art styles of New Guinea was developed. The range of design motifs was not great, although they were used in a vast variety of combinations.

Huon Gulf work included architectural carvings, free-standing figures, masks and several other types of objects. Architectural carvings appear on the structural parts of the men's clubhouses *(lum)*. The free-standing figures, presumably depicting ancestors and spirits, were used in circumcision ceremonies which were of considerable importance in this culture. The masks were used in dances and represented supernatural spirits. Other objects of special interest are the neck rests, bull-roarers, coconut-shell cups, hooks and drums. All Huon Gulf pieces appear to have been painted in various combinations of white, black, yellow and red.

Extensive tropical swamps and heavy jungle make this region one of the most inhospitable of New Guinea. A little more than twenty years ago, when rich gold deposits were discovered in the interior near the coast, the intervening country proved so impassable that the mines could be exploited only by establishing air service from the now famous coast towns of Lae and Salamaua. While there are evidences of some contacts with the coast of Dutch New Guinea and New Britain, the culture and art of the Huon Gulf show that the ruggedness of the surrounding terrain tended to isolate these peoples from inland influences. This geographical isolation gave rise to a comparatively static culture. Inherited rights preserved clan ownership of specific designs. These designs were important for clan prestige because they called to mind important ancestors or mythological or historical events. A relative meagerness of ceremonies seems to have resulted from a more or less fixed pattern of relationships. Competition was at best but slight. The inflexibility of Huon Gulf society is reflected in a rigid adherence to art styles established by tradition.

Circumcision, performed at the initiation of a boy into manhood and active clan membership, was the occasion for a series of ceremonies in which the novice was acquainted with clan ancestors and supernatural spirits. For these rites special houses were built, carved figures set up and bull-roarers made to represent the voices of the participating spirits. Bull-roarers are thin oval-shaped pieces of wood with a hole at one end through which a length of cord is attached. The sound is produced by whirling them rapidly through the air by this cord. Huon Gulf bull-roarers *(kani)* are fairly large, often more than fifteen inches long and two inches wide. They were objects of special veneration which had the name of the clan ancestor whose voice they simulated. When not in use, they were kept in the men's house. Clan designs were carved on them in low relief into which white clay was rubbed so that the pattern appeared prominently on the dark surface of the wood.

Circumcision rites had socio-religious significance. They not only ushered the boy into adult society, but also marked the division of

that society into men on the one hand and women and children on the other. This division was necessary on religious grounds, for women and children could not come into contact with the sacred paraphernalia of the spirit world. To have done so would have been a sacrilege punishable, as in many regions of Melanesia, by instant death.

The *lum* or men's house was moderate in size and does not seem to have been a ceremonial center. It was more of a club house where the unmarried and sometimes the married men slept and lounged. The house, rectangular in plan, was always raised off the ground on posts and the walls were surfaced with large planks. Both the supporting posts and the wall planking were carved and painted black, white, yellow and red. The posts usually represented full-length figures in the round; the planking, heads and geometric forms were in high relief and often arranged heraldically.

These people made two types of masks, the one of wood and the other of bark-cloth stretched over a palm wood frame. They were both painted red, black and white, had similar features and were used in like ceremonies. The bark-cloth masks, which seem to have been restricted to Tami Island, measured from two to three feet in height and were called *tago*. They represented particular spirits who visited the villages at ten- to twelve-year intervals when they remained for about a year. The right to wear the masks was inherited, and the persons who possessed it constituted an hereditary secret society into which they were initiated. A shredded palm-leaf costume completely concealed the identity of the wearer and death was the fate of any uninitiated person or woman or child who recognized the dancer. Although a religious importance was probably attached to the masks and to the prolonged rites, they also served to discipline the uninitiated and to affirm privileged rights.*

Conspicuous among the best carvings from the Huon Gulf are some of the neck rests, which have human figures and snakes combined with geometric designs in a style entirely characteristic of this area. Carved from a single piece of wood, the top is generally concave and the supporting forms are often composed of complex designs in which the contorted human figure is most commonly used. Coconut-shell cups are also elaborately carved with incised designs into which white lime is rubbed. A large cat-like face surrounded by geometric elements frequently appears as a design motif.

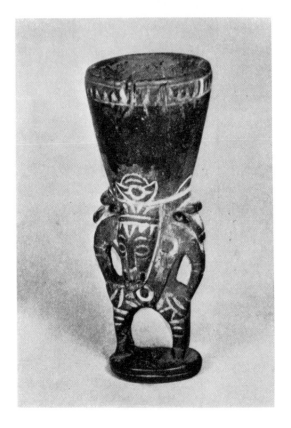

Carved betel mortar from the Huon Gulf, New Guinea. 6″ high. Collection Peabody Museum of Salem, Salem, Mass. (19504)

* These masks were said to have come from New Britain through intermarriage and are very similar to the bark-cloth masks of that area.

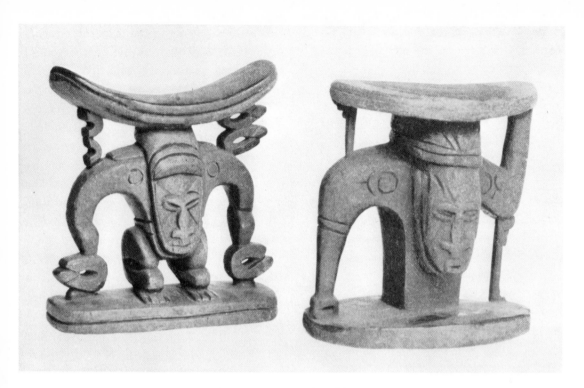

Carved neck rests from the Huon Gulf, New Guinea. 6" and 6¾" high. Collection Chicago Natural History Museum, Chicago. (138.422 and 146.082)

All representations of human figures in Huon Gulf work follow a traditional pattern, with only minor variations. The head is long and narrow with a high tapering hat. Large in proportion, the head is often placed directly on the body without a neck so that it is, in fact, carved partially in high relief on the front of the torso. In these figures the shoulders are therefore hunched very high and in some they actually touch the large geometrically shaped ears. The features of the face are frequently depicted in low-relief line-pattern in which large triangular patches appear above and below the eyes. Mouth, nose, and eyes usually form a continuous design, the nostrils marked by a flowing M-motif. Sometimes the features have a degree of plasticity, as in the masks, and frequently the mouth is filled with sharp teeth and the projecting end of the tongue. Often a sharp zigzag rims the eyes, decorates the surface

of the nose and represents the teeth. A heavy expression, impersonal, formalized, fixed, gives these heads a static quality. The bodies are highly conventionalized. Some of them, especially on the neck rests, are contorted to form a curvilinear pattern.

The motifs most commonly used in all types of carvings from the Huon Gulf include a wavy, snake-like zig-zag, a sharp-toothed design, and concentric parallel lines. White is practically always rubbed into the surface patterns.

In general, this art has a lethargic heaviness and inertness, which is sometimes relieved by the flowing curves of decorative detail. One is tempted to interpret this style as the outgrowth of a culture where static, inherited rights oppress and restrain the active forces of man's nature. Many of the carved figures seem to resemble massive tree trunks that are covered by the clinging tendril-like forms of tropical vines.

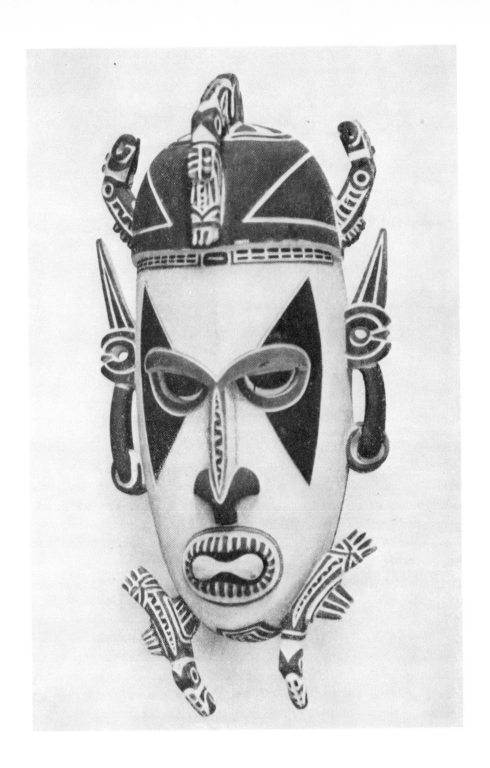

Painted wooden mask from Tami Island in the Huon Gulf, New Guinea. 24″ high. Collection Chicago Natural History Museum, Chicago. (138.432)

Melanesia: Huon Gulf, New Guinea

The Dutch area of New Guinea is in itself vast and, with the exception of coastal areas, imperfectly known. In recent years expeditions into the interior have found high fertile plateaus, set in the midst of lofty mountains, supporting a sizable population. A number of pygmy tribes have also been discovered living in wild inland mountainous regions. But the material culture of these inland peoples does not compare with that of the coastal peoples of the north and south.

The Geelvink Bay area of the northwest coast and also the Doreï Bay and Merat Island regions to the west have produced a quantity of wood carvings—small ancestor figures, moderate-sized decorated canoe prows, sculptured neck rests and tall carved shields. In some regions the supporting posts upon which large ceremonial houses are built are carved to represent compact human figures, while the high gabled façades are entirely covered with plaited fiber forming a rich geometric decoration of narrow vertical stripes in red, black and white.

Strong Indonesian affinities are evident in these house fronts and in many objects from Dutch New Guinea. Design units and their combination into patterns are sometimes strikingly similar to those of Borneo, Sumatra, or Java. Certain conventionalisations such as the pointed noses and the angular, twisted bodies of the ancestor figures (korowaar) are practically analogous to certain carved figures from Borneo. The shields carved in pierced flowing arabesques held by many of the korowaar figures, and the same type of carved arabesques found in canoe prow decorations might easily be taken at first glance for Javanese work, while many tall oval shields, decorated with high-

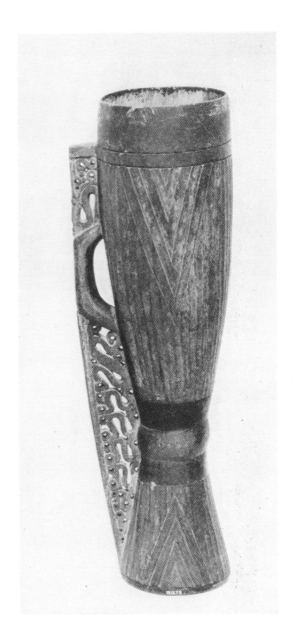

Carved drum from Jappen Island, Dutch New Guinea. 21" high. Collection Chicago Natural History Museum, Chicago. (151.275)

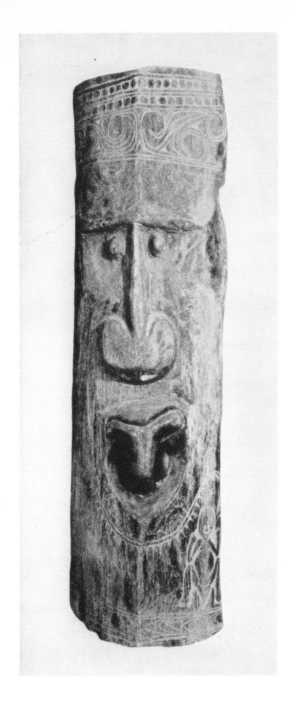

Carved shield. 46″ high. Collection Peabody Museum of Salem, Salem, Mass. (E 24679)

This shield has been attributed to the Sepik area but its incised designs suggest its provenience as Dutch New Guinea.

relief surface designs, use motifs similar to the Sumatran water buffalo motif: two curves arranged horizontally, one to either side of a circular center. But in every case these strong Indonesian affinities are combined with other distinctive features which establish the existence of clearly recognizable Dutch New Guinea styles.

A kinship, for instance, is readily apparent in all the objects from the Geelvink Bay area —ancestor figures, neck rests and canoe prow decorations. All of these carvings are relatively small in size, the largest of them, the canoe prows, being seldom more than three feet high, while the *korowaar* figures (p. 139) are from five to twelve inches in height. The latter are represented in different ways: some have large rectangular heads, some figures stand or squat, some hold the pierced shields in front of them, others have their elbows resting on drawn-up knees and their hands joined under their heads. With the exception of the pierced arabesques of the shields, the carvings have angular, four-sided and often rubbery forms, and are generally crudely done. A great long nose, sharp-pointed, with flanking nostrils, divides the head and extends sometimes to the chin. The mouth is a very wide oval, filled with big, strong teeth. Although the *korowaar* are small figures, the exaggeration of legs, arms and particularly of the head gives them a monumental character. They were made as residing places for the spirits of the dead and were regarded as highly sacred. The figure was carved during the life of a person so that at the moment of death the spirit could enter it. Sometimes the head of the *korowaar* was hollowed out and the skull of the deceased placed inside it. It is likely that the rank and importance of a person was indicated by the size and pose of his *korowaar*.

The canoe prow heads and the figure carvings on neck rests from the Geelvink Bay area are

134

similar in style to those of the *korowaar*, having many Indonesian elements handled in an unmistakable local manner. Most of these objects were probably painted red, black and white.

Two entirely different types of canoe prow decoration come from other regions of the north coast. One is a curved, pointed prow, carved in a rich and complex design (pp. 136-7) composed of interlocking fish and human forms and heads. Painted red, black and white, these prows are carved with considerable care and a good technique. Parts are clearly defined; detail is bold and sharp. The combination of fish and human forms again suggests totemic content and the complex designs often imply a narrative character. These canoe prows include some of the finest carvings from Dutch New Guinea. The other type of prow (p. 140), trapezoidal in shape, is carved in rich pierced arabesques of strong Indonesian character. Some-

times figures somewhat similar to those of Geelvink Bay appear on these carvings.

From the Eilanden River region on the south coast come the big, finely carved, impressive shields on which are found design elements resembling the Sumatran water buffalo motif. But farthest east on the south coast, figures are carved in a style free of any Indonesian associations whatsoever. These are ancestor figures, larger than life-size, represented in a seated posture. They have very attenuated proportions, small heads and nervous, alert expressions, and are the work of a distinct, localized style area.

Most of the arts of Dutch New Guinea show a strong outside influence due to its proximity to Indonesia. In style, it is transitional between Indonesia and Melanesia, the preference for rich complex decorative designs being Indonesian, and the boldness and vigor of interpretation being Melanesian.

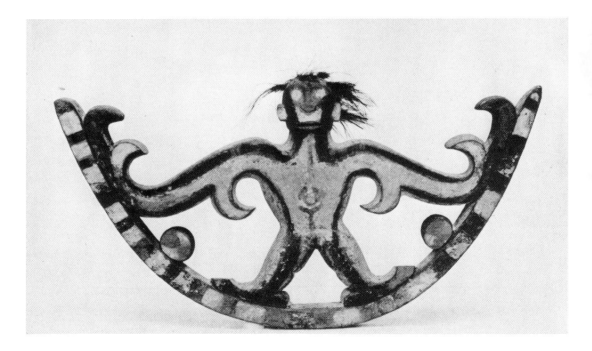

Carving representing the moon, from Dorei Bay, Dutch New Guinea. 26″ wide. Collection Chicago Natural History Museum, Chicago. (151.157)

Melanesia: Dutch New Guinea

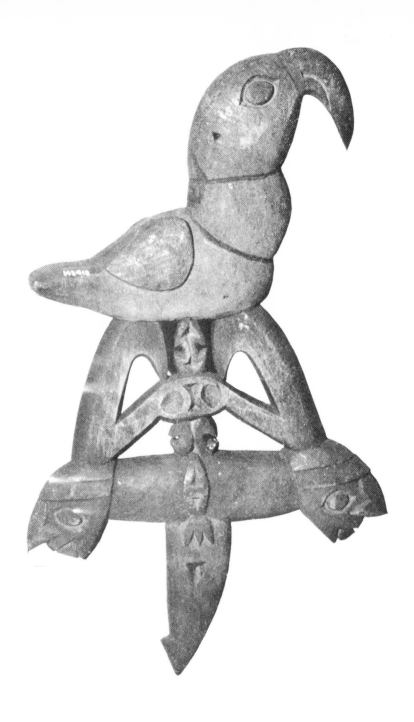

Carved canoe prow ornament from Dutch New Guinea. 16″ high. Collection Chicago Natural History Museum, Chicago. (143.418)

Melanesia: Dutch New Guinea

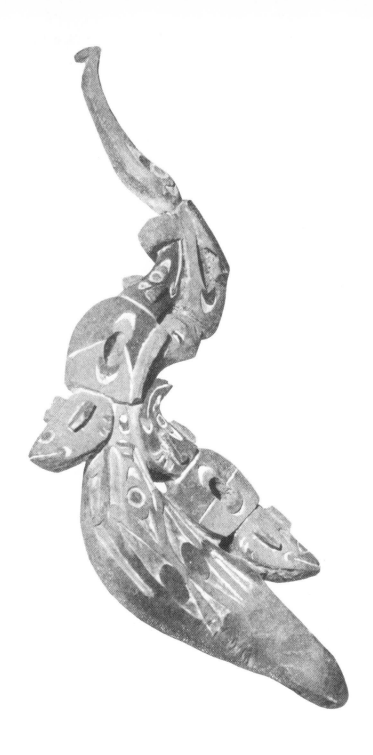

Carved canoe prow ornament from Humboldt Bay, Dutch New Guinea. 26″ high. Collection Chicago Natural History Museum, Chicago. (139.199)

Melanesia: Dutch New Guinea

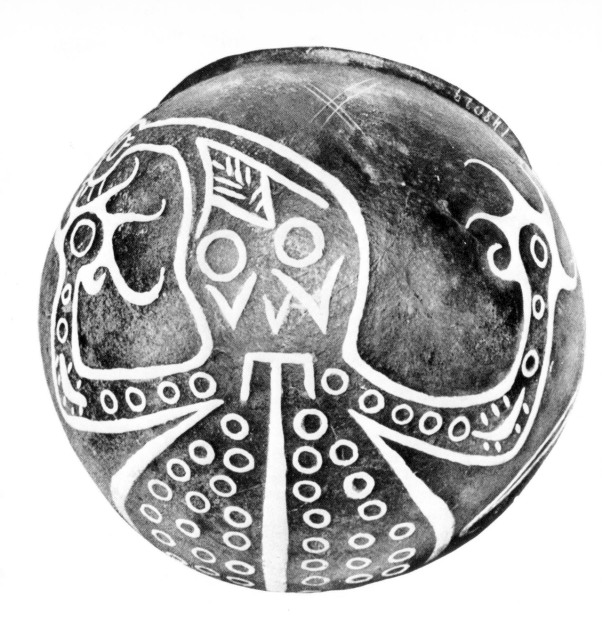

Painted pottery vessel from Humboldt Bay, Dutch New Guinea. 11½″ diam., 10″ high, Collection Chicago Natural History Museum, Chicago. (148.029) The design represents a crocodile.

Melanesia: Dutch New Guinea

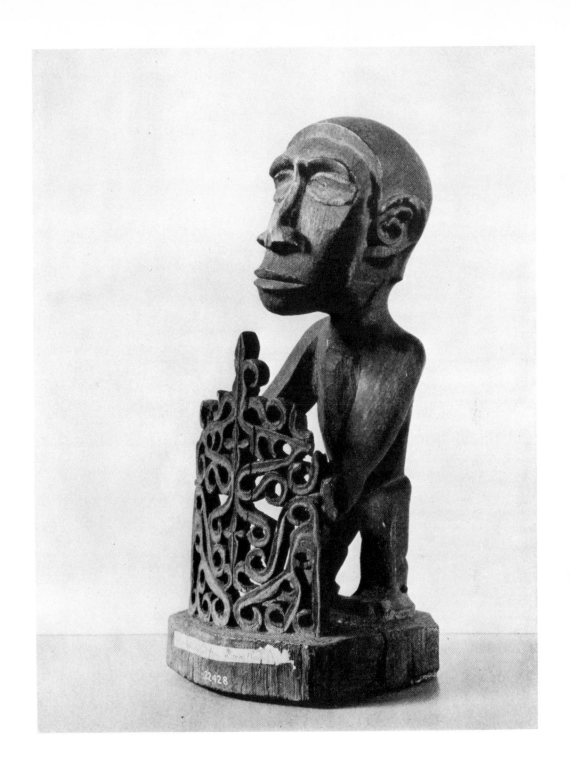

Mortuary figure (*korowaar*) from Dutch New Guinea. 12″ high. Collection University of Pennsylvania Museum, Philadelphia. (P 3587)

Melanesia: Dutch New Guinea

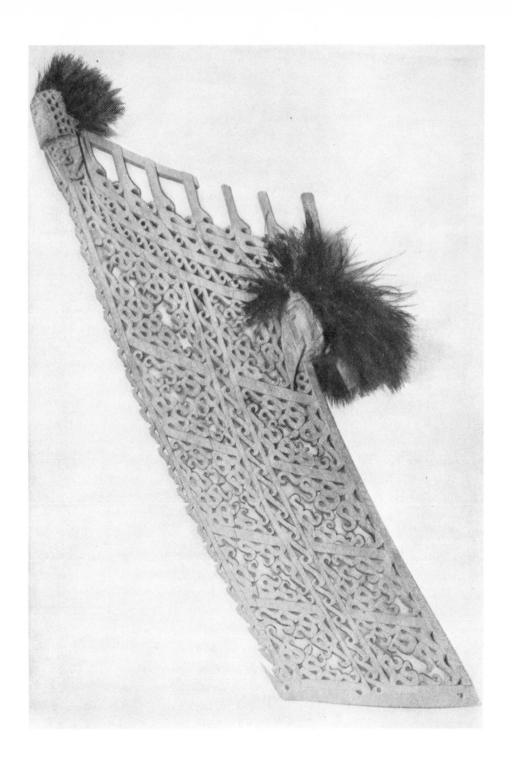

Carved canoe prow from Dutch New Guinea. 34″ high. Collection Peabody Museum, Harvard University, Cambridge. (72754-5)

The highest technical development of New Guinea carving was reached in the southeastern portion of Papua, the so-called Massim area. Magnificent spirals and scrolls and a great variety of curvilinear design motifs give this art its distinctive character. It is primarily an art of line; designs are precisely composed and carefully executed. They are usually incised on the surface of a hard dark wood, the incisions being filled in with white or red. The work shows considerable refinement, even elegance and delicacy, and although superficially it bears some resemblance to certain features in the art of Dutch New Guinea and of the Maori of New Zealand, it nevertheless remains one of the most clearly identifiable styles of Oceania.

The most important examples of Massim carvings come from the easternmost part of the area, including the coastal portion of the mainland and the various archipelagoes to the north and east. Of the latter, the principal ones are d'Entrecasteaux, the Trobriands, Woodlark and Louisiade, the Trobriands being the most important for the richness of their carvings.

Portions of this part of New Guinea were discovered in 1606 by Torres. But many of the islands were not discovered until late in the eighteenth century, and the charting of the coast and islands was not completed until 1849. Towards the end of the last century the discovery of gold in some regions led to an influx of adventurers from all parts of the world who contributed to the disruption of native culture.

Except for the Trobriands, the islands are mountainous. Since only a few are surrounded by coral reefs providing them with sheltered fishing waters, agriculture is the main means of livelihood. In fact some of the islands, including the Trobriands, have been noted for their fine gardens.

The people are mostly a mixture of Papuan and Melanesian but some of the inhabitants of the islands to the north seem to have a Polynesian strain. Culturally they differ considerably from the Papuans to the west. Men's clubhouses do not exist and initiation is not practiced, hence masks, bull-roarers and other paraphernalia used in such rites are not found here. The spear and the wooden club, often elaborately carved, are the important weapons. Except for certain regions of the Sepik River and the Huon Gulf, the only decorated pottery in New Guinea was made in this area. Betel nuts were used extensively as mild stimulants, and the decorated spatulae and mortars, employed in their preparation, were made in great numbers. Prolonged dramatic spectacles were not a feature of Massim life. But harvest festivals, with feasting and dancing, were held in the Trobriands when carved shields, clubs, staffs and wooden bowls were used. These islanders, unlike the people from other parts of New Guinea, payed allegiance to formally recognized chiefs and lived in comparatively small villages composed of individual houses, either raised on posts or built on the ground.

An interesting feature of Trobriand culture is the plan of the villages. The houses are placed to form a sizable circle, while opposite each house, and forming an inner concentric circle, are built the storehouses for yams, the principal produce of the gardens and the people's main item of diet. In the space in the center of these two circles is the dancing ground, the cemetery, and the house of the chief. The storehouses are the best built of the

structures and were frequently decorated with carvings, shells and streamers. The plan of the village protected the yams, the most important item of wealth, in case of attack, and at the same time allowed for the display of that wealth, since the area between the storehouses and the houses served as the village street.

Although cultural differences are found throughout the Massim area, the art style is nearly homogeneous. This is partly the result of frequent intercourse among the islands, and between them and the mainland for purposes of trade and the ceremonial exchange of objects. Large, sturdy canoes of the dugout-outrigger type, each equipped with a sail, were made for these expeditions. In the Trobriands the canoes (masawa) used for trips involving the ceremonial exchange of objects, had inset-carved boards placed transversely and longi-tudinally at both the prow and stern. These canoe boards are among the finest objects from the archipelago.

The most numerous Massim objects are the lime spatulae (opposite and p. 149). Usually made of ebony, they range from six inches to over two feet in length, and have beautifully proportioned handles carved with a wide variety of designs. In fact, the variety is so great that no design or profile can be considered characteristic, although some general principles of style and a preference for certain design elements can be discerned.

The spatula handles were always made with a specific surface design in mind, so that form and decoration would supplement each other. One of the most subtle achievements of the Massim wood carver was this complete integration of the shape of the handle and the design

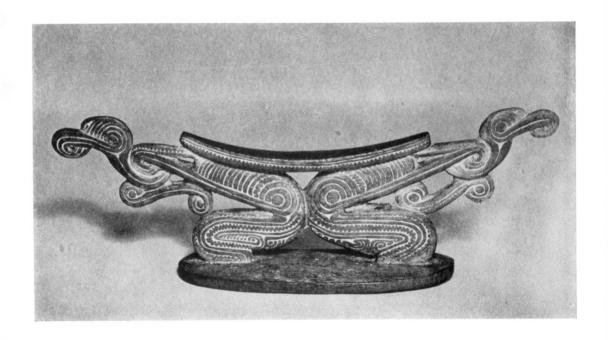

Carved neck rest with frigate bird design, from the Massim area, New Guinea. 20″ wide. Collection Royal Ontario Museum, Toronto. (HB 765)

Melanesia: The Massim Area, New Guinea

incised on its surface. Although the patterns are actually only lightly incised, they are essentially sculptural in concept. In general, the design is skillfully arranged along a longitudinal axis. There is a tendency to carve motifs within parallel framing lines, and clarity of design elements and cleanness and fineness of execution are distinctive qualities. Most of the designs are purely geometric, but on some spatulae a bird's head, crocodile or human figure is incised, each highly conventionalized to form a moving curvilinear pattern.

Some of the spatula handles have simple outlines. Others have broken profiles and perforated designs. In all New Guinea only the masks and figures of the coastal Sepik River area show a comparable feeling for elegance of shape.

Many canoe paddles and war clubs from the Massim area are carved in a style similar to that of the spatulae and finished with the utmost skill and precision. Most of these objects have lime rubbed into the incised lines of the design to make it stand out more clearly.

For one of the harvest dances in the Trobriands a uniquely shaped, very richly carved shield, *kai-diba* (p. 144), was made. It consists of two round parts connected by a thin hand-hold. The dance was one of quick, circular movements around the drummers in the center and, during these gyrations, the shield was constantly turned. For this reason both parts have identical designs, but they are in reverse on the handle so that no matter which part is uppermost, the design will be the same. The surfaces are carved in low relief in an elaborate design composed of long, free curves and spirals, and per-

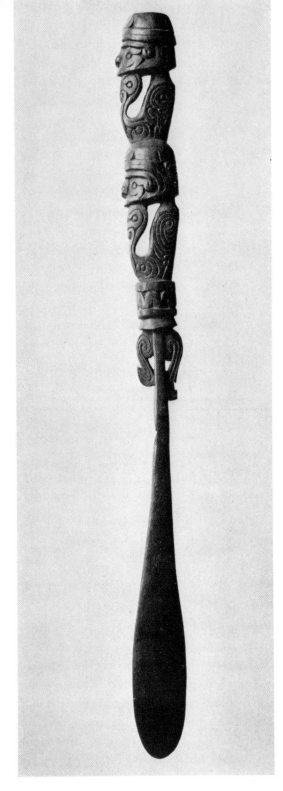

Lime spatula from the Massim area, New Guinea. 18½″ high. Collection University of Pennsylvania Museum, Philadelphia. (P-2605)

Melanesia: The Massim Area, New Guinea

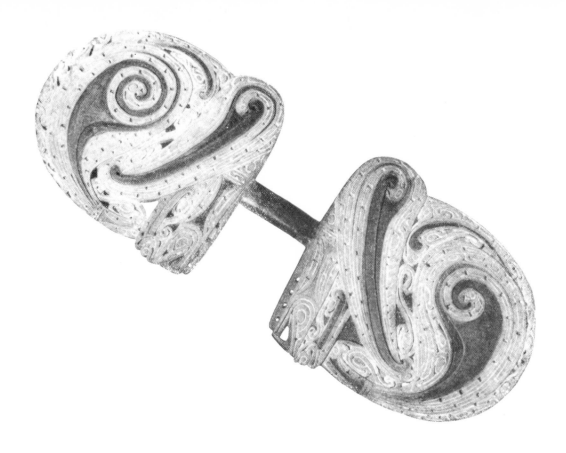

Carved and painted dance shield (*kai-diba*) from the Trobriand Islands, New Guinea. 27½" high. Collection Chicago Natural History Museum, Chicago. (R 135,934)

forations within this carving and the general interrelation of the curves in the pattern suggest that they represent highly conventionalized birds perched on a horizontal cross-piece. Snake forms are also sometimes suggested by the long curves. Although the general plan of these shields is always the same, no two of them are exactly alike in composition. They are carved in a light wood and are often painted red and white, or black, white and red, or sometimes black, red and brown. They are superb examples of Trobriand technique and style.

Painted shields of the type illustrated on page 148 are also made in this archipelago. They are ovoid in shape, with a marked convex longitudinal curvature. On a background of white, a strictly symmetrical design composed of curvilinear geometric elements is painted in red,

black and yellow. This has the characteristic delicacy and fineness of all Trobriand work, but, although the patterns show considerable variety within a basic design, they are generally highly formalized and ornate and lack the vitality and verve of other objects from this area.

The climax of Massim art was reached in the canoe carvings (pp. 146-7), many of which have come from the Trobriand Islands. Characteristic of these carvings are the perforations which appear within and as·part of the design and the strength of the carved profiles of the longitudinal pieces. As a motif the highly conventionalized "frigate bird" is most commonly used, but it is often combined with snake forms and always with a number of curvilinear geometric elements. A rhythmic sequence of interrelated motifs is often used to replace bilaterally symmetrical composition, and to achieve perfect balance. In the composition of their design elements and in the flowing rhythm of their free curves, these carvings bear a close resemblance to the *kai-diba* dance shields. They frequently surpass them, however, in the richness of their designs.

Sculpture in the Trobriands was done by experts, who were technically trained and knew the proper magic with which to accompany their carving. There was a special magic for every activity—canoe building, gardening, rainmaking or curing the sick. A carving could not succeed without the proper incantations, involving formulae and ceremonies in which ancestor and spirit names were frequently mentioned. Magic pacified the wood spirits and acted through the carver's tools as a necessary collaborator in his task. Proper instructions were often handed down from father to son, but could also be purchased. A uniformly high quality of craftsmanship was passed on together with this practice and belief.

The art of the Massim Area has great rich-

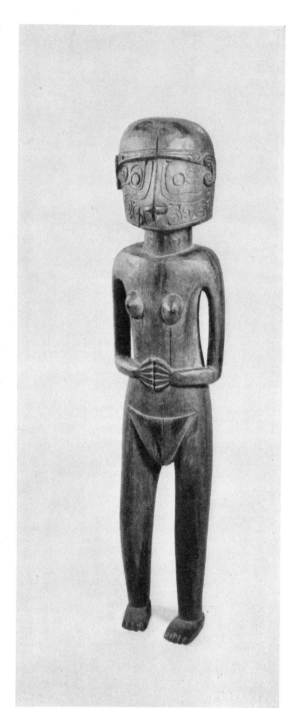

Standing female figure from the Trobriand Islands, Massim area, New Guinea. 16″ high. Collection Peabody Museum of Salem, Salem, Mass. (24629)

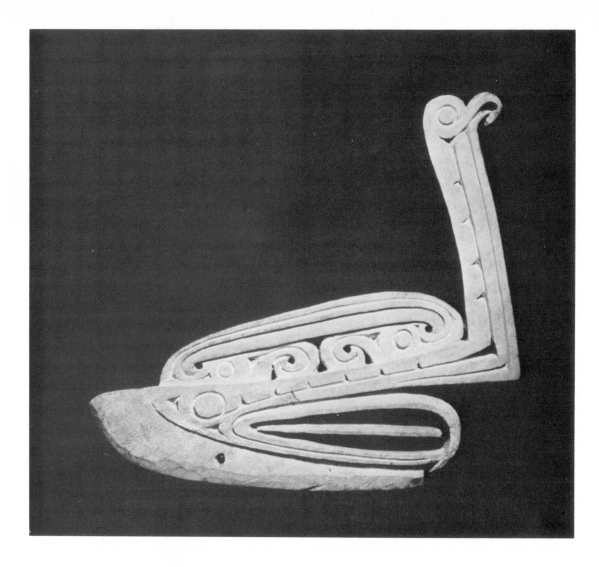

Carved prow ornament from Panite Island, Louisiade Archipelago, Massim area, New Guinea. 14″ long. Collection Buffalo Museum of Science, Buffalo. (C-11029)

ness, elegance and refinement. Surface carving is important but each object was carefully and precisely shaped to receive the decoration. It is an art of curves, free, interlocking, intricate and rhythmic, which give the surface movement and richness. Even the comparatively few figures carved in the round are given a rhythmic movement through flowing lines. The objects and the design units are small but clean cut and show a fine sense of proportion. In spite of their close association with magic practices, Massim carvings have none of the emotional qualities of the work from other sections of New Guinea. It may be that magic lost its haunting spell when it became a system in the hands of this orderly people.

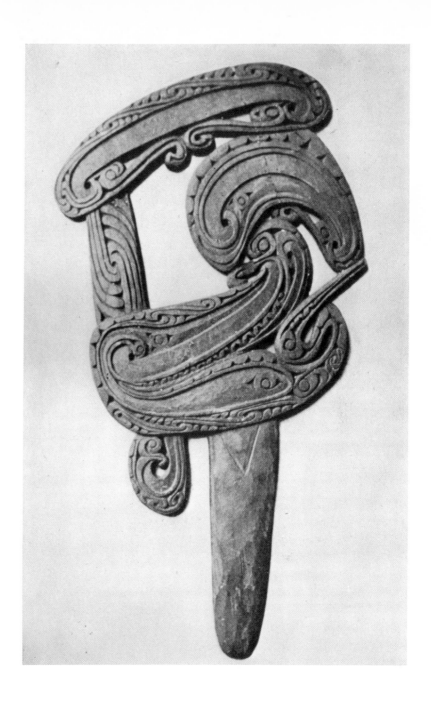

Carved canoe prow ornament from the Trobriand Islands, Massim area, New Guinea. 19″ high. Collection Chicago Natural History Museum, Chicago. (98243)

Melanesia: The Massim Area, New Guinea

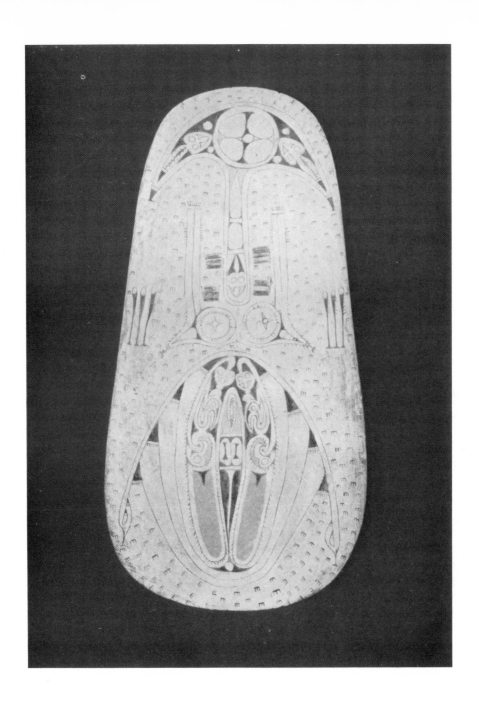

Painted shield from the Trobriand Islands, New Guinea. 31″ high. Collection Buffalo Museum of Science, Buffalo. (C-8163)

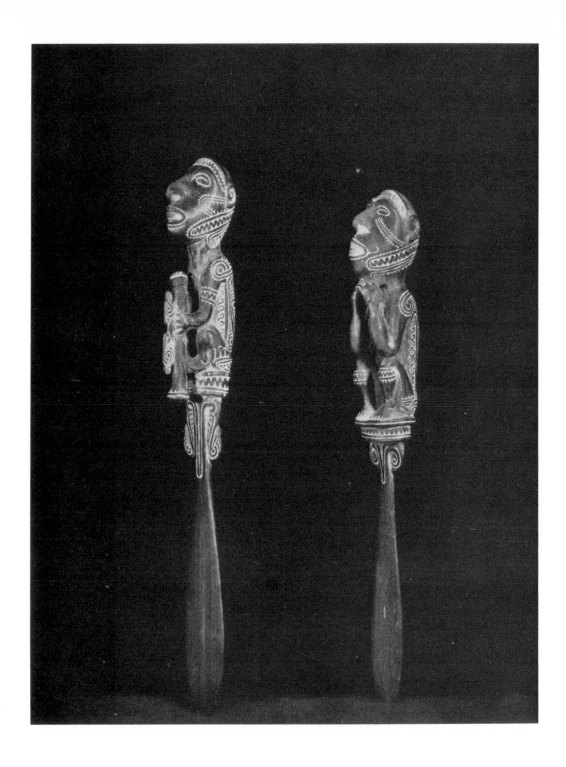

Lime spatulae from the Massim area, New Guinea. 15¾″ and 16¾″ long. Collection Buffalo Museum of Science, Buffalo. (C-8335 and C-8337)

Melanesia: The Massim Area, New Guinea

NEW BRITAIN

New ireland

Gazelle peninsula

New britain

New Britain is a large island, three hundred and seventy miles long and more than ninety miles across at the widest point. It was named by Carteret in 1767.

A strait about fifty miles wide separates it from New Guinea to the southwest. It is very irregularly shaped and the northern portion, known as the Gazelle Peninsula, where Rabaul is situated, is a center of the greatest volcanic activity in the Pacific. For a time it was a German possession and known as New Pomerania, but it is now a part of Australian mandated New Guinea. The Gazelle Peninsula and portions of the coast are the only regions which are fully known; the mountainous interior having been at best but imperfectly explored.

The people of New Britain are mostly Melanesians, but in the southwest, Papuan intermixture is evident while in the interior of the Gazelle Peninsula and to the southeast there are tribes who speak non-Melanesian languages. Two of these tribes, the Sulka and the Baining, have produced Oceania's most fantastic masks.

The Baining are a loosely organized, seminomadic people who live in small villages most of the time. They are crude agriculturists with a generally meager culture. They have no men's clubhouses and apparently no secret societies, yet they use masks in at least two ceremonies, one of which may be mainly social in character, while the other, associated with the cult of the dead, has religious significance. The culture of the Sulka is more clearly of a Melanesian type. Their masks seem to be made for use by a secret society which exerted great power over the tribe through sanctions and violence. A similar society using masks existed among other tribes of the Gazelle Peninsula.

One of the most interesting features of the culture of this part of New Britain was the development of a monetary system based on shells. Shell money was used in various regions of Melanesia, and ordinarily consisted of large cut shell rings or of small shell beads threaded on fiber string. In some areas the latter type were, upon certain occasions, worn as necklaces, to enhance prestige. In northern New Britain the small shapely nassa shells were strung tightly on strips of rattan. A length of about six feet, containing something over three hundred shells, constituted the chief unit of value, and strips were cut into fractions of this length or spliced together according to need. Nassa shells were also strung on thin strings of rattan tied in concentric rows to form a semicircular breast ornament of great elegance.

The material culture of the Baining was poor and the bark-cloth masks were the only elaborate objects made by the tribe. These masks, however, often show great imagination and feeling for form (p. 155). Some had tall cylindrical shapes and others were conical, hat-like forms surmounted by a thin bamboo pole which was often twelve feet high or more. The finest of the masks are the large animal-like heads. They have a wide projecting forehead and a large, open, snout-like mouth, said to represent that of a crocodile, out of which pro-

trudes a tongue-like form. Their surface is often elaborately painted. Concentric circles form huge eyes. A crescent-shaped design is often painted on the forehead and is connected with the narrow straight nose below, while a geometric pattern of angular elements is painted on the "tongue." Sometimes the large eyes are slightly depressed and the nose projects as a ridge. The designs are usually painted in white, tan, maroon and black. Several features of these masks recall those of the Papuan Gulf of New Guinea.

The meaning of these masks and the significance of the ceremonies in which they appeared are not known. They were used in nocturnal snake dances held in jungle clearings in celebration of such events as the birth of a child or the completion of a new house. The masks were kept in a sacred house connected by a path with the dance ground. After preliminary dancing and singing in which the women participated, the masked dancers suddenly emerged and rushed down the path from the sacred house. Besides the masks, they wore a projecting framework from which hung a cloth made of leaves and bark cut into different geometric patterns and sewn together. A long trumpet was often attached to the mouths of the masks and the dancers always carried snakes. The appearance of these forms—the climax of the ceremonies—when seen in the unstable light of fires against the black jungle background, must have been truly fantastic.

These dances were of great social importance since they were one of the few unifying elements in the life of the loosely organized groups within the tribe. They followed the pattern found in many regions of Melanesia—the dramatic building up of an intense expectancy which reached a climax with the spectacular emergence of the masked figures. Like all barkcloth masks they are weird and ghostlike.

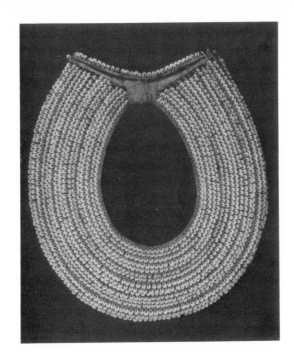

Nassa-shell necklace from New Britain. Collection Buffalo Museum of Science, Buffalo. (C 10782)

Totally unlike the Baining masks in design and material, the Sulka masks have a wide variety of extremely bizarre shapes (pp. 152 and 153). They are almost entirely covered with narrow strips of pith which is secured from a vine or reed. The strips are sewn in place with fiber in such a way that they often resemble basketry. These masks are usually painted in bright green and yellow on a bright pinkish-red background. Sometimes they are covered with a bold curvilinear pattern. Sometimes only a single color is used and in still other instances colors are used to differentiate individual parts. Many of these masks consist entirely of geometric forms with no indication of the anatomy of a human head. In others, facial features appear in high relief. This type usually has small round eyes set close to a long straight nose, while the mouth is often not represented.

Sulka masks appear to have been the property of secret societies. Their meaning and pur-

pose may have been like those of the very tall conical masks of the *Duk-Duk* Society of the Gazelle Peninsula, which represented supernatural spirits of the jungle, and were used in severe initiation rites in which the novices were killed if they did not show a proper fortitude in the face of certain ordeals. Here, too, the masked figures appeared suddenly and spectacularly from out of the jungle.

Entirely unrelated in style to the group of fabricated masks is a realistic type that is modeled over human skulls or carved from wood. The large wooden mask from the Chicago Natural History Museum is a masterpiece of this style (p. 158). Firm surface planes define rugged, bold forms which are integrated into a monumental three-dimensional structure. A powerful volume presses against the surfaces

and contributes to the vitality inherent in the forms. In style, the mask seems related both to New Ireland and New Britain objects. The crest-like form on the head, the shaping of the eyes, ears and mouth bear comparison with certain New Ireland style elements, while the emphasis on bony structure, particularly on that of the brows, and the representation of a short, fringed beard suggest a relationship with certain old New Britain wooden masks and with the skull masks from the Gazelle Peninsula. The latter are modeled over the front of a human skull with a paste made from mashed *Parinarium* nuts. Both the New Britain wooden and skull masks were painted with bold angular geometric designs in red, black and white. The meaning and function of these wooden and skull masks are not known.

Small chalk figures, many of them wearing a short beard like that of the monumental mask, were used by the Ingiet secret society of the Gazelle Peninsula, an important magico-religious society. The figures represented ancestor spirits and were housed within a sacred enclosure. The finest of these small carvings have simple but strong sculptural qualities.

The art of New Britain is most dramatically represented by the bizarre fabricated masks. A few important style affinities with the art of New Ireland suggest that certain features in the latter style may be late local developments of an older, more sculptural style which originated in central New Britain and of which the monumental mask is a survivor. In comparison with the more linear style of New Ireland, that of New Britain is fundamentally sculptural.

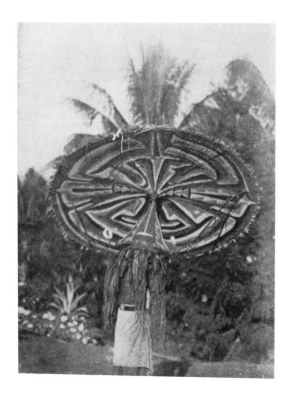

Sulka mask from New Britain. Photo courtesy Chicago Natural History Museum, Chicago.

Opposite: Dance mask made of a palm wood frame covered with pith, from the Sulka tribe of the Gazelle Peninsula, New Britain. 40″ high. Collection Chicago Natural History Museum, Chicago. (138.890)

Melanesia: New Britain

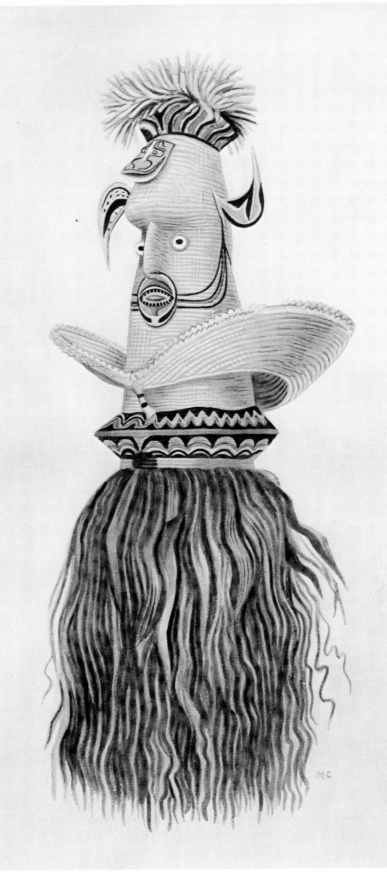

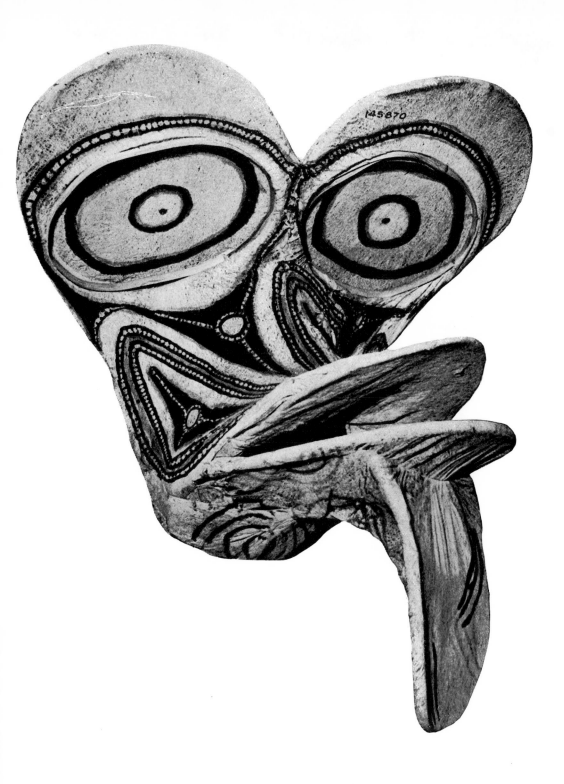

Mask made of bark-cloth by the Baining tribe from the Gazelle Peninsula, New Britain. 18″ high. Collection Chicago Natural History Museum, Chicago. (145.870)

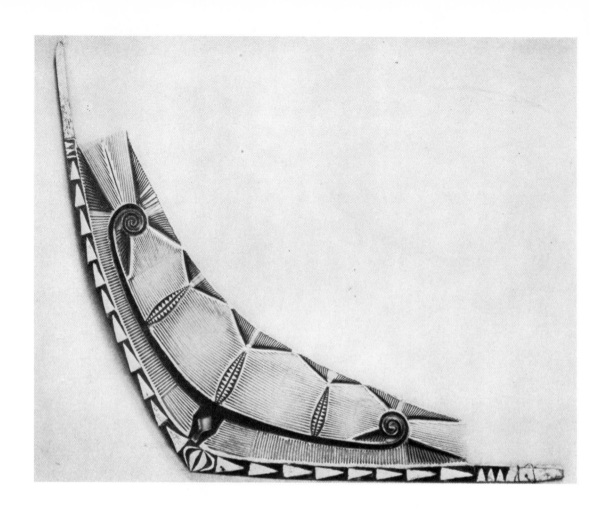

Carved and painted canoe prow ornament from the Gazelle Peninsula, New Britain. 94″ long. Collection Chicago Natural History Museum, Chicago. (138.895-2)

Melanesia: New Britain

Mask modeled on skull, from New Britain. 9½″ high. Collection Peabody Museum, Harvard University, Cambridge. (47343)

Melanesia: New Britain

157

Mask in the shape of a large wooden head from Central New Britain. 22″ high. Collection Chicago Natural History Museum, Chicago. (137.685)

A wealth of fantastic and elaborate carvings make New Ireland one of the most interesting sources of Oceanic art. Single figures, superimposed figures forming high poles, a vast variety of masks, and long planks carved into frieze-like reliefs were produced in great numbers. They are all richly painted in red, yellow, white, blue and black and decorated with various materials such as shell, bark-cloth and fiber and have a remarkable and often astounding degree of intricacy. Many of the forms, including the human figure, birds, pigs and snakes, appear in their entirety or in part, singly or in combination, always surrounded by complicated geometric shapes. Typical of New Ireland art was the extensive use of the opercula (valves) of marine snails for eyes.

Each object was unique in composition or in the elements of its composition and almost every one had its own particular meaning. For this was a mortuary art devoted to the commemoration of specific physical and mythological ancestors. The content of dances and ceremonies, and the basic forms of the objects used in them were rigidly prescribed by tradition, but enough freedom was given the artist in matters of composition and detail to allow for considerable variation.

New Ireland, together with New Britain, forms part of the Bismarck Archipelago. Its inhabitants are mainly Melanesians. The island is about two hundred miles long by twenty miles wide. It was discovered in 1616 by Lemaire and Schouten and was named by Carteret in 1767. When the Germans took possession of it they renamed it New Mecklenburg. The old material culture has been almost completely swept away and only a few objects are now made for sale to Europeans. The island is very similar to the majority of the islands of Melanesia: a high mountainous interior covered with a dense jungle, and a surrounding coastal plain. Although mainly agriculturists, the coastal peoples were also fishermen.

Ancestor rites were the dominating feature of New Ireland culture. Ceremonies or cycles of ceremonies were staged in commemoration of dead ancestors, all of whom, legendary as well as recently dead, were represented or symbolized by a great number of extremely elaborate carvings which were made for use in these rites. Dancing, feasting and the exhibition of the carved and painted objects were the main

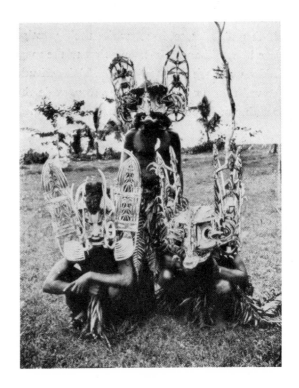

Masked men from New Ireland. Photo courtesy Chicago Natural History Museum, Chicago.

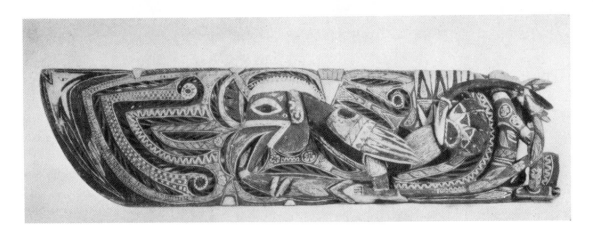

Carved memorial board from New Ireland. 41″ long. Collection Peabody Museum of Salem, Salem, Mass. (E 19492)

features of the most spectacular of New Ireland ceremonies, the *Malagan,* which consisted of memorial festivals held from one to five years after the death of a person. Tradition decreed so strongly that these be performed that the survivors of the deceased would lose caste if they did not conform, while their prestige would be enhanced in proportion to the magnificence of the ceremonies held. This attitude served as a powerful incentive to provide the maximum of food for the feasts and the richest

possible carvings. These carvings were called *Malagan* like the ceremonies in which they were used. The greater proportion of New Ireland art was made for use in the *Malagan.*

Clan organization was basic to the social system of New Ireland and had great influence on its ceremonial art, since each clan had the right to use particular designs in its carvings. The preparation for and the supervision of the performance of the *Malagan* ceremonies were always in the hands of the influential elders of

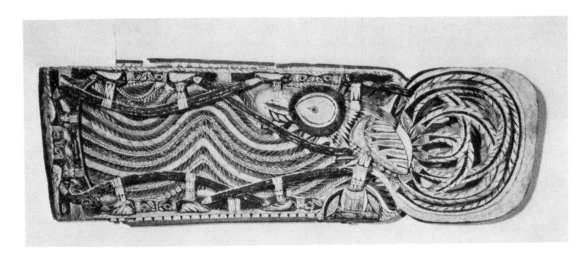

Carved memorial board from New Ireland. 82″ long. Collection Newark Museum, Newark, N. J. (24.707)

Melanesia: New Ireland

the clan. They knew the symbols and forms prescribed to represent clan totems and the exploits of their legendary and recent dead. They also knew the secret rites which had to accompany the making of these objects. These men were, in fact, through their knowledge, the guardians of the future material and spiritual well-being of a clan, since this depended on the aid of the ancestral spirits honored by these ceremonies.

When the influential men of a clan wished to stage a *Malagan* ceremony, one or more sheds were built within a high-walled enclosure, usually adjacent to the cremation or burial ground of each clan. Here, it was believed, the power of the spirits of the clan dead was strongest. Expert carvers were employed who worked in secret within the enclosure. It often took the better part of a year to make the objects needed in great ceremonies. Paid well for their services, the artists worked under the direction of the clan elders who saw that the appropriate symbols and forms were used in their proper context. In the meantime a great quantity of food was being collected—taro, bananas, pigs—for certain parts of these ceremonies were communal and provision had to be made for much feasting. At last everything was in readiness. The frieze-like reliefs, single figures and some of the masks were arranged against the back wall of the enclosure in an open shed and the huge "poles" were set up nearby. Finally, the festival began when the front wall of the enclosure was dramatically pulled down, "unveiling" the carvings to the assembled crowd. There were shouts of amazement, recognition and delight. For two to four days, traditional processions and dances were performed in which the smaller carvings and masks were carried or worn. Between ceremonies, feasts were held. Although the *Malagan* was a memorial festival in honor of the dead, it was not mourn-

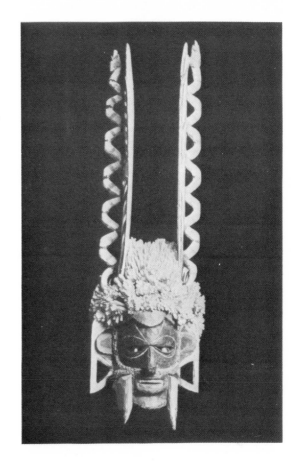

Mask from New Ireland. 32½″ high. Collection Museum of Art, Rhode Island School of Design, Providence. (43.184)

ful—it was rather an occasion for the expression of joy. With the exception of a few wooden masks and one type of frieze, the carvings were discarded after the ceremonies and allowed to rot away.

Large carved masks with perforated side-pieces (p. 164) were used in a ceremony *(dzafun-fun)* associated with the *Malagan* cycle. In these rites children were secluded within the clan enclosure for the length of time during which the food was assembled and paraphernalia prepared. At the appointed time big figures *(murua)* wearing masks and girdles of colored leaves emerged from the enclosure, each with a child in its arms. Each figure represented a

particular ancestor spirit who became a guardian of the child it carried. A dance and a feast concluded the ceremony. As a result of these rites, children were made wards of specific ancestor spirits on whose aid and protection their future welfare depended.

Crested helmet-like masks were worn in other dances performed as part of the *Malagan* cycle. The crest, built up of yellow, blue, red and white fiber over a wooden frame, represented in monumental proportions the old method of wearing the hair during the mourning period when a crest from front to back was formed by shaving the head on each side. It is said that the dance in which they were worn represented the courting of the women by the men of the tribe. While the dance itself may have had a fertility theme, it is likely that the masks depicted specific clan ancestors. Other New Ireland masks were made of painted bark-cloth stretched over a wooden frame with carved parts such as eyes, nose or mouth, attached.

Most New Ireland sculpture has parts that are carved free of the background and others that project from a central core, thus producing an open-work effect characteristic of the art of the region. In the tall poles an open framework surrounds a central pillar built of a succession of strongly sculptured forms. Within the basic shape of the log, this framework defines and restricts the space around the central form elements, but its carved and painted surface designs often obscure the subtle relationship between the core and the openwork shell of the column. Many of the masks have attached parts such as elaborate side-pieces and fantastic nose constructions. The surfaces of these, too, are covered with painted designs.

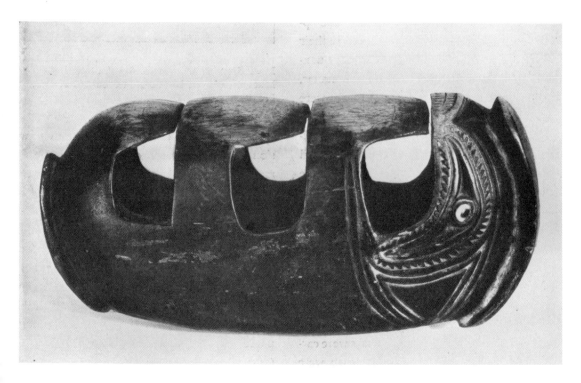

Musical instrument from New Ireland. 19½" long. Collection American Museum of Natural History, New York. (80.0-255)

Melanesia: New Ireland

With few exceptions, the art of New Ireland is composed of two conflicting elements: the clearly organized, although frequently complex, carved parts and the profuse, elaborate surface designs. This combination gives the objects an appearance of nervous movement and tension. Although distinctive in style, the openwork and intricate character of the overall pattern of the objects suggests Indonesian affinities, while the face types, dominated by enormous looped noses, compare with certain carvings from New Caledonia, the New Hebrides and the Sepik River area of New Guinea.

New Ireland *Malagans* commemorated mythological ancestors such as the sun and the moon, long-dead relatives and the recent dead who were the immediate reason for the ceremony. Innumerable sun and moon symbols occur on all of the objects. The moon is symbolized by a boar's head or tusks, by snake, fish and bird forms, by clam shells and by white striations about the eyes of a figure; the sun, by the head of a bird and by rayed disks, while a representation of the circular breast ornament *(kapkap)* was in some areas a symbol of the sun and in others of the moon. Carved human forms represented dead relatives, but these were frequently combined with other, often fantastic, forms and symbols in order to refer to a legend or event associated with the ancestor (p. 168). Other elements in the designs are clan totems and badges and a number of design fill-ins, which seem to have been used for no other purpose than to balance and enrich a pattern. The desire to include in one sculpture representations of physical and mythological ancestors and symbols of their deeds resulted often in a conspicuous elaboration.

Related in style to the *Malagan* carvings, another type of ancestor figure *(uli)* was made in central New Ireland (p. 165). *Ulis* are powerfully proportioned, bearded, phallic figures with large protruding breasts that convey a feeling of strong sexual aggression. They are carved in the round and have large heads with ferocious expressions. Some have smaller figures attached to their bodies which illustrate a story or legend connected with the ancestor. *Ulis* were used in extremely sacred rites in which women could not participate. One series of such ceremonies lasted sometimes over a year. The figures were never discarded, but were carefully preserved for future use.

In the south of New Ireland, small chalk figures were carved at the death of a person, set up in a special house for a certain time and then destroyed. Although women were permitted to stand in front of the house and mourn the deceased, they were not allowed to see the figures. Very simple but impressive, even monumental in style, they are similar to figures found in eastern New Britain. There is an underlying resemblance between their forms and some of those found in the more elaborate carvings to the north, suggesting that the latter style may have started from such simple but fundamentally strong sculptural beginnings.

Some of the finest breast ornaments of Melanesia come from this island. These are called *kapkaps* in pidgin English. A *kapkap* consists of a disk of tridacna (giant sea clam) shell to which is attached a wheel-shaped, perforated tortoise-shell ornament of extreme delicacy. That these breast ornaments may have had more than mere ornamental significance is obvious from their use in carvings to symbolize the sun or the moon.

In addition to its religious significance, New Ireland art served an important social function by integrating the various elements of a loosely organized society. It is characterized by multiplicity of detail, openness of design and rich use of color, and represents the apex of formal virtuosity in Oceania.

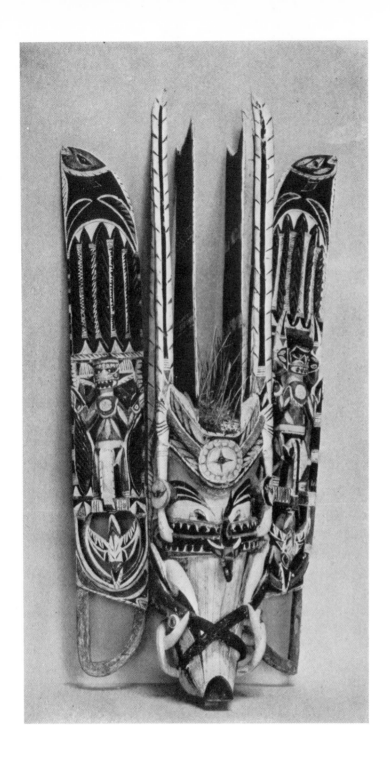

Large mask in the shape of a pig's head, from New Ireland. 60″ high. Collection Chicago Natural History Museum, Chicago. (138.855)

Opposite: Carved ancestral figure (*uli*) from New Ireland. 43″ high. Collection Chicago Natural History Museum, Chicago. (148.093)

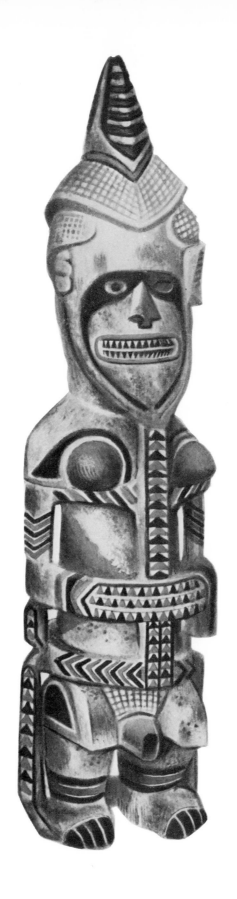

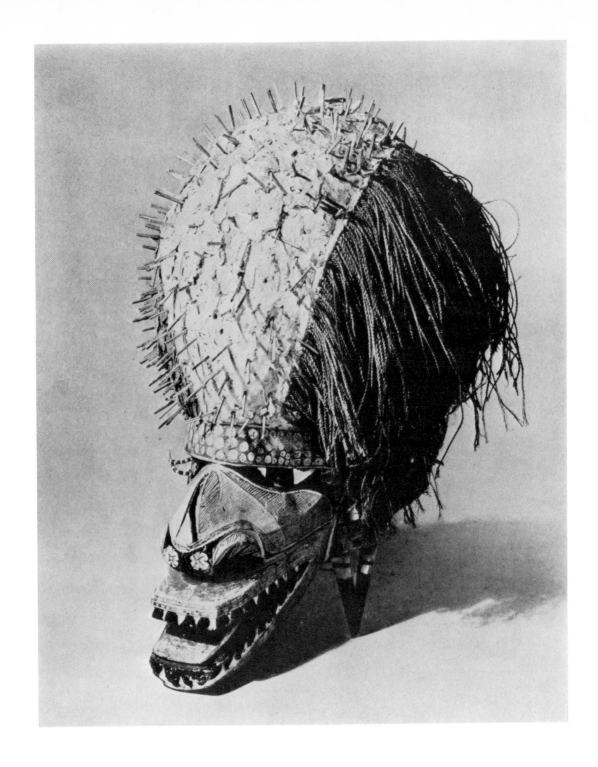

Mask from New Ireland. 10″ high. Collection American Museum of Natural History, New York. (S/2222)

Melanesia: New Ireland 167

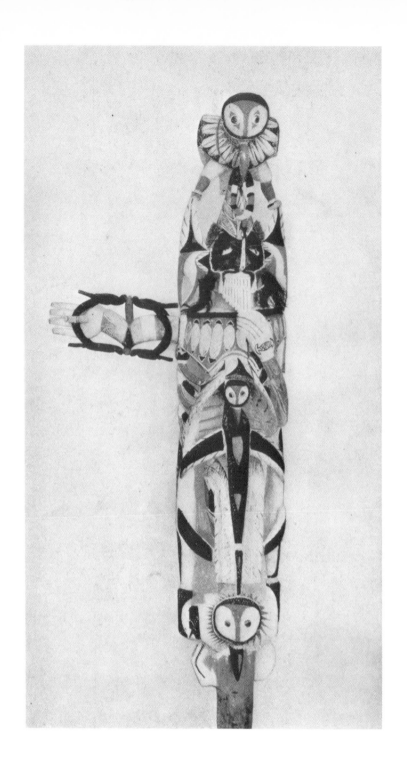

Ancestral figure from New Ireland. 73″ high. Collection Chicago Natural History Museum, Chicago.
(138.801)

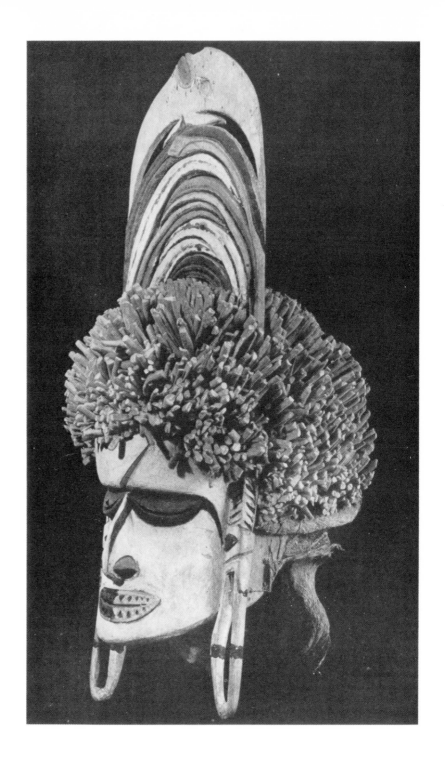

Mask from New Ireland. 20″ high. Collection Peabody Museum, Harvard University, Cambridge. (47844)

Melanesia: New Ireland 169

THE ADMIRALTY ISLANDS

Great admiralty island

Pak

Lou

Baluan

Roughly two hundred miles west-northwest of New Ireland and a like distance north-north-east of the Sepik River area of New Guinea lie the Admiralty Islands. They too are former German possessions now mandated to Australia. One large mountainous island, the Great Admiralty, and a number of small outlying islands, surrounded by reefs and lagoons, make up the group. As in most of Melanesia, the coastal peoples differ racially and culturally from those of the interior. They are more aggressive and have different customs. This difference is carried to an extreme in the Admiralties where the coastal people, the Manus, are warriors and fishermen and live in large sturdy pile houses in the lagoons, while the islanders, the Usiai, are agriculturists, fearful both of the sea and of the Manus peoples. Between the two are the Matankor who supplement their agriculture with fishing. This division of peoples is purely geographic, however, and within each group there are different and totally unrelated linguistic groups.

A distinctive feature of the archipelago is the complete dependence of these peoples upon each other for the most essential things of life.

The Usiai need the proteins the Manus fish provide; the Manus, the taro (carbohydrates), wood, fiber and betel nut from the Usiai, and the yams and coconuts from the Matankor, while both the Usiai and the Matankor depend upon the Manus, who are expert canoe-men, as carriers. This dependence has produced a system of trade based mainly on barter, although there exists an established currency of dogs' teeth and shell money, the latter very much like that of New Britain.

The arts of the Admiralties were greatly affected by trade for man-made objects were traded as extensively as food products. Carvings needed for ceremonial use or desired as decorations could be had from certain islands or groups of people in exchange for objects which other groups needed but did not make. Specialization became possible because trading assured the different areas of needed objects which they themselves lacked. This interchange is perhaps to a large extent responsible for unifying the artistic style of this archipelago. Of the three peoples in the Admiralties, the Matankor appear to have produced the greatest number of carvings while the Manus, who pro-

170

duced nothing, owned more of these fine pieces due to their key position as fishermen, carriers, and traders.

A wide variety in medium, size, technique and scale is found in the art of the Admiralties. Wood is by far the most commonly used material, but shell is also extensively found and a paste of mashed Parinarium nuts is employed as a surfacing for some objects. Human figures, dogs and crocodiles are represented constantly in these carvings, while with the exception of *kapkaps* geometric motifs are limited to the zigzag—and derivatives from it—and to very fine spirals. Only three colors are used—red, white and black. Characteristic of Admiralty Islands carved figures is the all-over painting with red ochre, with black and white used only for detail. Objects unique for this area include elaborately carved spears and daggers tipped with large flakes of obsidian; war charms consisting of a carved wooden head and long frigate bird feathers; richly carved beds, the legs, sidepieces and top being made separately and mortised together; and magnificently carved large wooden bowls which often measure over five feet in diameter and have elaborately pierced handles mortised in place. Even the best examples of this art show a rugged technique and, with the exception of certain details, little interest in smoothness of finish or refinement of detail.

Wood-carving from the Admiralties includes non-representative geometric work and human or animal figures. Both are used decoratively and appear often on the same objects. Human and crocodile forms are carved in the round in large scale and as small decorative motifs on lime spatulae, daggers and spears, house posts and on the posts of carved beds. The large figures in the round average from four to eight feet in size and the small ones, from four inches to over two feet. The geometric type is found

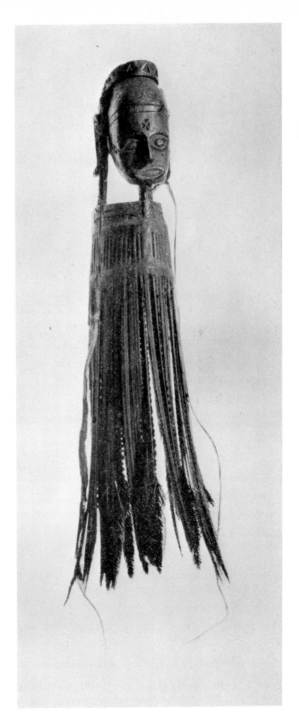

War charm decorated with frigate bird feathers, from the Admiralty Islands. 24" high. Collection American Museum of Natural History, New York. (80.0-5198)

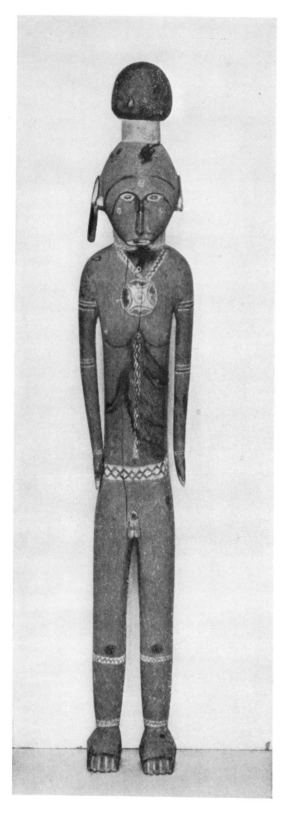

both in relief and in the round. The most interesting examples of the latter appear in the free spiral handles for the wooden food bowls, and in the carving of bed posts. Geometric relief designs are found on very many objects. They are often used simply to enrich a surface, but just as often to define the structural or formal parts of an object, as for instance the rim of a bowl, the hairline, clavical structure and joints of human figures, or the head, teeth and scales on crocodile forms. Designs are arranged within parallel lines and are carved in low relief. One of the most distinctive features of the decorative art of these islands is the almost constant appearance of a cross motif. This is produced by carving in relief the crossing diagonals within a square or rectangle so that the interstices are in intaglio. The segments of this motif are the same as those of the constantly used zigzag pattern. With but few exceptions the geometric relief carving is rectilinear.

The red-colored figures in the round so characteristic of the Admiralties display clearly recognizable stylistic peculiarities despite variations in proportion, in amount of surface decoration and in technique. A distinguishing feature of many figures is a very high head-dress ending in a rounded topknot which is said to represent the headdress worn by the Matankor on the island of Rambutchon from which many of these figures come. It is somewhat reminiscent of the headdress worn with the large New Caledonian masks. Other types of elongated head-gear are also found in these carvings. The face tends to be long and narrow and is often framed at the top by a decorative

Large male figure from the Great Admiralty Island. 60″ high. Collection Chicago Natural History Museum, Chicago. (133.788)

Melanesia: The Admiralty Islands

band of zigzag motifs carved in low relief. Eyes are moderately small pointed ovals, the nose flat and straight with no indication of nostrils, and the mouth a long protruding oval, often set in a pouting expression, with clearly indicated lips and teeth. Large projecting ears with pendulous, pierced ear lobes flank the head. Often lifelike in their proportions, the figures are static but not rigid in pose since the knees are slightly bent. The parts of the body are well related and represented by simplified shapes, some of which show a slight modeling of bony and muscular parts. They are always compact in design. There appear to be two traditions in Admiralty Islands figure carving: one of them emphasizes angular, four-sided shapes and a facial expression of fixed aggressiveness; the other stresses rounded, cylindrical shapes and a calm, almost introspective expression. Set up in houses, the large red figures were memorials to the dead and, together with skulls, were used in ancestor ceremonies. It has been said, however, that some of them were regarded purely as objects of art. Large figures were also often carved on top of ladders made by lateral notches in a heavy plank.

The finest small figures in the round are on the handles of the spatulae or lime sticks used in betel nut chewing. Especially the examples from Balowan Island which are sometimes two feet long have an elegance of shape and balance equaling those of the Massim area of New Guinea. In many cases, these small human figures are sculpturally as well integrated as the best of the large figures and have a slenderness of proportion and a compactness of design that

Dagger with obsidian blade, from the Admiralty Islands. 12¼" long. Collection Buffalo Museum of Science, Buffalo. (C-10763)

Melanesia: The Admiralty Islands

173

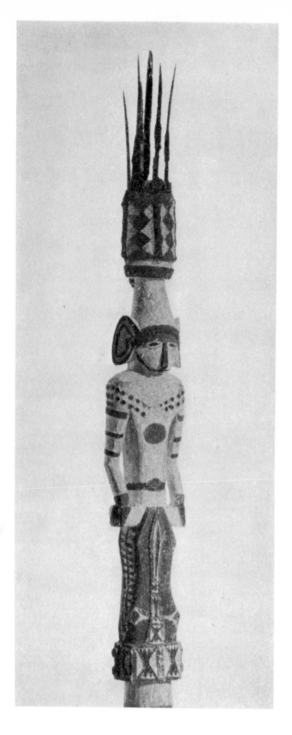

agree perfectly with the shape of the blade. Crocodiles, human figures combined with crocodiles, and some geometric designs are also used on spatula handles and within every type there is a considerable variety.

Among other small objects of high esthetic quality are the carved heads on war or dance charms. These were kept within a family as heirlooms and held in high esteem since they gave a man both courage and power in battle. Many of them were made on the island of Pak. The carved beds from the same island are the most elaborately decorated of all objects found in the Admiralty Islands. They were used both as beds and as benches. The legs are almost always heavily proportioned and designed with well-marked angular rhythms. An outstanding characteristic of these beds is the complete integration of geometric pattern and representative sculpture into one harmonious unit. This is also true of the carving on spears and daggers. An interesting feature of the decoration of the spears is the frequent use of pairs of standing figures or of heads placed back to back. Sometimes also human figures and crocodiles are combined in a composition having narrative implications. Like the beds, the spears and daggers are profusely painted with light red ochre and white and black, while the war charms and spatulae are painted black.

Admiralty Islands figure carving shows great plastic feeling for the organization of clearly defined forms. In many instances the tool marks give the surfaces of these carvings a very interesting texture. Surface decoration, although often used profusely, does not conflict with form. It is frequently limited to details such as arm bands or anklets or emphasizes the basic structure of the sculpture. Carved in relief, it has a plastic rather than a linear quality. A general resemblance to the work of certain islands of the Solomons is quite evident here.

Dagger with sting-ray spines, collected on St. Matthias Island. 22¾″ high. Collection American Museum of Natural History, New York. (80.0-244)

Melanesia: The Admiralty Islands

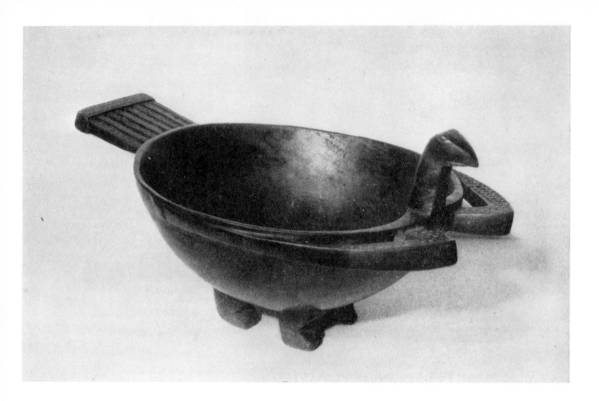

Bowl in the shape of a bird, from the Admiralty Islands. 18″ long. Collection Peabody Museum, Harvard University, Cambridge. (D-1245)

A sculptor's feeling for three-dimensional form is also apparent in the wooden bowls that measure up to six feet in diameter. Two types of bowls were made, those carved from one block of wood, often in the shape of a bird, crocodile or hybrid animal, and those with attached handles. They all rest on bases which frequently consist of four heavy, short round legs. The bowls are usually circular in plan and shaped like a section of a sphere. Composed of spiral, zigzag and cross motifs, pierced or carved in the round, the handles often seem to be ornamental adjuncts to the bowl proper. This is true even of the bird forms. In this respect they differ from the Solomon Islands bowls where the entire design is unified. These bowls were frequently made as gifts at marriage feasts. Large coconut oil jars show a comparable feel-

ing for fine shapes. These stood up to four feet high and were made of coiled basketwork with the inner and outer surface covered with crushed Parinarium nut paste which made them watertight. Some of these jars were decorated with geometric designs, painted in red, white and black.

The most delicate objects made in the archipelago are the fine shell breast ornaments *(kapkaps)* and the aprons made of woven strings of shell money and worn by brides as part of their dowry. These aprons often have great richness of pattern and show fine craftsmanship.

The art of the Admiralties has great distinction and a well-defined style. Perhaps its outstanding characteristic is a formal dignity that recalls, particularly in the case of the great bowls, some of the early Mediterranean styles.

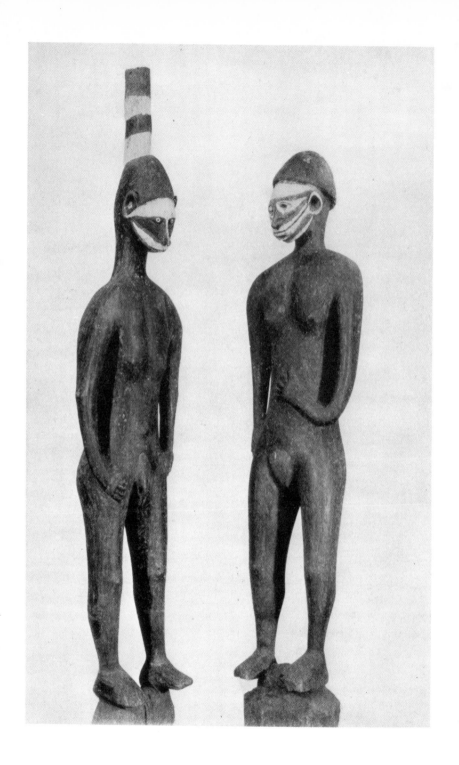

Carved male and female figures from the Admiralty Islands. 78″ and 72″ high. Collection Peabody Museum, Harvard University, Cambridge. (D 1255 and D 1256)

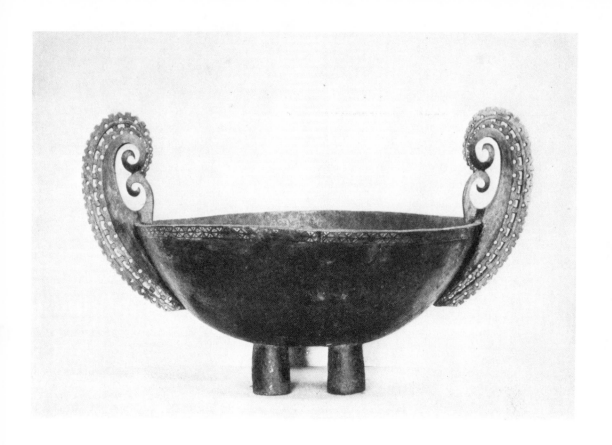

Large bowl from the Admiralty Islands. 54″ diam. Collection Chicago Natural History Museum, Chicago. (133.543)

Melanesia: The Admiralty Islands 177

THE SOLOMON ISLANDS

In 1567 the Spanish navigator Alvaro de Mendana discovered a sizable island in the South Pacific which he named Ysabel, after his wife. When he returned to Peru, his point of departure, he gave glowing accounts of this island and in an attempt to stimulate colonization, called it "Solomon Island" to suggest its wealth. But attempts to find the island again failed and it was exactly two hundred years later that the group was rediscovered.

The Solomon Islands consist of ten large and many small islands that lie in two nearly parallel rows. They are over nine hundred miles long and extend almost exactly in the same northwest-southeast direction as New Ireland, from which they are separated by less than one hundred and fifty miles of open sea. The objects most important esthetically come from the following islands: Buka, Bougainville, Treasury, Choiseul, Vella Lavella, New Georgia, Guadalcanal, Ulawa and San Cristoval. Between 1893 and 1900 a British protectorate was established over all of these islands except Buka and Bougainville, which, once German, were mandated to Australia in 1920.

Since the Solomon Islands are the peaks of submerged mountain ranges, low coastal plains lead up to high mountainous interiors. The natives are warlike Melanesians who succeeded for a long time in repelling European intrusion. But now, although native cultures have survived in the still comparatively unknown rugged interior, they have been greatly altered along the coast of many of the islands by contact with traders, missionaries, and European government administrators. For the most part the traditional way of life has been so disrupted that objects of native art are no longer made.

Culturally, the Solomons fall into three major groups—western, central, and eastern. Prolonged initiation rites, which marked a boy's attainment of manhood, were common in the western islands. These were conducted partly in secret in the depths of the jungle and partly communally in the villages, and were presided over by monstrous supernatural spirits. In some of the central islands, head hunting was of great importance. Evidences of totemism remain in the eastern islands where a close economic dependence upon the sea gave rise to a belief in powerful sea spirits. Each of these cultural characteristics called for the making of specific objects, and despite certain differences in form and function, a similarity of design elements and a kindred feeling for form and materials give this art a degree of homogeneity.

Common characteristics of Solomon Islands art are the general use of shell inlay, a predominance of borders in both shell and paint, the great importance given to the human head, the prevalence of seated or squatting figures and the frequent use of black as an all-over

SOLOMON ISLANDS

Buka
Bougainville
Treasury island
Choiseul
Vella lavella
New georgia
Santa Isabel
Malaita
Ulawa
Guadalcanal
San Cristoval
Rennell

coloring. Masks are conspicuously absent. The only object resembling a mask is the huge, half-length spirit figure used in a phase of the initiation ceremonies in the western islands. This is sometimes twelve feet high, very crudely carved, and hollow, fitting over the entire upper part of the body of the man who wears it. There is a great deal of decorative carving on clubs, paddles, canoes, slit-gongs, spears and small betel nut mortars. Many shell ornaments for breast, ear and forehead were also made throughout the Solomons.

Large figure carvings seem to have been comparatively uncommon, but life-size female figures of natural proportions were made for the female initiation rites on a small island off the north coast of Bougainville. They were carved of soft wood, stained and polished black, with details such as the breast ornament, eyes and hairline incised and picked out in white. These carvings, now rare, rank with the finest of Oceanic sculptures. Animated in pose, with legs and arms flexed, the figure is composed of simple shapes well integrated in an organic plastic design. Other large but rather dull naturalistic figures were used on Guadalcanal as guardians surrounding a necropolis. Only in the intensity of the facial expression are they comparable to the female figures. In typical examples, the planes of the face, the eyes and the hair line are marked by a wide painted border of white.

At certain phases of the boys' initiation rites on Bougainville, figurines (kasai) measuring about three feet, and carved on a handle, were carried as standards. Painted red, black and white, these are simply carved in rather slender, very natural proportions. The heads frequently have a wide, low cranium and a flat, sharp-chinned face which is found in other Bougainville figure carvings. The meaning and function of these figures are obscure. They probably represented spirits, but were not particularly feared or revered.

Canoe from the central Solomon Islands. Photo courtesy Chicago Natural History Museum, Chicago.

Melanesia: The Solomon Islands

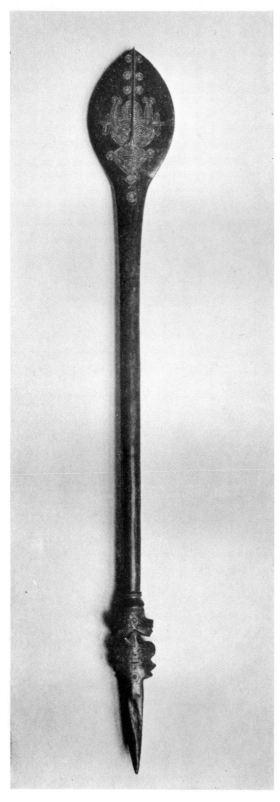

Reported to have had decorative value only, the small figures, two feet high, carved at the top of ceremonial canoe-house posts on Ulawa are among the strongest of Solomon Islands sculptures. With their tight, compact forms clearly defined and articulated, they have a formal sobriety which represents an important sculptural tradition, found also on a few other islands scattered throughout the archipelago. Two head types appear in these figures, a large rectangular and a rounded oval type, the latter having two braids of hair hanging down at either side at the back of the head. The short heavy legs on all of these carvings are bent at the knees in a manner which emphasizes the structural rhythm of the forms and gives them a feeling of vitality rather than an appearance of movement. Similar in style are a group of heads and figures carved on posts from Treasury Island. These have large, bulbous, ball-shaped crania, short faces with straight-cut brows, long aquiline noses and short chins.

A series of finely shaped paddle-clubs from the western, and some spears from the eastern islands are carved in this same tradition. Many of the clubs are surmounted by a small head or two heads placed back to back. Frequently, simple geometric designs composed of zigzag and straight lines picked out with white, decorate the lower part of the club. At the top of the spears two small squatting figures are placed back to back. These are carved in a style similar to that of the canoe-house posts.

The sculptures in this style have a controlled intensity of expression, clarity of modeling, and strong sculptural rhythm. Balance, volume, weight and surface combine to create an effect of force in repose, and there is little to suggest

Carved and engraved paddle from Bougainville, Solomon Islands. 45½″ long. Collection University of Pennsylvania Museum, Philadelphia. (29-58-42)

the terrifying and awesome spirits of the dead. A marked affinity is apparent between carvings in this tradition and certain objects from the Admiralty Islands.

In the central islands, religious concepts gave rise to a group of powerful, dramatic carvings. Head-hunting raids against the nearby islands were carried out in large, decorated canoes, which sometimes measured more than ninety feet and accommodated forty men. The finest of these *(tomako)* were made on New Georgia. Solomon Islands canoes in general were of two types, the comparatively small and simple dug-out and the big, often elaborately decorated plank or built-up type *(mon)*, with which no outrigger was used. Common throughout the group, with each island having its own peculiar design and decorative features, the *mon* were made of separately shaped planks lashed together, the seams calked with a resinous gum. Very high bow and stern posts were peculiar to the canoes used for head hunting in the central islands—those of New Georgian *tomakos* often rising ten or twelve feet. Short, horizontal cross-pieces were lashed to the stem and to these were fastened very large conch-like shells. Near the top and facing the stern was attached a small squat figure with a large head and huge piercing eyes of shell inlay. Near the top of the stern stem two small faces carved in high relief were placed, one facing port and the other starboard. But the most important decoration was a small figure *(musumusu)* with a monstrous head, which was lashed to the bow just above the waterline. It peered intently forward. Thus all sides of the boat were guarded.

The most powerful and expressive carving of the Solomons, the *musumusu* is said to be a protective figure on the lookout for shoals; it seems, however, more likely that it was the incarnation of one of the strong spirits whose co-operation was necessary to insure success in a

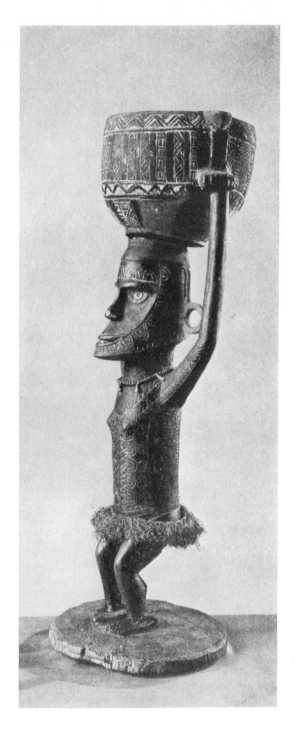

Carved female figure from the Solomon Islands. 24″ high. Collection University of Pennsylvania Museum, Philadelphia. (18221)

Melanesia: The Solomon Islands

181

dangerous quest. Figures of this type average only ten to twelve inches in length and eight to ten inches in height, but their bold shape suggests a tremendous scale. A small, high cranium tops heavy projecting jaws, almost equine in character. Large eyes, a long nose ending in huge, high nostrils, and a wide, partly open mouth, usually showing heavy teeth, give these heads a savage animal character. The jaws, the slightly concave planes of the face, and the eyes are frequently outlined with shell inlay or sometimes with white paint. Below the head, arms project from a short schematized body and directly beneath the powerful jaws the hands clasp another small head. A savage, supernatural power is dramatically expressed.

The quest for heads replaced in the central Solomons the dramatic performances typical of other regions of Melanesia. The acquisition of heads gave individual prestige and, through the securing of the power of the victims which resided in their heads, insured perpetuation of the spiritual and physical well-being of the community. The expedition in itself was a dramatic performance. *Tomakos* set out with streamers of leaves, bright colored flowers and feathers tied to the tall bow and stern stems; feathers, paint, and shell ornaments were worn by the raiding warriors. Upon their successful return, the raiders were welcomed ceremonially and the heads, dangerous with the powerful lurking spirits of the dead, were gratefully received by the tribe.

An intensity and vigor similar to that of the *musumusu* appear in the small mortar figures from New Georgia. This similarity extends

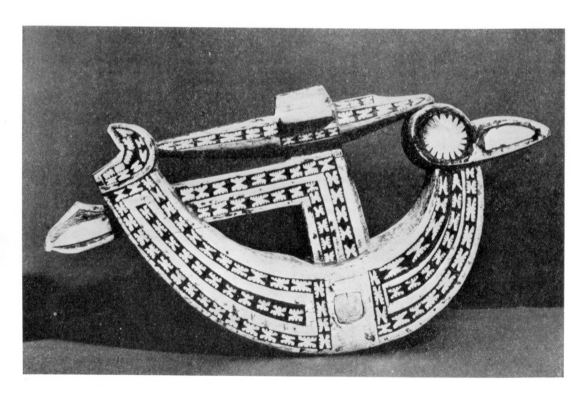

Float in the shape of a frigate bird, inlaid with mother-of-pearl, from the Solomon Islands. 21¼" long. Collection Lieutenant John Burke, U.S.N.R.

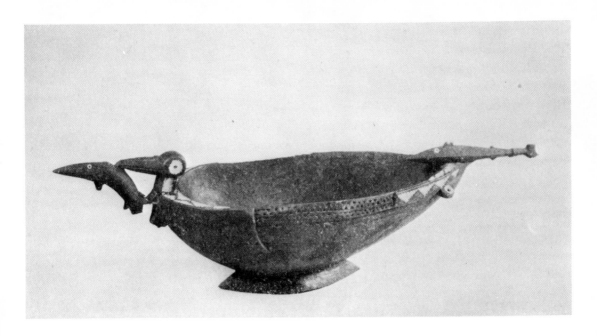

Small bowl in the shape of a bird, from the Solomon Islands. 12″ long. Collection Peabody Museum of Salem, Salem, Mass. (E 12.028)

also to proportions, technical treatment and surface decoration.

Other ceremonial objects from the Solomons include the clubs from the western and the spears from the eastern group, which have been considered previously. To these should be added the paddles from Bougainville and the bird-bowls from San Cristoval. Both surfaces of the paddles are carved in a low relief design called *kokorra* which consists of a squatting figure, knees drawn up, elbows resting on knees, and hands supporting the chin. In this design the legs form the letter M and the arms the letter W. The carving is picked out in red, black and white. This design also appears on slit-gongs, sides of canoes, and on clubs. The bird bowls, reputed to have once had a totemic significance, have considerable variety in size and design. In general, the bowl forms the body of the bird, the handles the head and tail. Richness of shape and a decorative and func-

tional integration of these three parts give the finest of these bowls great beauty. A rich shell inlay was often used as a border design.

Shell work plays a very important role in Solomon Islands art. It is frequently used as inlay in wood carvings and for the making of *kapkaps* and other ornaments. Very fine shell work of another sort is found in Vella Lavella, where the small gabled skull-nuts have the ends filled in with a thick piece of tridacna shell richly carved in a curvilinear, open-work design. That these designs may have had more than decorative significance is suggested by the appearance of schematized bird and human forms. They alone of the work of these islands imply the quality of virtuosity.

Solomon Islands art combines elegance with boldness and intensity. A great variety of local styles exists, but an underlying similarity of shapes, of decorative motifs and of expression give to this art a high degree of homogeneity.

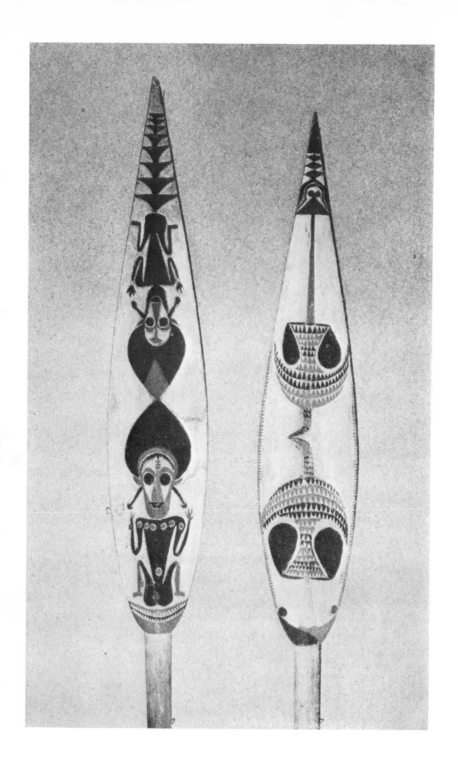

Painted and incised canoe paddles from Buka, Solomon Islands. 81″ and 75″ long. Collection Peabody Museum of Salem, Salem, Mass. (E 19.385 and E 19.383)

Melanesia: The Solomon Islands

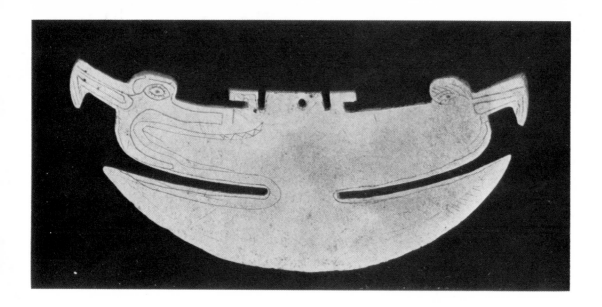

Pendant made of mother-of-pearl, from the Solomon Islands. 3⅜" high. Collection Buffalo Museum of Science, Buffalo. (C-10845)

Pendant made of shell from the Solomon Islands. 2" diam. Collection Buffalo Museum of Science, Buffalo. (C-11736)

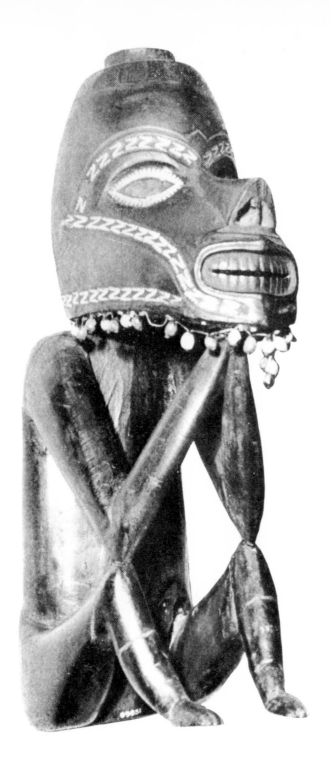

Canoe prow ornament in the shape of a seated human figure, inlaid with mother-of-pearl, from the Solomon Islands. 13½″ high. Collection Chicago Natural History Museum, Chicago. (99.851)

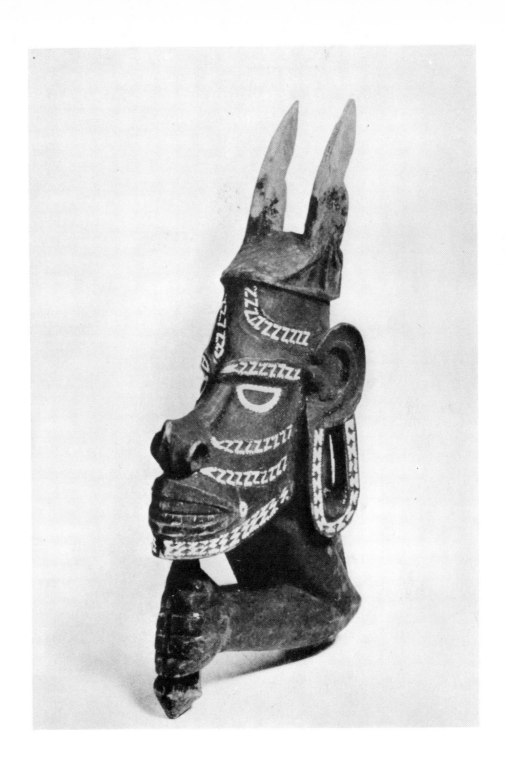

Canoe prow ornament in the shape of a human figure, from New Georgia, Solomon Islands. 11″ high. Collection Buffalo Museum of Science, Buffalo. (C-12041)

Melanesia: The Solomon Islands

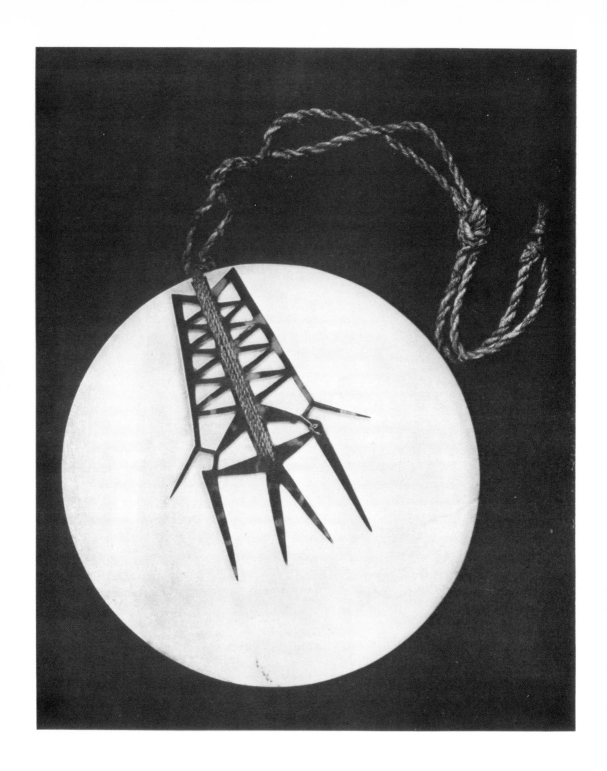

Shell pendant with tortoise-shell ornament, from Santa Cruz, Solomon Islands. 6¾″ diam. Collection
Buffalo Museum of Science, Buffalo. (C-10723)

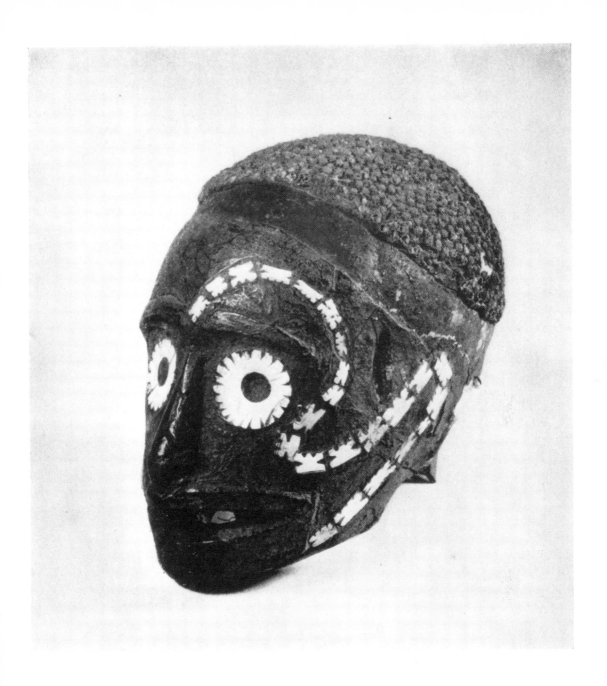

Head modeled over a skull, inlaid with mother-of-pearl, from the Solomon Islands. Collection Peabody Museum of Salem, Salem, Mass. (E 19.898)

Melanesia: The Solomon Islands

189

Australia

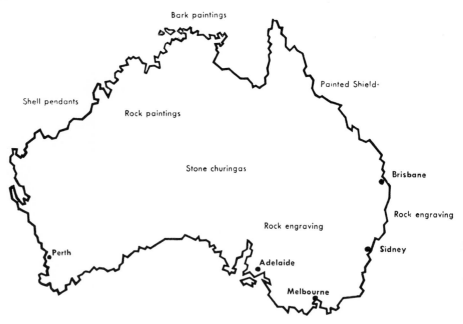

The dark-skinned aborigines of the vast island continent of Australia differ racially and culturally from the peoples of Melanesia and Polynesia. They are believed to be related to the Caucasian Dravidians of India and are therefore rather distant kinsmen of the brunette peoples of Europe.

They are divided into a great number of tribes who live in small, scattered, usually nomadic groups. Neither the extensive forests and grasslands along the Australian coast, well supplied with water, nor the desert areas of the central regions have provided them with animals that could be bred and domesticated or with plants suitable for cultivation. They have no choice but to forage and hunt for their subsistence. Even the European settler, with all the accumulated knowledge at his command, has been unable to utilize a single Australian cereal or animal in a hundred and fifty years of colonization.

The material culture of the native Australian tribes is, in fact, the most primitive in Oceania, if not in the world. The types of objects they produce are very limited—their only arms for hunting and warfare are spears and spear throwers, throwing clubs, simple stone axes, wooden shields and boomerangs (p. 194). The latter are used throughout most of the continent, though the famous returning type is known only along its southern edge. The household equipment of the women consists of vessels for carrying, stones for grinding and sticks for digging. Nothing is worn by men or women except occasionally a belt or a headband.

Yet in spite of this extremely limited material culture, the Australian aborigines have well developed concepts of the supernatural, a complex social organization and many wise law codes. Customs, language and belief vary greatly from tribe to tribe, but certain ideas are widely distributed.

190

Totemic elements can be recognized in the social and religious life of nearly all Australian tribes. These elements often merge with a belief in deities such as the "sky people" who originally may well have been cultural heroes. This latter cult appears to be of a more recent origin than those based on totemic concepts.

The totems of the Australian aborigines are species of animals, or occasionally plants, believed to be the ancestors of the various groups within the tribe. They are considered the kinsmen and protectors of their human progeny and are shown such respect that in spite of the scarcity of food, they are never eaten except on ceremonial occasions. Totems are venerated as originators of laws and customs and as sources of supernatural power. The totemic aspects of social organization, particularly in Central Australia, are very complex. The division of a tribe into totemic groups determines or strongly affects the relationships between individuals, their duties and responsibilities within the tribe, and the system of marriage.

In making ceremonial designs and objects to invoke the supernatural powers, many of the aboriginal groups have developed art forms of great complexity and often of great beauty. An object bearing a totemic symbol is believed to possess the power of the totem itself; such a symbol engraved on a weapon, for example, endows it with strength and deadly accuracy. Totemic art is almost never realistic in our sense. Animals and human figures are often represented by their footprints only, while geometric patterns may represent localities, people, animals, objects or even ideas.

Among the objects held most sacred are the *churingas* or *tjurungas*—engraved oval plaques of stone or wood. In Central Australia they are decorated with geometric patterns consisting mainly of concentric circles and arcs which often represent topographic features such as the

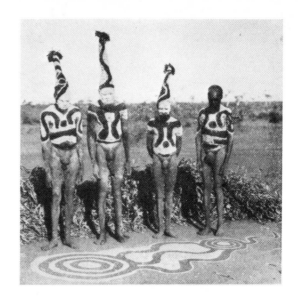

Australian aborigines of the Warramunga tribe in ceremonial costume made of feathers glued to the skin. Ground drawing in the foregound.

mountains and water-holes, created by the totemic ancestor of the *churinga's* owner. The plaques are believed to be the dwelling places of the spirits of the owner and his totem and to have mystic powers.

The large and often very complex ground paintings made in Central Australia are another vital feature of the ceremonial life of the region (above). Like the *churingas,* they are held sacred and can only be made by initiated members of the group who know the chants which must accompany the painting. No woman or uninitiated youth is allowed to see them.

Various combinations of broad, curving parallel bands and concentric circles are used as design elements. The painting is done on a hard earth surface with charcoal, red and yellow ochre and white eagle down, the latter stuck on with human blood. All these materials are also used for ritual body painting.

A different type of geometric design resembling a maze drawn in angular lines is incised

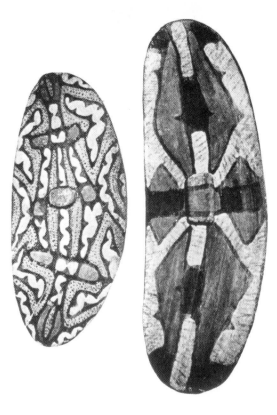

wood carvings in Australia. All the different carvings of the region, including those found on weapons and message sticks, show a certain similarity of design.

The sticks play an important role in commerce and in inter-tribal communication. The specific occasion on which they are used determines the interpretation of the carving. Sometimes the number and arrangement of the notches cut into them has some bearing on the content of the messages; in other cases the sending of the stick simply means that its receiver is to proceed in accordance with a prearranged plan that is not necessarily indicated by the incisions.

Rock paintings and rock carvings are found in many parts of Australia. Among the former, the most interesting are the *wondjina* from the

Painted shields from Queensland. 30″ and 37″ high. Collection Chicago Natural History Museum, Chicago. (91332 and 99975)

on the pearl shell ornaments from the northwest coast, where they play an important role in the initiation rites of youths (p. 193). These ornaments are worn on braided cords of human hair, and since they are used for trade they are sometimes found over two thousand miles from their place of origin.

A highly localized southeastern art form is that of tree carving in the River Darling area in New South Wales. A large oval piece of bark is removed from a living tree and geometric designs are cut deep into the exposed wood. Tree carvings are frequently found at burial sites and near ceremonial grounds but little is known about their significance. Some of them measure over seven feet and are the largest

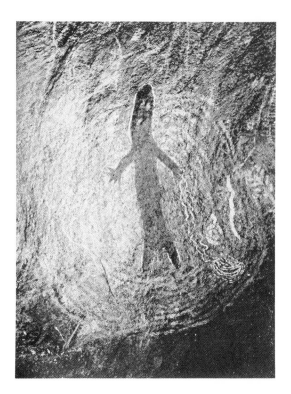

Rock painting. Photo courtesy C. P. Mountford.

Australia

northwest coast which represent weird rudimentary human figures with simple outlines painted in flat color on the walls and roofs of rock shelters. Some have large eyes, no mouth and an aura around the head and are as high as ten feet. They embody rain-making power and therefore also the reproductive power of nature and man. The natives repaint the *wondjinas* periodically to revitalize them. Plants and animals are often depicted close to the figures, possibly to bring them under their fertility-giving influence.

Among the rock carvings, two styles are of special interest. In the simple intagliated type found in large numbers in South Australia, a series of small holes is pecked out of the rock with a sharp pointed stone to form animals, human figures and imaginary beings. It seems likely that these rock carvings are of great age since the aborigines of today either have no knowledge of them or attribute them to mythological ancestors. In their appearance they are similar to the rock carvings of Arizona, Utah and other parts of our southwest.

The second type, found near Sydney on the east coast, is of comparatively recent date. Contours of fish, animals and human figures are cut into flat sandstone surfaces in continuous lines, with an attempt at life-like representation. These carvings often measure twenty feet.

The famous bark paintings of Arnhem Land (p. 195) in the north show great power of observation in the portrayal of animals and plants. These paintings are among the most remarkable local developments in Australia. On sheets of bark like those used for the walls of huts, fish, snakes, crocodiles and kangaroos are painted; also hunting scenes with the human figures represented on a much smaller scale than the animals. Here we have a good example of a primitive type of rationalized realism depicting structural elements that the artist

Belt made of human hair with engraved shell pendant, from West Australia. 8″ high. Collection Chicago Natural History Museum. (172807)

knows to be part of the subject even if he cannot see them; parts of the anatomy of both animals and human beings, particularly the spinal column and the alimentary canal, are often clearly indicated, and both eyes are frequently shown on profiles. Sometimes elements associated with a subject are shown as though part of it. Animals, for instance, are depicted with their tracks, reminding us that for these hunters they were part of the animals' total reality. Many of the hunting scenes are full of movement and executed with a keen sense for the dramatic, while the stylization and use of color show great sensitivity.

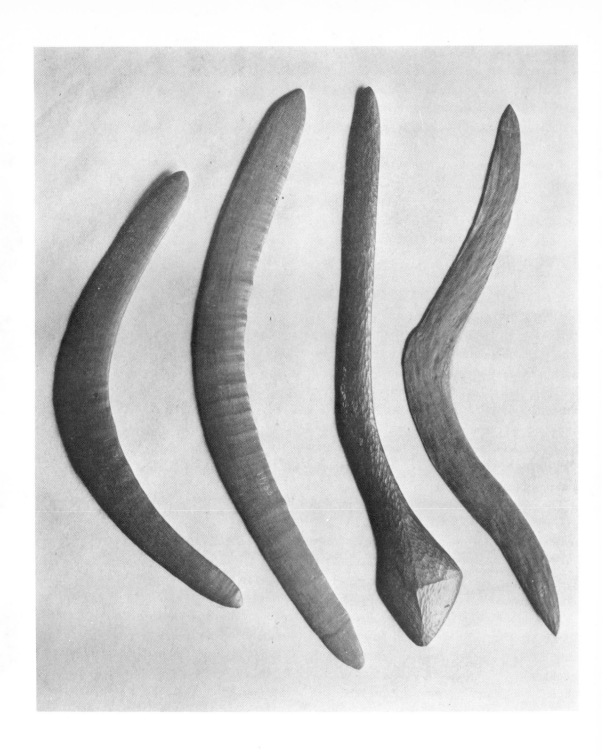

Boomerangs of various shapes. Collection University of Pennsylvania Museum, Philadelphia. (19933, 19934, 42-30-474, P 2347)

194 *Australia*

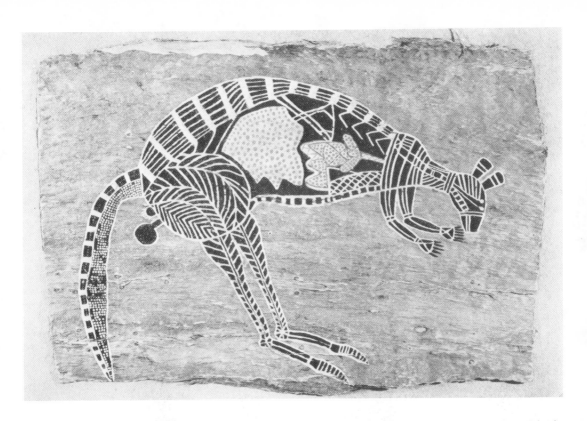

Kangaroo. Bark painting from Northern Australia. 20 x 45″. Collection Miss M. Matthews, Adelaide, Australia. (A 34825)

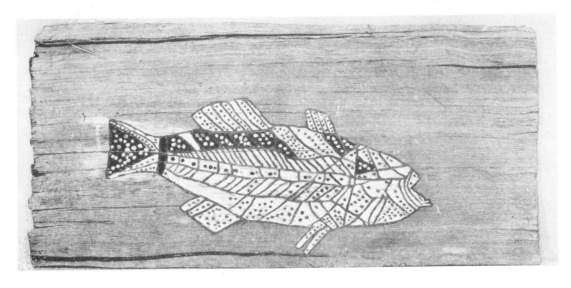

Butterfish. Bark painting from Northern Australia. 33 x 50″. Collection South Australian Museum, Adelaide. (A 34823)

Bibliography

OCEANIA, *General*

L'art des Océaniens. *Cahiers d'art*, 2-3, 1929

Basler, A. L'art chez les peuples primitifs, Paris, 1929

Bougainville, L. A. A voyage around the world . . . 1766-1769, trans. by J. R. Forster, London, 1772

Brigham, W. T. Index to the islands of the Pacific, *Memoirs, Bernice P. Bishop Museum*, 1, no. 2, 1900

British Museum. Handbook to the ethnographical collections, 2nd ed., London, 1925

Clawson, H. P. By their works, Buffalo, 1941

Cook, James. A voyage towards the South Pole and round the world, performed in His Majesty's ships Resolution and Adventure in the years 1772, 1773, 1774, 1775, London, 1777, 2 vols.

——— A voyage to the Pacific Ocean, London, 1785, 5 vols.

Edge-Partington, James. An album of the weapons, tools, ornaments, articles of dress of the natives of the Pacific Islands, Manchester, 1890-98, 3 vols.

Finsch, O. Südseearbeiten, Hamburg, 1914

Forster, G. A voyage round the world in His Britannic Majesty's sloop "Resolution," London, 1777, 2 vols.

Frazer, J. G. The native races of Australasia, compiled and edited by R. A. Downie, London, 1939

Haddon, A. C. and Hornell, James. Canoes of Oceania, Honolulu, 1936-37. (Bernice P. Bishop Museum. Special publication, nos. 27-29)

Krieger, H. W. Island peoples of the western Pacific: Micronesia and Melanesia, Washington, 1943 (War background studies, no 16. Smithsonian Institution. Publication 3737)

Kühn, Herbert. Die Kunst der Primitiven, Munich, 1923

La Perouse, Comte de. Voyage round the world, 1785-1788, London, 1799

Markham, Sir Clements. The voyages of Pedro Fernandez de Quiros, 1595-1606, London, Hakluyt Society, 1904

Nevermann, Hans. Südseekunst, Berlin, Staatliches Museum, 1933

Parkinson, R. Dreissig Jahre in der Südsee, Stuttgart, 1907

Portier, A. et Ponceton, F. Les arts sauvages: Océanie, Paris, 1930

Robson, R. W. The Pacific Islands handbook, 1944, New York, 1945

San Francisco. Golden Gate International Exposition, Pacific cultures, 1939

Springer, A., ed. Die aussereuropäische Kunst, Leipzig, 1920 (Handbuch der Kunstgeschichte, 6)

Stephan, E. Südseekunst, Berlin, 1907

Sydow, E. von. Die Kunst der Naturvölker und der Vorzeit, Berlin, 1923

Wilkes, C. Narrative of the U. S. Exploring Expedition, London, 1841, 5 vols.

AUSTRALIA

Basedow, H. The Australian aboriginal, Adelaide, 1925, chapter 28

Davidson, D. S. Aboriginal Australian and Tasmanian rock carving and painting, *Memoirs, American Philosophical Society*, 5, 1936

——— A preliminary consideration of aboriginal Australian decorative art. *Memoirs, American Philosophical Society*, 5, 1937

Elkin, A. P. Rock paintings of North-West Australia, *Oceania*, 1, 1930-31, pp. 257-79

McCarthy, F. D. Australian aboriginal decorative art, Sydney, 1938

Mountford, C. P. Aboriginal decorative art from Arnhem Land, northern territory of Australia. *Transactions, Royal Society of South Australia*, 63 (2), 1939

——— Aboriginal crayon drawings, Warburton Ranges, Western Australia, Sydney, Australasian Medical Publishing Co., Ltd., 1939 (Reprinted from *Oceania*, 10, no. 1, Sept. 1939)

National Museum of Victoria. Australian aboriginal decorative art, Melbourne, 1929

Spencer, W. B. Native tribes of the northern territory of Australia, London, 1914, chapter 14

Spencer, W. B. & Gillen, F. G. The Arunta, London, 1927, 2 vols.

MELANESIA, *General*

Codrington, R. H. The Melanesians, Oxford, 1891

Entrecasteaux, B. d'. Voyage d'Entrecasteaux, envoyé à la recherche de La Perouse, Paris, 1808, 2 vols.

Lewis, A. B. Ethnology of Melanesia, 2nd ed., Chicago, 1945 (Chicago Natural History Museum Guide, pt. 5)

Reichard, G. A. Melanesian design, New York, 1933, 2 vols.

Rivers, W. H. R. The history of Melanesian society, Cambridge, 1914

NEW CALEDONIA

Leenhardt, M. Notes d'ethnologie néo-Calédonien, Paris, Institut d'Ethnologie, 1930

Luquet, G. H. L'art néo-Calédonien, Paris, Institut d'Ethnologie, 1926

Sarasin, F. & Roux, J. Nova Caledonia, Munich, 1929

Sarasin, F. Ethnologie der Neu-Caledonier und Loyalty-Insulaner, Munich, 1929, 2 vols.

Sebbelov, Gerda. E. W. Clark Collection, New Cale-
donia, *Journal, University of Pennsylvania Mu-
seum*, 2, 1911, pp. 72-82.

NEW HEBRIDES

Deacon, A. B. Malekula, London, 1934
Harrison, Tom. Savage civilization, New York, 1937
Layard, J. W. Degree-taking rites in Southwest Bay,
Malekula, *Journal, Royal Anthropological Institute*,
58, 1928, pp. 139-223
Speiser, F. Ethnographische Materialien aus den Neuen
Hebriden und den Banks—Inseln, Berlin, 1923

NEW GUINEA

Bateson, Gregory. Naven, Cambridge, 1936
Cambridge University, Reports of the Cambridge An-
thropological Expedition to the Torres Straits. A. C.
Haddon, ed., vol. 1, General ethnography, Cam-
bridge, 1935, vol. 4, Arts and crafts, Cambridge,
1912
Chauvet, Stephan. Les arts indigènes en Nouvelle
Guinée, Paris, 1930
Firth, Raymond. Art and life in New Guinea, London,
1936
Fuhrmann, E. Neu-Guinea, Hagen, 1922. (Kulturen der
Erde, 14)
Haddon, A. C. The decorative art of British New
Guinea, Dublin, 1894
Landtmann, G. The Kiwai Papuans of British New
Guinea, London, 1927
Lewis, A. B. Carved and painted designs from New
Guinea, Chicago, 1931 (Chicago Natural History
Museum. Anthropological design series, no. 5)
——— Decorative art of New Guinea. Incised designs,
Chicago, 1925 (Chicago Natural History Museum.
Anthropological design series, no. 4)
Malinowski, B. Argonauts of the western Pacific, Lon-
don and New York, 1922
Mead, Margaret. The Mountain Arapesh, *Anthropologi-
cal Papers, American Museum of Natural History*,
36, pt. 3, 1938, pp. 139-349; 37, pt. 3, 1940, pp.
317-451
——— Sex and temperament in three primitive societies,
New York, 1935
——— Tamberans and Tumbuans in New Guinea,
Natural History 34, 1934, pp. 234-46
Meyer, A. B. Masken von Neu Guinea und dem Bis-
mark Archipel, Dresden, 1889 (Königliches Ethno-
graphisches Museum zu Dresden. Publikationen,
bd. 7)
Nuoffer, O. Ahnenfiguren von der Geelvinkbai, Hol-
ländisch Neu-Guinea, Leipzig, 1908 (Königl. Zoolog-
isches Anthropologisch-Ethnographisches Museum
zu Dresden. Abhandlungen und Berichte, 12)
Reche, O. Der Kaiserin-Auguste-Fluss, Hamburg, 1913

Sterling, M. W. The native peoples of New Guinea,
Washington, 1943 (War background studies, no. 9.
Smithsonian Institution. Publication 3726)
Whiting, John W. M. Becoming a Kwoma, New Haven,
Yale University Press, 1941
Williams, F. E. Orokaiva Society, Oxford, 1930
——— Drama of Orokolo, Oxford, 1940
Wirz, P. Die Marind-anim von Holländisch-Süd-Neu-
Guinea, Hamburg, 1922-24, 2 vols., 4 pts.

NEW BRITAIN

Bateson, Gregory. Further notes on a snake dance of the
Baining, *Oceania*, 2, 1931-32, pp. 334-41
Churchill, W. The Duk-Duk ceremonies, *Popular
Science Monthly*, 38, 1890, pp. 236-46
Meyer, A. B. und Parkinson, R. Schnitzereien und
Masken vom Bismark Archipel und Neu Guinea,
Dresden, 1895 (Königliches Ethnographisches Mu-
seum zu Dresden, Publikationen, bd. 10)
Read, W. J. A snake dance of the Baining, *Oceania*, 2,
1931-32, pp. 232-36

NEW IRELAND

Groves, W. C. Secret beliefs and practices in New Ire-
land, *Oceania*, 7, 1936-37, pp. 220-45
Hall, H. U. Malagan of New Ireland, *Bulletin, Univer-
sity of Pennsylvania Museum*, 5, no. 4, 1935, pp.
2-11
Krämer, A. Die Malanggane von Tombara, Munich,
1925
Meyer, A. B. und Parkinson, R. op. cit.
Powdermaker, Hortense. Mortuary rites in New Ireland,
Oceania, 2, 1931-32, pp. 26-43
——— Life in Lessu, New York, 1933
Stephan, E. und Gräbner, F. Neu-Mecklenburg, Berlin,
1907

SOLOMON ISLANDS

Blackwood, Beatrice. Both sides of the Buka Passage,
Oxford, 1935
Edge-Partington, J. & Joyce, T. A. Notes on funerary
ornaments from Rubiana and a coffin from Sta.
Anna, Solomon Islands, *Man*, 4, 1904, pp. 129-31
Fox, C. E. The threshold of the Pacific, London and
New York, 1924
Ivens, W. G. Melanesians of the southeast Solomon Is-
lands, London, 1927
Woodford, C. M. The canoes of the British Solomon
Islands, *Journal, Royal Anthropological Institute*,
39, 1909, pp. 506-16

ADMIRALTY ISLANDS

Mead, Margaret. Growing up in New Guinea, New
York, 1930
——— Melanesian middlemen, *Natural History*, 30,
1930, pp. 115-30

——— Living with the natives of Melanesia, *Natural History* 31, 1931, pp. 62-74

Nevermann, H. Admiralitäts—Inseln, Hamburg, 1934

MICRONESIA

Christian, F. W. The Caroline Islands, London, 1899

Furness, Wm. H. The island of stone money. Lippincott, Philadelphia and London, 1910

Grimble, Arthur. Canoes in the Gilbert Islands, *Journal, Royal Anthropological Institute,* 54, 1924, pp. 101-39

——— From birth to death in the Gilbert Islands, *Journal, Royal Anthropological Institute,* 51, 1921, pp. 24-54

Kubary, J. S. Ethnographische Beiträge zur Kenntnis der Karolinischen Inselgruppe. Asher, Berlin, 1885.

——— Ethnographische Beiträge zur Kenntnis des Karolina Archipels. Trap, Leiden, 1895.

Pitt-Rivers, G. L. F. Ava Island; ethnographical and sociological features of a South Sea pagan society, *Journal, Royal Anthropological Institute,* 55, 1925, pp. 425-38

Thompson, L. M. Guam and its people, San Francisco, 1941 (Institute of Pacific Relations. Studies of the Pacific no. 8)

Thompson, L. M. Archaeology of the Marianas Islands, *Bulletin, Bernice P. Bishop Museum,* 100, 1932, pp. 1-82

Winkler, Captain. On the sea charts formerly used in the Marshall Islands with notices on the navigation of these islanders in general. *Annual Report, Smithsonian Institution,* 1899, pp. 487-508

POLYNESIA, *General*

Beechy, F. W. Narrative of a voyage to the Pacific and Bering Strait, London, 1831, 2 vols.

Buck, P. H. (Te Rangi Hiroa) Vikings of the sunrise, New York, 1938

Burrows, E. G. Western Polynesia, a study in cultural differentiation, Göteborg, 1938

Christian, F. W. Eastern Pacific Islands, London, 1910

Churchill, W. Polynesian wanderings, Washington, 1911

——— Club types of nuclear Polynesia, Washington, 1917 (Carnegie Institution. Publication 255)

Ellis, W. Polynesian researches, London, 1831-32, 4 vols.

Firth, R. Primitive Polynesian economy, London, 1939

Fornander, A. An account of the Polynesian race, London, 1898, 3 vols.

Handy, E. S. C. Polynesian religion, *Bulletin, Bernice P. Bishop Museum,* 34, 1927

Langsdorff, A. H. von. Voyages and travels in various parts of the world, 1803-07, Philadelphia, 1817, pp. 158-265

Linton, R. Ethnology of Polynesia and Micronesia, *Chicago Natural History Museum Guide,* Chicago, 1926, part 6

Williamson, R. W. Religious and cosmic beliefs of Central Polynesia, Cambridge, 1933, 2 vols.

——— The social and political systems of Central Polynesia, Cambridge, 1924, 3 vols.

——— Essays in Polynesian ethnology, R. Piddlington ed., Cambridge, 1939

FIJI ISLANDS

Fijian Collection, *Journal, American Museum of Natural History,* 9, 1909, pp. 117-22

Roth, K. The manufacture of bark-cloth in Fiji. *Journal, Royal Anthropological Institute,* 64, 1934, pp. 289-303

Seemann, B. Viti, an account of a government mission to the Vitian or Fiji Islands in 1860-1861, Cambridge and London, 1862

Thomson, B. The Fijians, London, 1908

Thompson, Laura. Southern Lau, Fiji: an ethnography, *Bulletin, Bernice P. Bishop Museum,* 162, 1940, pp. 1-228

Williams, T. & Calvert, J. Fiji and Fijians, London, 1858, 2 vols.

CENTRAL POLYNESIA

Buck, P. H. (Te Rangi Hiroa) Additional wooden images from Tonga, *Journal, Polynesian Society,* 46, 1937, pp. 74-82

——— Material representatives of Tongan and Samoan gods, *Journal, Polynesian Society,* 44, 1935, pp. 48-53, 85-96, 153-62

——— Samoan material culture, *Bulletin, Bernice P. Bishop Museum,* 75, 1930

Gifford, E. W. Tongan myths and tales, *Bulletin, Bernice P. Bishop Museum,* 8, 1924

McKern, W. C. Archaeology of Tonga, *Bulletin, Bernice P. Bishop Museum,* 60, 1929

Mead, M. Coming of age in Samoa, New York, 1928

Stair, E. B. Old Samoa, St. Pauls, 1897

Thompson, B. H. Savage Island, London, 1902, pp. 1-151

Turner, G. Samoa, London, 1884

AUSTRAL ISLANDS

Aitken, R. T. Ethnology of Tubuai, *Bulletin, Bernice P. Bishop Museum,* 70, 1930

Hall, H. V. Woodcarvings of the Austral Islands, *Journal, University of Pennsylvania Museum,* 12, 1921, pp. 179-99

COOK (HERVEY) ISLANDS

Buck, P. H. (Te Rangi Hiroa) Mangaian society, *Bulletin, Bernice P. Bishop Museum,* 122, 1934, pp. 1-207

——— Arts and crafts of the Cook Islands, *Bulletin, Bernice P. Bishop Museum,* 179, 1944

Dodge, E. S. The Hervey Islands adzes in the Peabody Museum of Salem, Salem, 1937

Gill, W. W. Life in the southern Isles, London, 1876

TIKOPIA (TUCOPIA)

Firth, R. We, the Tikopia, New York, 1937

MANGAREVA (GAMBIER) ISLANDS

Buck, P. H. (Te Rangi Hiroa) Ethnology of Mangareva, *Bulletin, Bernice P. Bishop Museum,* 157, 1938, pp. 1-519

SOCIETY ISLANDS

Handy, E. S. C. History and culture of the Society Islands, *Bulletin, Bernice P. Bishop Museum,* 74, 1930

Henry, T. Ancient Tahiti, *Bulletin, Bernice P. Bishop Museum,* 48, 1928

MARQUESAS ISLANDS

Christian, F. W. Notes on the Marquesas, *Journal, Polynesian Society,* 4, 1895

Dodge, E. S. The Marquesas Islands collection in the Peabody Museum of Salem, Salem, 1939

Hall, H. U. Art of the Marquesas Islands, *Journal, University of Pennsylvania Museum,* 12, 1921, pp. 253-92

Handy, E. S. C. The native culture in the Marquesas, *Bulletin, Bernice P. Bishop Museum,* 29, 1923

Handy, W. C. L'art des Iles Marquises, Paris, 1938

Linton, R. The native culture of the Marquesas Islands, *Memoirs, Bernice P. Bishop Museum,* 8, No. 5, 1923

Melville, H. Typee, London, 1892

Steinen, K. von den. Die Marquesaner und ihre Kunst, Berlin, 1925-28, 3 vols.

NEW ZEALAND

Archer, G. Maori carving patterns, *Journal, Polynesian Society,* 45, 1936, pp. 49-62

Best, E. The Maori, Wellington, 1924, 2 vols.

Cowan, J. The Maoris of New Zealand, Melbourne & London, 1910

Dodge, E. S. The New Zealand Maori collection in the Peabody Museum of Salem, Salem, 1941

Firth, R. The Maori carver, *Journal, Polynesian Society,* 34, 1925, pp. 277-91

——— Primitive economics of the New Zealand Maori, New York, 1929

Hamilton, A. The art workmanship of the Maori race in New Zealand, Wellington, 1896-1901

Mead, Margaret. The Maoris and their arts, *American Museum of Natural History. Guide Leaflet,* 71, 1928

Skinner, H. D. Evolution in Maori art, *Journal, Royal Anthropological Institute,* 46, 1916, pp. 184-196, 309-321

Smith, S. P. The lore of the Whare-Wananga, New Plymouth, 1913, 2 vols.

Tregear, E. The Maori race, Wanganni, 1904

HAWAII

Alexander, W. D. A brief history of the Hawaiian people, New York, 1899

Beckwith, M. W. Hawaiian mythology, New Haven, 1940

Bishop, Marcia B. Hawaiian life of the pre-European period, Salem, 1940

Brigham, W. T. Additional notes on Hawaiian feather work, *Memoirs, Bernice P. Bishop Museum,* 1, no. 5, 1903, pp. 1-19

——— The ancient Hawaiian house, *Memoirs, Bernice P. Bishop Museum,* 2, 1906-09, pp. 185-378

——— Hawaiian feather work, *Memoirs, Bernice P. Bishop Museum,* 1, no. 1, 1899, pp. 1-88

——— Ka Hana Kapa: the making of bark-cloth in Hawaii, *Memoirs, Bernice P. Bishop Museum,* 3, 1911, pp. 1-276

Cheever, H. T. Life in the Sandwich Islands, London, 1851

Dodge, E. S. The Hawaiian portion of the Polynesian collection of the Peabody Museum of Salem, Salem, 1937

Ellis, W. Narrative of a tour through Hawaii, London, 1826

Emerson, J. S. The lesser Hawaiian gods, *Papers of the Hawaiian Historical Society,* 2, 1892

Emory, K. P. Hawaii: notes on wooden images, *Ethnologia Cranmorensis,* 2, 1938, pp. 2-7

Handy, E. S. C. and Buck, P. H., and others. Ancient Hawaiian civilization, Honolulu, 1933

Luquiens, H. M. Hawaiian art, Honolulu, 1931

EASTER ISLAND

Casey, R. J. Easter Islands, Indianapolis, 1931

Metraux, E. Ethnology of Easter Island, *Bulletin, Bernice P. Bishop Museum,* 160, 1940

Routledge, Mrs. S. The mystery of Easter Island, London, 1919

——— Survey of the village and carved rocks of Orongo, Easter Island, *Journal, Royal Anthropological Institute,* 50, 1920, pp. 425-51

Thomson, W. J. Te Pito Te Henua, or Easter Island, *Report U. S. National Museum, Smithsonian Institution, for 1889,* Washington, 1891, pp. 447-552

Twenty-three thousand five hundred copies of this book have been printed in February 1946 for the Trustees of the Museum of Modern Art by the Plantin Press, New York.

Museum of Modern Art Publications in Reprint

Abstract Painting and Sculpture in America. 1951. Andrew Carnduff Ritchie

African Negro Art. 1935. James Johnson Sweeney

American Art of the 20's and 30's: Paintings by Nineteen Living Americans; Painting and Sculpture by Living Americans; Murals by American Painters and Photographers. 1929. Barr; Kirstein and Levy

American Folk Art: The Art of the Common Man in America, 1750-1900. 1932. Holger Cahill

American Painting and Sculpture: 1862-1932. 1932. Holger Cahill

American Realists and Magic Realists. 1943. Miller and Barr; Kirstein

American Sources of Modern Art. 1933. Holger Cahill

Americans 1942-1963; Six Group Exhibitions. 1942-1963. Dorothy C. Miller

Ancient Art of the Andes. 1954. Bennett and d'Harnoncourt

The Architecture of Bridges. 1949. Elizabeth B. Mock

The Architecture of Japan. 1955. Arthur Drexler

Art in Our Time; 10th Anniversary Exhibition. 1939.

Art Nouveau; Art and Design at the Turn of the Century. 1959. Selz and Constantine

Arts of the South Seas. 1946. Linton, Wingert, and d'Harnoncourt

Bauhaus: 1919-1928. 1938. Bayer, W. Gropius and I. Gropius

Britain at War. 1941. Eliot, Read, Carter and Dyer

Built in U.S.A.: 1932-1944; Post-War Architecture. 1944. Mock; Hitchcock and Drexler

Cézanne, Gauguin, Seurat, Van Gogh: First Loan Exhibition. 1929. Alfred H. Barr, Jr.

Marc Chagall. 1946. James Johnson Sweeney

Giorgio de Chirico. 1955. James Thrall Soby

Contemporary Painters. 1948. James Thrall Soby

Cubism and Abstract Art. 1936. Alfred H. Barr, Jr.

Salvador Dali. 1946. James Thrall Soby

James Ensor. 1951. Libby Tannenbaum

Max Ernst. 1961. William S. Lieberman

Fantastic Art, Dada, Surrealism. 1947. Barr; Hugnet

Feininger-Hartley. 1944. Schardt, Barr, and Wheeler

The Film Index: A Bibliography (Vol. 1, The Film as Art). 1941.

**Five American Sculptors: Alexander Calder; The Sculpture of John B.
Flannagan; Gaston Lachaise; The Sculpture of Elie Nadelman; The
Sculpture of Jacques Lipchitz.** 1935-1954. Sweeney; Miller, Zigrosser;
Kirstein; Hope

**Five European Sculptors: Naum Gabo—Antoine Pevsner; Wilhelm Lehmbruck—
Aristide Maillol; Henry Moore.** 1930-1948. Read, Olson, Chanin; Abbott;
Sweeney

**Four American Painters: George Caleb Bingham; Winslow Homer, Albert P.
Ryder, Thomas Eakins.** 1930-1935. Rogers, Musick, Pope; Mather, Burroughs,
Goodrich

German Art of the Twentieth Century. 1957. Haftmann, Hentzen and Lieberman;
Ritchie

Vincent van Gogh: A Monograph; A Bibliography. 1935, 1942. Barr; Brooks

Arshile Gorky. 1962. William C. Seitz

Hans Hofmann. 1963. William C. Seitz

Indian Art of the United States. 1941. Douglas and d'Harnoncourt

**Introductions to Modern Design: What is Modern Design?; What is
Modern Interior Design?** 1950-1953. Edgar Kaufmann, Jr.

Paul Klee: Three Exhibitions: 1930; 1941; 1949. 1945-1949. Barr;
J. Feininger, L. Feininger, Sweeney, Miller; Soby

Latin American Architecture Since 1945. 1955. Henry-Russell Hitchcock

Lautrec-Redon. 1931. Jere Abbott

Machine Art. 1934. Philip Johnson

John Marin. 1936. McBride, Hartley and Benson

Masters of Popular Painting. 1938. Cahill, Gauthier, Miller, Cassou, et al.

Matisse: His Art and His Public. 1951. Alfred H. Barr, Jr.

Joan Miro. 1941. James Johnson Sweeney

Modern Architecture in England. 1937. Hitchcock and Bauer

Modern Architecture: International Exhibition. 1932. Hitchcock, Johnson,
Mumford; Barr

Modern German Painting and Sculpture. 1931. Alfred H. Barr, Jr.

Modigliani: Paintings, Drawings, Sculpture. 1951. James Thrall Soby

Claude Monet: Seasons and Moments. 1960. William C. Seitz

Edvard Munch; A Selection of His Prints From American Collections. 1957.
William S. Lieberman

The New American Painting; As Shown in Eight European Countries, 1958-1959.
1959. Alfred H. Barr, Jr.

New Horizons in American Art. 1936. Holger Cahill

New Images of Man. 1959. Selz; Tillich

Organic Design in Home Furnishings. 1941. Eliot F. Noyes

Picasso: Fifty Years of His Art. 1946. Alfred H. Barr, Jr.

Prehistoric Rock Pictures in Europe and Africa. 1937. Frobenius and Fox

Diego Rivera. 1931. Frances Flynn Paine

Romantic Painting in America. 1943. Soby and Miller

Medardo Rosso. 1963. Margaret Scolari Barr

Mark Rothko. 1961. Peter Selz

Georges Roualt: Paintings and Prints. 1947. James Thrall Soby

Henri Rousseau. 1946. Daniel Catton Rich

Sculpture of the Twentieth Century. 1952. Andrew Carnduff Ritchie

Soutine. 1950. Monroe Wheeler

Yves Tanguy. 1955. James Thrall Soby

Tchelitchew: Paintings, Drawings. 1942. James Thrall Soby

Textiles and Ornaments of India. 1956. Jayakar and Irwin; Wheeler

**Three American Modernist Painters: Max Weber; Maurice Sterne; Stuart
 Davis.** 1930-1945. Barr; Kallen; Sweeney

**Three American Romantic Painters: Charles Burchfield: Early Watercolors;
 Florine Stettheimer; Franklin C. Watkins.** 1930-1950. Barr; McBride; Ritchie

**Three Painters of America: Charles Demuth; Charles Sheeler; Edward
 Hopper.** 1933-1950. Ritchie; Williams; Barr and Burchfield

Twentieth-Century Italian Art. 1949. Soby and Barr

Twenty Centuries of Mexican Art. 1940

Edouard Vuillard. 1954. Andrew Carnduff Ritchie

The Bulletin of the Museum of Modern Art, 1933-1963. (7 vols.)